Their Fathers' Daughters

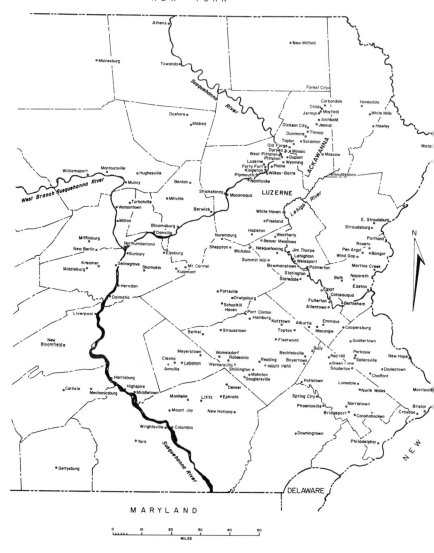

Map prepared by Larry Grantham.

Their Fathers' Daughters

Silk Mill Workers in Northeastern Pennsylvania, 1880–1960

Bonnie Stepenoff

SUP

Selinsgrove: Susquehanna University Press
London: Associated University Presses

Associated University Presses
440 Forsgate Drive
Cranbury, NJ 08512

Associated University Presses
16 Barter Street
London WC1A 2AH, England

Associated University Presses
P.O. Box 338, Port Credit
Mississauga, Ontario
Canada L5G 4L8

The paper used in this publication meets the requirements of the American National Standard for Permanence of Paper for Printed Library Materials Z39.48-1984.

Library of Congress Cataloging-in-Publication Data

Stepenoff, Bonnie, 1949–
 Their fathers' daughters : silk mill workers in Northeastern
Pennsylvania, 1880–1960 / Bonnie Stepenoff.
 p. cm.
 Includes bibliographical references and index.
 ISBN 1-57591-028-4 (alk. paper)
 1. Women silk industry workers—Pennsylvania—History. I. Title.
HD6073.T42U574 1999
331.4'877391'097483—dc21 99-26413
 CIP

In memory of my father,
Ernest W. Steckel

Contents

Acknowledgments

Thanks are due to Susan Porter Benson, David Roediger, Lee Ann Whites, and Laurel Wilson. I am grateful to Dr. Thomas Dublin for kind advice and perceptive criticism. Drs. Ardis Cameron and Mary Frederickson commented on a conference paper. Dr. Rowland Berthoff generously shared information.

The Museum of American Textile History awarded a Sullivan Fellowship, and the Hagley Museum and Library gave a grant-in-aid for the research on this project. The University of Missouri and Southeast Missouri State University also supported this effort.

Portions of this study have appeared in *Pennsylvania History* (April 1992), *Labor's Heritage* (winter 1996), and *Labor History* (fall 1997). I presented papers at the "Reworking Labor History" conference sponsored by the University of Wisconsin (April 1992), and at the annual conference of the Organization of American Historians (April 1994).

Chester Kulesa of the Anthracite Heritage Museum in Scranton, Pennsylvania, offered valuable assistance. Ray Zabofski, Dolores Gonus Liuzzo, Martha Warosh Mroczka, and Linda Newberry generously shared their knowledge of the silk industry.

My husband Jerry drove me cross-country and helped me complete my research. My daughters Samantha and Hannah gave me great joy. My mother and father gave me love and an education.

Prologue:
The Girls at the Mill

In 1956 or 1957, my great-aunts Laura Allio and Lizzie Owens climbed a long flight of concrete steps up the side of a steep hill to the Willow Silk Mill in Slatington (Lehigh County), Pennsylvania. They spoke of it poetically as "going up to the Willow." At this time they were women in their fifties, but they had begun to climb those steps as girls of fourteen. They still called themselves and their co-workers "girls," speaking of the "girls at work," or the "girls at the Willow." Sometimes I pictured girls in long dresses, lazing under a tree. I never went up to the mill. Laura and Lizzie never took me there. It would not be part of my world. They didn't want it to be.

Laura and Lizzie were sisters, the daughters of a Welsh immigrant named Owen Owens. I remember them carrying their aprons in cloth bags and wearing heavy oxfords and plain cotton print dresses. They trapped their grey hair in hairnets, either out of habit or to keep it from straying into the machinery. Sometimes they talked and sometimes they were silent as they climbed the two-hundred-odd steps to the entrance of the red brick factory.

Why did they do it? They had done it so long, there had hardly been a moment in their lives when they might have decided not to do it, to do otherwise. As young girls they came to the mill to help support themselves, their parents, and their brothers David, Morris, and Tommy. Their father worked in a slate quarry. Morris went to France during World War I, returned to Slatington, went up to the mill, and eventually became a loom fixer. Laura and Lizzie continued to work in the mill after David died, Tommy moved to New York City, and Morris got married and started a family.

Laura put off marriage until middle age; Lizzie never married. I don't know why, but I know that some factories fired "girls" when they married. My mother's cousin Diane lived with a man named Linnie for many years without benefit of a marriage license so that she could keep her job at the PP&L (Pennsylvania Power and Light). Maybe the Willow discriminated against married women.

11

Laura and Lizzie reported to the mill faithfully through the upheavals of the early twentieth century, the panic of 1929, and the Great Depression of the 1930s. The prosperity of the 1950s meant that Laura's soon-to-be-husband Tony could earn enough money drilling wells and working on construction crews to build the couple a sturdy two-story house on Hill Street. Lizzie refused to live with them there unless they became legally married. After Laura became an "honest woman," Lizzie lived with them the rest of her life.

Laura worked as a weaver and Lizzie as a quiller until they retired in the 1960s. By that time the silk mills were closing in towns and villages in the hills all around them. The death of the industry did not change these women's lives. If they entertained thoughts of a different kind of life, they did not act upon them. But Laura saved enough money to help send me, her grandniece, to college.

Laura and Lizzie did not change the course of history. They were not revolutionaries. They were not self-conscious actors on the historical stage. But they were not the passive victims of inexorable historical forces. If they accepted a certain dreariness in their own lives, they did not necessarily wish it on a future generation. The society in which they lived constricted their choices, but did not deprive them of hope. Like many daughters of immigrants in northeastern Pennsylvania, Laura and Lizzie had visions of a better life, if not for themselves, then for their children, and if not for their own children, then for the children of their brothers.

For Laura and Lizzie as for many women in their part of the world, the key to that dream for the future was something they had given up at age fourteen: an education. It took a couple of generations. But finally I was given that key. I was allowed to live their dream. Because of this privilege, I have written this book.

Introduction

The female silk workers of northeastern Pennsylvania were truly "their fathers' daughters." In the late nineteenth and early twentieth centuries, silk manufacturers moved their plants to northeastern Pennsylvania because of its large population of anthracite (hard coal) miners. These men worked in a dangerous and volatile industry that sometimes left their families without a dependable income from a male breadwinner. Their sons went to work in the "breakers" (coal breaking machines) and mines. Their daughters were eager for work in the mills.

Despite their gender, female silk workers emulated their fathers' behavior in many ways. Like their fathers, they reported to work dutifully, enduring long hours and harsh conditions. And like their fathers, they sometimes rose up in militant protest. Anthracite miners went on strike in 1900. Silk workers in the hard-coal region walked off the job in the winter of 1900–1901. Reporters for Scranton, Pennsylvania, newspapers wondered at the stridency and determination of pickets who were hardly beyond the age of short dresses.[1] Muckraking journalists wrote provocatively of little girls wearing their Sunday best to attend meetings at the union hall.[2]

During the great Anthracite Strike of 1902, young silk workers had a chance to tell their story in court. At hearings in Scranton, the miners' attorney Clarence Darrow called little girls to the witness stand to tell the world about ten-hour shifts and sixty-hour weeks in the mills. Twelve-year-old girls spoke of working the night shift and walking home alone. During the strike some of these girls were the only breadwinners for large families. Darrow used their testimony to argue that miners' wages were insufficient to support their families and that child labor was the inevitable result. The girls' were supporting players in the miners' great drama, but their strength and courage mirrored their fathers'.[3]

As historian John Bodnar has argued, family loyalty lay at the center of working-class culture in Northeastern Pennsylvania.[4] Most young girls who went to work in the silk mills dutifully brought their wages home to parents and siblings. Older girls often continued working so that younger siblings could remain in school.

13

14 INTRODUCTION

When fathers suffered injuries or became disabled, daughters went to work. Many left the mills when they married. Other women remained single and continued supporting parents through their old age. This self-sacrifice was not considered extraordinary, but the proper result of filial piety.

Adult female silk workers commonly thought of themselves not as independent women but as dependent girls. In this respect they conformed to cultural norms. A 1959 edition of *Roget's Thesaurus*[5] offered as synonyms for "laborer" the words "hired man" and "hired girl," but not "hired boy" or "hired woman," and "working girl" but not "working boy." As late as 1959, publishers and users of the thesaurus assumed that men would work and that boys who worked would have the status of men, or at least would grow up to be working men. Girls who worked, however, would remain girls until they grew up to be wives and mothers. In her study of female textile workers in Lawrence, Massachusetts, Ardis Cameron shows how the label of "factory girls" served to trivialize women's roles not only in the work place, but in labor militancy and history.[6]

In Pennsylvania's silk mills in the late nineteenth and early twentieth centuries, the majority of workers were female and a sizable minority were children. The American silk industry developed in the mid-nineteenth century when skilled silk-makers emigrated from Europe to Paterson, New Jersey, the center of silk production in the United States.[7] Increasing mechanization in the late nineteenth and early twentieth centuries made it possible for manufacturers to hire unskilled workers for many tasks, particularly in the throwing plants that produced silk yarn and silk thread.[8] Silk mills sprang up in the hills of northeastern Pennsylvania, where state regulations were lax and many working-class families were willing to send their daughters out to work. Popular articles as well as government studies confirmed that in the early twentieth century the vast majority (sixty to seventy percent) of Pennsylvania's silk workers were females under the age of twenty-two.[9] In the early twentieth century, the silk industry employed a higher percentage of child labor than any other industry in Pennsylvania. By 1910, five thousand children under sixteen worked in the state's silk mills, where they made up about fifteen percent of the work force.[10]

Industrial capitalists did not invent child labor. In agricultural societies, children traditionally contributed by working to help support the household. When the industrial revolution removed the tasks of production from the home, children went to work in mines, shops, and factories, away from the protection of parents or guardians.[11] The sight of children hawking newspapers on the street cor-

ners, delivering messages in office buildings, and filing through the gates for shifts in mines and factories caused men and women to assess the benefits and costs of industrial production. Industrialization and urbanization drew attention to child labor as a social issue.

The ideology of industrial capitalism embraced the notion that work was good for children. Popular novelist Horatio Alger promulgated the image of hardworking lads who reaped the benefits of capitalism through a combination of luck, pluck, and virtue. In the 1880s, boosters in Scranton, Pennsylvania, welcomed the new silk mills, which would provide jobs for girls and young women who might otherwise drift into prostitution.[12] Newspaper articles presented the argument that work in the mills was not arduous and might be educational for working-class girls with few prospects other than early marriage or dependence upon economically deprived families.[13] Silk manufacturers, testifying before the United States Industrial Commission in 1901, made no apologies for locating plants in Pennsylvania to take advantage of the pool of cheap young workers there.[14]

In the early twentieth century, as the Pennsylvania silk industry grew, an increasingly vocal group of reformers condemned industrial work for children.[15] These social critics articulated a distinction between children's work in the household and children's work in the streets, mines, and factories of industrial America. In traditional societies, girls had learned important skills from their mothers, and boys had learned trades from their fathers or from master craftsmen. Industrial labor differed from labor in households. Monotonous and dangerous work in mines and factories, argued reformers, did not prepare young people for healthy and productive lives. Reformers defined child labor as work inappropriate for children because it endangered their physical, moral, or mental development.

Young female silk workers were in some ways the beneficiaries and in some ways the victims of the Progressive Era campaign to end child labor. Middle-class reformers, journalists, and labor leaders drew attention to real abuses in the industry. Muckraking writers came to Pennsylvania and observed little girls of eight, ten, and twelve working ten-hour shifts, sometimes night shifts, in the mills. Readers of popular magazines learned that the mill girls had to cut or bind their hair to keep it from getting caught in the machinery and that child laborers sometimes became deaf from the noise or lame from standing too long at their tasks. In order to elicit sympathy, writers portrayed female silk workers as waif-like, fragile beings unable to speak for themselves and in need of protection from

strong adult males. The reformers' campaign led to anti-child-labor legislation, factory inspections, and mitigation of abuses, but it did not provide a basis for silk mill "girls" to become independent, self-directed working women.

Labor leaders and progressive reformers generally agreed that adult males should earn a living wage, females should remain in the home, and minor children should obtain an education. In the minds of many reformers a living wage, or more precisely a family wage, meant an amount sufficient to maintain a working man and his family in reasonable comfort. Male unionists naturally favored this idea and resented competition from cheap female and child workers, who tended to lower the wage scale for all workers. Middle-class progressives tended to support the image of traditional domesticity centered around a homebound wife and mother. A growing number of reformers perceived the value of a public school system that trained working-class children in proper American values.

One of the heroes of the anthracite region, Terence Powderly, was both a labor leader and a progressive politician. Powderly grew up in Carbondale, Pennsylvania, headed the Knights of Labor from 1879 to 1893, and served as mayor of Scranton from 1878 to 1884. The Knights won a large national membership during the railroad strikes of the 1870s and 1880s. But Powderly had an aversion to strikes. Although he had a genuine compassion for exploited workers, he mistrusted the ideology of class conflict and believed in self-improvement through hard work, temperance, and education.[16] The Knights allowed women to participate in union activity. Nevertheless, Powderly's bedrock philosophy demanded the protection of dependent women and children by strong male workers.

Leaders of the United Mine Workers of America (UMWA) in the early twentieth century shared this basic philosophy. Although they disagreed bitterly on other issues, John Mitchell and Mary Harris ("Mother") Jones both demanded protection for young and vulnerable female laborers in the anthracite region. Mother Jones organized parades and demonstrations in Scranton during the 1901 silk strike. By putting the youngest female silk workers at the head of parades, she drew attention to the cruelty of the labor system. Mitchell made child labor one of the issues of the great Anthracite Strike of 1902, arguing that the inadequacy of miners' wages forced their daughters to become slaves in the mills. If the fathers earned decent wages, however, they would be able to keep daughters at home under their protection.

This philosophy closed the door on labor militancy for young female workers, but gradually opened doors to education. Reformers

who frowned upon women in the labor force encouraged girls' attendance in school. Middle-class journalists, politicians, and social workers fought long and hard to get minors out of the factories by changing the laws regarding compulsory education and child labor. Middle-class activists spearheaded the fight, but received support from labor unions including the UMWA.[17] Responding to pressure from these groups, in the first half of the twentieth century most American states and finally the federal government passed laws requiring school attendance and restricting child labor.[18] Many girls in northeastern Pennsylvania benefited from these reforms, although many continued to leave school at an early age and report to the mills.

By the 1920s, silk-mill operators in northeastern Pennsylvania confronted a new kind of workforce of older and sometimes married women. Warren P. Seem, writing in 1926 on management problems in the silk industry, reflected nostalgically on the days of child labor and noted that restrictive laws had reduced the labor supply and caused hardship for families. Seem observed that "modern girls" with high school educations found it hard "to break away from the training of the mind" and take up jobs requiring quick finger movements and physical endurance. He worried about a shortage of willing hands in the future and urged mill operators to handle their workers more efficiently.[19]

After its peak in the 1920s, Pennsylvania's silk industry dwindled to near extinction. Throughout the 1930s, 1940s, and 1950s, owners moved mills out of the region in an unrelenting search for cheap, compliant workers. Strikes and unrest recurred in some of Pennsylvania's silk mills, particularly in Allentown, in the 1930s.[20] Growing numbers of silk manufacturers moved plants to other, mainly southern, states with less troublesome workforces.[21] After World War II, more and more companies moved south and began producing new fabrics with updated machinery, using rayon and other synthetic fibers.

In the second half of the twentieth century both the silk industry and the anthracite industry virtually disappeared from northeastern Pennsylvania. Population declined in the region, which suffered from mine cave-ins and environmental degradation in addition to economic depression. By the 1990s only a handful of silk mills remained in operation. Only a small number of women still worked as mill hands, although many more had memories of working in the mills as adolescents or younger adults.

Women who remembered life in the silk mills also often remembered fathers who worked in the mines. They recalled illnesses, lay-

offs, and hard times. They spoke of starting work at an early age, but they also spoke of continuing work after marriage and helping to put sons and daughters through high school and college. Like earlier generations of silk workers, they expected life to be tough. But they had learned the value of education and had obtained its benefits, if not for themselves, then for their children. Family loyalty placed high in their system of values. Although they were not very likely to call themselves "girls," they remained in many ways "their fathers' daughters."

Their Fathers' Daughters

1
To Keep Them from Becoming Harlots

Is there any man so blind that he does not know why that anthracite region is dotted with silk mills? Why are they not on the prairies of the West? Why are they not somewhere else? Why is it that men who make money that is spun from the lives of these little babes, men who use these children to deck their daughters and their wives—why is it that they went to Scranton and to all those towns? They went there because the miners were there. They went there just as naturally as a wild beast goes to find its prey. They went there as the hunter goes where he can find game.
—Clarence Darrow

Silk producers located factories in the anthracite region for the specific purpose of utilizing cheap female labor. Mechanization of silk production made such a labor force desirable, and social conditions in northeastern Pennsylvania made female workers readily available. The anthracite region in particular had a large population of families that depended on the uncertain and often inadequate wages of males employed in a volatile mining industry. Historian Perry K. Blatz has ably described the "capriciousness and complexity" of the anthracite industry.[1] Injuries, health hazards, disasters, seasonal layoffs, and competition for jobs in the industry could deprive a family of a male breadwinner's support. Females in these families wanted and needed employment.

The region welcomed silk mills precisely because they employed young single women. Coal mining was defined as man's work, but miners could not always support dependent females. Enterprising young women might be tempted to look for work outside the region, but as the newspaper reporter implied, this adventurous spirit could lead them into danger. Silk mills employed females, but kept them at home in coal mining communities under the watchful eyes of fathers and other male protectors. Fathers could send their daughters out to work while maintaining some level of parental

21

control. Community boosters could promote economic growth by taking the moral high ground and protecting potentially wayward girls.[2]

By providing employment, silk mills potentially could keep young females from leaving the hard coal region. In 1881, a newspaper reporter fretted that every year hundreds of girls left the hills and valleys of northeastern Pennsylvania "to become harlots".[3] The cause of this exodus, he implied, was a lack of economic opportunity. Unmarried daughters without gainful employment could become burdens to their families. The silk mills promised gainful employment to these young single women, whose only prospects might otherwise be early marriage or flight to the dangerous and corrupt cities. By creating jobs, the reporter argued, the mills kept the young women from leaving home.

Northeastern Pennsylvania had a peculiar hold on its people. Under its ancient mountains and deep valleys lay the world's only supply of the hard, clean-burning coal called anthracite. Three rivers, the Susquehanna on the west, the Lehigh, and the Delaware on the east, bounded and powered the hard-coal region. Three other rivers, the Wyoming, the Schuylkill, and the Lackawanna ran through its heart, cutting narrow valleys through mineral-laden hills.

Seven Pennsylvania counties (Carbon, Columbia, Lackawanna, Luzerne, Northumberland, Schuylkill, and Susquehanna) shared hard-coal resources and belonged properly to the region. Five counties (Luzerne, Lackawanna, Schuylkill, Northumberland, and Carbon) yielded ninety-six percent of the hard coal output.[4] Geologists recognized three major coal fields: the northern, the middle, and the southern. These fields roughly conformed to the valleys of three rivers: the Wyoming, the Lehigh, and the Schuylkill. The northern fields dominated anthracite production. Principal cities in the northern fields, embracing Lackawanna and Luzerne counties, were Carbondale, Scranton, and Wilkes-Barre. Hazleton was the principal city of the middle fields. Pottsville and Tamaqua were major communities in the southern fields.

On the region's southern border, three counties (Lehigh, Northampton, and Berks) possessed iron deposits and other natural resources that allowed them to develop industries that utilized anthracite.[5] Towns and cities like Allentown, Bethlehem, Reading, and Easton flourished in the rich valley of the Lehigh River. Like the communities in the hard-coal area, these towns and cities attracted silk manufacturers in the late nineteenth and early twentieth

centuries. The histories of these counties and of the anthracite region are not identical, but they are intertwined.

Deposits of iron and hard coal brought the industrial revolution to northeastern Pennsylvania. Beginning in the late eighteenth century, ambitious men discovered anthracite and attempted to transport it from the rugged hills to towns and cities, especially Philadelphia. These hard-driving entrepreneurs faced two major problems. First, anthracite had a reputation for being hard to ignite, and secondly, moving shipments of coal along rivers and canals was costly and arduous. Despite these frustrations, in 1820 the Lehigh Coal and Navigation Company managed to ship more than 350 tons of anthracite to Philadelphia.[6] In 1828, a Scottish inventor developed the hot blast system, making it possible to use anthracite coal in iron production. By 1840, a Welsh iron maker had fired America's first anthracite-burning iron furnace near Allentown in the Lehigh Valley.[7]

Railroads carried coal out of the area and immigrants into it. The earliest settlers were farmers of English and German descent. Pioneers cultivated land in rich but isolated valleys on streams they named the Schuylkill and Little Schuylkill, Laurel Run, Locust Creek, Beaver, Wolf, and Panther Creeks, and Nanticoke Run. With the discovery and exploitation of iron, coal, and other underground minerals, their isolation ended. As canals and railroads penetrated the region, large numbers of immigrants sought work in coal mines, slate quarries, and iron works. Beginning in the 1830s, Welsh pioneers recruited miners from their homeland. Welsh laborers outnumbered all others in the coalfields before the 1880s.[8] After 1840, Irish immigrants began displacing Welsh and English workers in the lower ranks of the laboring population.

Between 1860 and 1870, the decade of the Civil War, the number of miners in the anthracite region more than doubled and most of the new workers were Irish immigrants.[9] In some ways the region experienced its own civil war as labor fought against capital and new immigrants clashed with resident workers and bosses. Fear and suspicion of Irish miners flared wildly in 1862 and 1863 as miners in some towns rose up to resist being drafted into the Union Army. This resistance to conscription, a violation of federal law, made it feasible and legal to bring in federal troops to assert the authority of the coal bosses and the state.[10] Ethnic conflict between English and Welsh bosses and Irish workers resulted in the pursuit, prosecution, and execution of members of the Molly Maguires, an Irish-American labor organization, in the 1870s.[11]

Beginning in 1868, the Workingmen's Benevolent Association

(WBA) attempted to organize and protect anthracite miners. In 1869 a fire in a mine shaft at Avondale, south of Plymouth, Pennsylvania, killed more than one hundred men trapped in the tunnel. Most of the men were Welsh and many were recent immigrants. After quenching the fire, volunteers brought body after lifeless body out of the tunnel to the cries and shrieks of relatives. During the days after the tragedy, trains carried thousands of mourners, curiosity seekers, and embittered observers to the site of the burned out coal breaker. John Siney, WBA president, eulogized the dead and called for a fight to win justice for the living. In his autobiography another labor leader, Terence V. Powderly, recalled making a pilgrimage to the scene, listening to Siney and seeing "Christ in his face."[12] Within six years, however, the WBA had disbanded because of company resistance, workers' mistrust, and ethnic divisions.

During and after the great railroad strikes of 1877, a significant number of anthracite miners joined the Knights of Labor. In July 1877 miners walked off their jobs in the Wyoming Valley. The spontaneous walkouts spread to the Lehigh but not the Schuylkill coalfields. By the end of the year anthracite miners had founded nearly sixty local assemblies of the Knights. Some of these assemblies were short-lived. Another organizing push in 1885 and 1886 resulted in forty-eight new assemblies. In some years there may have been as many as two thousand active Knights among anthracite workers.[13]

Powderly, who became the Knights' most famous leader, was a native of the anthracite region. His father, an Irish immigrant, worked as a miner and for several years owned a mine near Carbondale. He passed on to his son his entrepreneurial spirit and a belief in hard work as the road to success. By 1858 the elder Powderly had gone out of business and found work with the Delaware and Hudson (D & H) Railroad. Young Powderly attended school for six years and then went to work for the railroad at the age of thirteen.[14] Throughout his life he remained proud of having gone to work at such an early age. Although he became a union leader, he retained his republican faith in self-help and individual advancement.[15] In 1869, at the age of twenty, he completed his apprenticeship as a machinist in a railroad shop and found himself laid off. The D & H cut back operations in response to the miners' strike. He returned to work later that year as a machinist for a railroad in Scranton but did not become active in the union until 1871.[16]

Between 1873 and 1878, Powderly rose from the depths as an out-of-work machinist blacklisted for union activity to become the

progressive mayor of Scranton. In 1876 he entered Luzerne County politics by organizing a Greenback-Labor club. Two years later this reform organization triumphed over the Democrats and Republicans and put him in the mayor's office.[17] Almost immediately he reorganized the police force, which had disgraced itself in 1877 during a strike of anthracite miners in the Scranton area.[18] Between 1878 and 1884 he carried out a moderate list of reforms and maintained law and order. As a high-ranking local official he lived out the American dream, but he also kept up his labor activities.

Upon the resignation of Uriah Stephens in September 1879, Powderly became Grand Master Workman of the Knights of Labor.[19] The Knights' membership swelled to more than seven hundred thousand after successful strikes against the railroads in the 1880s.[20] Ironically, Powderly opposed strikes, putting his faith in negotiation and political reform. Meaningful change could only come, he believed, through education and better understanding between employers and workers. He did not see their interests as unalterably opposed.

Under Powderly's leadership the Knights' membership declined.[21] His conservative philosophy did not win favor with the rank and file. Although the son of an immigrant, he shared many of the ethnic prejudices that made labor solidarity impossible. His genuine compassion for the poor did not change his belief that by education and individual effort a hardworking man could raise himself up by his bootstraps. But this philosophy did not embrace the realities of life in the anthracite region at the end of the nineteenth century.

While the Knights struggled to organize workers, the first silk mills came to Pennsylvania. The *Scranton Republican* proudly announced the opening of the Scranton Silk Company, the first silk factory in the area, in 1873. One local man, George Fisher, had a seat on the board of directors. The president and other members of the board lived in New York and Connecticut. With paid-up capital of one hundred thousand dollars, the board hoped to raise one million dollars in order to expand their plant.[22]

The company employed more than two hundred hands, mostly girls, in a four-story mill equipped with the most up-to-date throwing machinery. In this mill workers took imported raw fibers, wound them on spools, cleaned and dried them, twisted several strands together to form yarns of varying thicknesses, rolled the yarns into skeins, cleaned and dried them again, and then sorted and bundled them for shipment. Female workers tended machines that performed most of these functions at high speeds. Machinery

recently invented by Mr. John E. Atwood efficiently detected im-
perfections in the fibers, ensuring a high-quality product. Young
boys performed the task of rolling the yarn into skeins because, the
newspaper reported, the rolling apparatus was too heavy for girls.

The newspaper touted the industry as a positive benefit to young
people in the region. Managers easily trained young and inexperi-
enced workers, the reporter said. The labor was "light." Workers
would benefit financially of course, but they would also benefit
"physically." Labor in the mill would "train their minds to habits
of thoughtfulness, and their hands to habits of industry."[23] The re-
porter seemed to be saying that work in the silk mills would be an
adequate substitute for a public-school education. Using this rea-
soning, morally squeamish employers, businessmen, and parents
could justify welcoming an industry that depended heavily upon
youthful and largely female labor.

By the 1880s the mass production of steel increased the demand
for hard coal and brought new prosperity to northeastern Pennsyl-
vania along with a surge of immigration. Irish immigrants contin-
ued to search for jobs in cities, towns, and mining patches. New
groups of workers from Italy and Eastern Europe also began to ap-
pear in the mines and mills. These new job seekers frightened other
laborers, whose livelihood seemed insecure, creating new tensions.
During this decade, silk mills sprang up in cities, towns, and mining
villages.

Despite economic growth, laboring families struggled against
want, debt, dependency on the coal companies, and sometimes
against each other as the population continued to grow. In Lehigh,
Luzerne, and Lackawanna counties, the population rose by fifty per-
cent during the first decade of the twentieth century.[24] Italians and
Slavs entered eastern Pennsylvania communities in large numbers,
often settling in ethnic enclaves where their countrymen had al-
ready established homes and communal organizations. These reli-
gious, social, and charitable organizations provided the only
security the region had to offer against illness, injury, unemploy-
ment, poverty, and the death of a breadwinner.[25]

As the population swelled and communities became more depen-
dent on the hard-coal economy, local business leaders scrambled to
attract more silk mills. Local retailers offered inducements to man-
ufacturers and citizens banded together to bring mills to their
towns.[26] The *Pottsville Daily Republican* gloated in 1889 that "all
our surplus female population is now profitably employed and the
town is reaping the benefit."[27]

Hazleton's business community tried hard to bring silk mills to

town. In 1886 a citizens' group attracted a silk mill by providing ninety thousand dollars of the company's capital. Ten years later a group of businessmen organized the Hazleton Improvement Company to buy land and build factories to lease to manufacturers. The town's "Factory Hill" soon contained a planing mill, a flax mill, and a brewery.[28] In December 1899 the French-based Duplan Corporation began construction of a mill in town.[29]

Silk manufacturers sought a pliant workforce, but from the very beginning Pennsylvania's silk workers showed the capacity for labor militancy. In August 1897, forty-five young women and girls walked off their jobs as weavers in the Simpson Silk Mill in Scranton. The weavers argued that they were paid $3.50 to four dollars per week for work that in other companies paid from seven to twelve dollars a week.[30] In October 1897, seventy-five silk workers failed to show up at the mill in Avoca, demanding higher wages and shorter hours. The proprietor took the next train from Hackettstown, New Jersey, and threatened to ship his raw materials back to his mills in that state. Two days later the mill resumed operations with only a few strikers returning to work.[31]

Labor unrest posed a threat to promotion of the silk industry in the region. Silk manufacturers came to the anthracite region for abundant fuel, good transportation, supportive communities, and first and foremost cheap labor. Shichiro Matsui, historian of American silk manufacturing, correctly argued that the geographical location of the industry was related closely to the type of labor employed. By the late nineteenth and early twentieth centuries, rising demand for plain rather than elaborate silk fabrics and increasing mechanization of the industry made it feasible for silk producers to utilize unskilled labor.[32] Plant locations were not related to raw materials because manufacturers imported raw fibers from Japan and China. Sources of fuel were important but not paramount. As Matsui wrote, the industry's location was "more influenced by labor than any other factor."[33]

Silk manufacturing was a highly competitive enterprise. American entrepreneurs had engaged in the silk business in the eighteenth and early nineteenth centuries without notable success. Tariffs on imported silk during the 1860s boosted the American silk industry. In Philadelphia, where W. H. Horstmann had begun producing silk in the 1820s, an upsurge in production occurred in the 1870s. The city's sixth ward became known as the Silk District.[34] By the late nineteenth century, however, Paterson, New Jersey, outstripped Philadelphia and became the center of domestic silk production as

English mill owners opened factories in the well-located town only seventeen miles from the major silk buyers in New York City.

Skilled workers emigrated to Paterson from England, Germany, Switzerland, and France. This mass migration of silk manufacturers and skilled operators and laborers reached its peak in the 1870s and tapered off in the 1880s. The immigrant weavers of Paterson clung to a long tradition of pride in their craft and product. Many of them operated hand looms in small shops or in their homes with the assistance of wives and children who performed such tasks as winding yarn on quills (cylindrical devices inserted into the shuttles). Other silk manufacturers and weavers moved into Paterson's abandoned cotton mills, where they established larger, more mechanized operations.[35]

The high cost of skilled labor spurred manufacturers to seek technological improvements in the three major aspects of the industry—throwing, weaving, and dyeing.[36] New machinery greatly altered the throwing phase of silk manufacturing. The process of silk throwing involved winding, twisting (or spinning), and combining filaments to form weaving yarns of various thicknesses. After the Civil War a new kind of throwing frame doubled the speed of the spindles from 3,500 to 7,000 revolutions per minute.[37] By the 1880s, spindle speed had advanced to ten thousand revolutions per minute. These new machines also required less labor.[38]

Development and use of power looms gradually made the skills

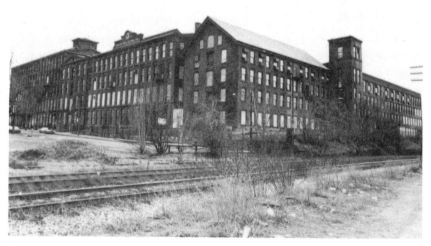

Sauquoit Mill, Scranton. Pennsylvania Historical and Museum Commission.

of the hand-loom weaver obsolete. The invention in the 1870s of a power loom with an automatic device that stopped the machine when a thread broke began the process that eventually destroyed the artisan tradition. Women and girls without lengthy training or highly developed skills could tend the new machines. In 1889 the invention of a high-speed automatic ribbon loom added to the mechanization of the industry. By 1905 the hand loom had virtually disappeared, although many of the Paterson silk weavers clung tenaciously to the dignity of their craft. Paterson, however, began to lose its place as the silk-making center of the United States.[39]

Increasing mechanization spurred the movement of the industry from Paterson to the cities and towns of northeastern Pennsylvania. In 1876 fewer than thirty silk manufacturing establishments existed in Pennsylvania, and most of these were located in Philadelphia.[40] During the following decade, many Paterson silk manufacturers established branches in and around Scranton, along the Lackawanna River, throughout the hard-coal region, and in the industrial area of the Lehigh Valley.[41]

By the turn of the century, the United States dominated the worldwide silk trade but domestic competition remained intense. In order to survive the hurly-burly of the marketplace a manufacturer needed capital, intelligence, drive, and stamina. Ira Dimock, president of the Nonotuck Silk Company of Hartford, Connecticut, testified to the U.S. Industrial Commission in 1901 that a successful manufacturer had to make harsh demands on his managers and operatives. Dimock stated:

> In our line of business competition is such that a man has got to get up early in the morning and hustle to be able to make his dividends. There are men in our employ that never fail to be at the mill when the wheels start in the morning at a little before 7 o'clock. They never fail to be there.[42]

If the managers failed in their diligence, reported Mr. Dimock, the help would "fall away." This was the nature of the business, he said. "That is the way with the home competition when you get enough of it."[43]

Leaders in the silk industry stated without embarrassment that they located plants in Pennsylvania because of its large supply of cheap female and child labor. In testimony before the United States Industrial Commission in 1901, one silk manufacturer after another described the quest for a docile and undemanding workforce. Strikes and unrest among skilled male employees in Paterson, New

Jersey, enraged employers, who viewed unionization as a contagious disease which they called "labor measles."[44] Fleeing this apparent "plague," many manufacturers built plants in the neighboring state of Pennsylvania which offered cheap fuel, good transportation, lax laws against child labor, and above all a great number of females and children willing to work for low wages.[45]

Franklin Allen, secretary of the Silk Association of America, commented on the reasons for Pennsylvania's growth as a silk center. He cited labor militancy and incidents of violence in Paterson, and continued:

> As a result these manufacturers began to look around for possibilities of the industry in other places, and that is inherently the reason why Pennsylvania has grown as a center of the silk industry, as represented in my report [of 1900], whereas Paterson has practically stood still. In Pennsylvania the labor laws regarding child operatives and the number of hours employed are different from those in the city of Paterson.[46]

Allen went on to emphasize that the availability of child labor was an important factor in the decision of mill owners to locate their operations in Pennsylvania.[47]

A federal government investigation in 1907 revealed striking differences between the silk industry in Paterson and in Pennsylvania. Investigators studied conditions in eighty-seven Paterson mills as well as thirty-six mills in eighteen cities, towns, and villages in Lackawanna and Luzerne Counties in northeastern Pennsylvania. Their findings indicated that most plants in Pennsylvania were throwing mills which manufactured yarn. Although there were some weaving and dyeing plants in Pennsylvania, the throwing branch of the industry was especially prevalent there. Weaving and dyeing plants remained more common in Paterson. Secondly, Pennsylvania throwing mills were on the average three to four times larger than the small plants and workshops characteristic of the industry in Paterson.[48]

Pennsylvania silk workers earned less than their counterparts in Paterson even when they performed the same tasks. Silk throwing, which paid the lowest wages in the silk industry, involved a complex set of processes. From raw-silk filaments, throwing mills produced varieties of yarn on spools, cones, tubes, or quills according to the clients' specifications. Two basic types of yarn called organzine and tram formed the warp and weft of silk fabric. Tram, the weft or filler, consisted of two or more threads of raw silk reeled onto swifts and twisted together loosely. The manufacture of organ-

zine, the warp or length of silk fabric, required the following operations: (1) winding the filaments from skeins onto bobbins, (2) sorting, (3) twisting, (4) doubling (combining two or more filaments) onto fresh bobbins, (5) twisting together, and (6) sorting again according to degrees of fineness.

Operatives who performed these various tasks received different wages. Lowest paid were the bobbin carriers, who helped the operatives by bringing fresh bobbins. Highest paid were the winders or twisters, who tended the machines that put the proper amount of twist into the yarn. The 1907 government survey yielded comparative figures for hourly earnings (see "Average Hourly Earnings" table).

Average Hourly Earnings[49]

Worker	Paterson	Pennsylvania
Bobbin carrier	.08	.06
Winder	.14–.15	.08–.09
Reeler	.12	.07
Doubler	.13	.08
Spinner	.14	.08

Clearly from these figures, Paterson workers earned more for performing these same tasks than Pennsylvania workers.

Ethnic composition of the workforce in Pennsylvania differed somewhat from that in Paterson. In the New Jersey mills, English employees were most numerous (18.8 percent), followed by Germans (17.5 percent), Italians (15.7 percent), and Irish (15.6 percent). In the Pennsylvania mills, Americans accounted for 30.2 percent of the workforce, Irish 19.1 percent, Germans 15.4 percent, and Polish 11.4 percent.[50] In New Jersey the English tended to fill the highest paid jobs, while in Pennsylvania Germans received the highest pay. However, all ethnic groups were represented across the spectrum of the workforce, in low-skilled and high-skilled, low-paid and higher-paid occupations.[51]

Many more adult males worked in Paterson's mills than in Pennsylvania's mills. Nearly fifty percent of Paterson's silk operatives were adult males. By contrast, in Pennsylvania less than one fourth of the silk workers were adult males. Silk-throwing plants, which clustered in Pennsylvania, employed a much smaller percentage of males than weaving and dyeing plants, which remained more prevalent in Paterson.[52]

Percentages of female workers of all ages were higher in Pennsyl-

vania than in Paterson mills. Government investigators compared census data for Paterson with similar data for Scranton and Wilkes-Barre, Pennsylvania, in 1900. Absolute numbers of silk workers were much higher for Paterson, and females made up slightly less than fifty percent of silk mill operatives. In Scranton and Wilkes-Barre, females greatly outnumbered males in the silk workforce (see table).

Number of silk mill operatives from 1900 census[53]

	Males	Females
Paterson, N.J.	6,536	6,066
Scranton, Pa.	159	1,600
Wilkes-Barre, Pa.	70	341

Although the percentage of married women working in silk mills in either place was small, Paterson employed a higher proportion of married females than Pennsylvania. Of the adult females (at least sixteen years of age) included in the samples for each state, 13.1 percent of those working in Paterson mills were married, while only 4.3 percent of those working in Pennsylvania mills were married. More than six percent of the adult females in the Paterson mills, but less than two percent of the adult females in the Pennsylvania mills, were widowed, divorced, or separated.[54]

Pennsylvania mills employed a much higher percentage of child labor than Paterson mills. In Paterson, according to the 1907 study, only 6.6 percent of the employees were children under sixteen years of age, while in the Pennsylvania mills 23.2 percent of the employees were under sixteen.[55] Throwing plants, more numerous in Pennsylvania, employed a higher percentage of child labor than broad-silk-weaving mills or ribbon-weaving mills. But Pennsylvania mills of every type employed higher percentages of child labor than New Jersey mills (see table).

Percentage of child labor by type of mill[56]

	Throwing	Broad silk	Ribbon
New Jersey	16.5%	4.0%	6.4%
Pennsylvania	30.0%	19.0%	10.8%

By 1910, the silk industry employed more of Pennsylvania's children than the anthracite breakers or any other single type of manufacturing. The 1910 federal census listed 3,721 boys under sixteen

working in the soft-coal mines of the state, 3,247 boys under six-
teen working in the hard-coal breakers of the anthracite region,[57]
and more than five thousand children under sixteen working in the
silk mills. Silk and other textile mills employed well over half of all
the child laborers in the state, with the silk industry employing the
highest proportion (14.9 percent) of workers under sixteen.

Child workers in Pennsylvania's silk mills were far more likely to
be girls than boys. Many Pennsylvania mills were located in mining
towns, where boys could find better-paying jobs in the coal break-
ers. Breaker boys could aspire to become miners, a more remunera-
tive, albeit more dangerous, occupation than silk work.[58] Nearly
seventy percent of textile-mill girls in Pennsylvania lived in the
eastern counties of Berks, Lackawanna, Lancaster, Lehigh, and
Luzerne. Investigators estimated that nearly twenty percent of girls
between thirteen and sixteen in Philadelphia worked for a living. In
Scranton the figure was more than thirty percent.[59]

Pennsylvania law allowed the employment of minors. At the end
the nineteenth century the legal working age was twelve in most
industries including the silk industry. Cigar making and several
other industries operated under no legal age requirements. Accord-
ing to the 1880 census, seventy-two thousand children between the
ages of ten and fifteen were gainfully employed. Tragically, in 1885
at least twenty-three children (aged ten to fifteen) were killed while
working in the mines and coal breakers.[60] In 1886, according to the
Pennsylvania Bureau of Industrial Statistics, more than two hun-
dred thousand children between the ages of six and fifteen did not
attend school regularly.[61]

The coming of the silk industry increased the number of child
workers. Official estimates varied wildly, but the state factory in-
spector observed an increase in child labor between the 1880s and
1905. Basing his figures on 16,589 factories inspected in 1905, this
state official reported that 41,140 workers were minors age thirteen
to sixteen. In his annual report the inspector stated:

There are many children employed in gainful occupations who, because
of their physical deterioration as a result of this employment, or for
physical deficiencies the result of other causes, appear to be of an age
less than thirteen.[62]

Factory inspections could not accurately uncover all the instances
of child labor or determine the age of all young workers. It seems
likely that many children who seemed to be under thirteen actually
were age ten to twelve. In 1910 the United States Department of

Labor Children's Bureau reported that 96,895 children age ten to fifteen held jobs in Pennsylvania.[63]

The factory inspector observed an increase in the number of females among young workers.[64] The silk industry offered jobs to girls and young women who had not previously worked for wages. The earnings of these young female workers gave their families a chance to escape privation and insecurity. Households whose fathers were absent, incapacitated, unable, or unwilling to earn a wage sufficient to support their wives and children grasped the opportunity to send new wage earners into the marketplace. Most of these new wage earners still lived in their parents' houses and brought their wages home.

Silk manufacturers brought a measure of economic stability to the anthracite region but families paid a very high price for this benefit. In many respects silk mills seemed a godsend to anthracite communities and families. To communities they offered a small but needed measure of economic diversity. To families they offered a secondary source of income which sometimes meant the difference between subsistence and want. In order to obtain that needed income, however, families had to exploit the labor of their daughters.

Early entry into the labor force limited options for the adult daughters of anthracite families. Silk mill workers very often ended their schooling early in order to add to their families' income. Incomplete education limited the ability of these young people to seek opportunities in occupations other than those of mill hand, and this of course ultimately limited their ability to prosper.

Northeastern Pennsylvania offered no real enticement to the industry other than cheap labor. This meant that Pennsylvania workers had to accept lower wages than their counterparts in Paterson and elsewhere. Young workers attempting to press their employers for higher wages soon learned the facts of life. At any sign of unrest or "labor measles," silk owners threatened to move their factories elsewhere. [65]

Silk manufacturers knew why coal communities welcomed them. They knew why families sent their daughters to the factory doors, looking for work. The silk mills drove a hard bargain. They had come to purchase female labor and they bought it cheap.

While accepting this hard bargain for the labor of their daughters, male workers did not relinquish the traditional role of protectors of vulnerable females. The rhetoric of newspaper editors and community boosters made it possible for them to believe that employment in a silk mill might save young women from a much crueler fate on the streets of some faraway city. By keeping them in their home-

:owns and under their roofs, fathers could still keep a watchful eye
on their working daughters.

Historian Ardis Cameron has shown that female workers could
be defiant and stand up for their rights.[66] Cameron identified many
laboring women in the Lawrence, Massachusetts, textile mills as
radicals who demanded a voice in their community and the work-
place and challenged conventional views of gender. The women of
Lawrence participated in militant actions and strikes, but contem-
porary and later observers marginalized their efforts by relegating
them to the category of "factory girls."[67] This label diminished the
impact of their militancy, making it seem temporary, something
they would grow out of, like girlhood, or something not quite seri-
ous, like a game.

Because of conventional gender labels, male unionists had a dif-
ficult time understanding and accepting female participation in
strikes and protests. During their brief heyday, the Knights of Labor
allowed female participation and even trained female organizers
like Mother Jones. But the world of the Knights was the world of
strong male unionism headed by a "Grand Master Workman," and
the Knights had faded from existence by the turn of the century.
Powderly, their most famous leader, gave up on labor activism in
the 1890s and became a Washington bureaucrat.

Despite barriers to labor activism, girls and young women who
went to work in silk mills did not always quietly and demurely ac-
cept the facts of their lives. Jobs in the mills may have kept them in
their hometowns living under their fathers' roofs, but going out to
work also helped them to begin finding a path to independent action
and self-determination. As young girls they learned domestic roles
from their mothers, but as wage earners they followed their fathers
and brothers out of the house and into the world.

2

Mother Jones and the Silk Strike of 1900–1901

> When I look into the faces of the little toiling children and see their appealing eyes, it touches the chord of a mother's heart. Think of these helpless little things with no one to fight their battles but labor's hosts!
>
> —Mother Jones, speech at the convention
> of the United Mine Workers of America,
> Indianapolis, Indiana, 25 January 1901

Miners of hard coal in northeastern Pennsylvania set an example of labor militancy for their daughters. In 1900 John Mitchell and the UMWA led a strike of anthracite miners. Mother Jones helped to organize the strikers and keep up their flagging spirits. Daughters working in silk mills in Carbondale and Scranton emulated their fathers and struck their employers in late 1900 and early 1901. These militant daughters apparently viewed their defiant fathers as models for their own behavior.

Mother Jones' life and character helped her win the confidence of coal miners and their working daughters. Born in Ireland in 1830, she came with her mother and siblings to join her father in Canada in 1838. She graduated from normal school at seventeen and showed a talent for debating. Throughout a difficult life she earned wages as a teacher and dressmaker. In 1867 she lost her husband and children to the yellow fever epidemic in Memphis, Tennessee. She joined the labor movement in Chicago in the 1870s, after the great fire had burned her home and destroyed her dressmaking business.

Despite contrasting personalities, she and Powderly became lifelong friends. They met at a Knights of Labor meeting in Chicago in the mid-1870s. Nineteen years her junior, he was already rising to power while she remained obscure but dedicated. He admired her

36

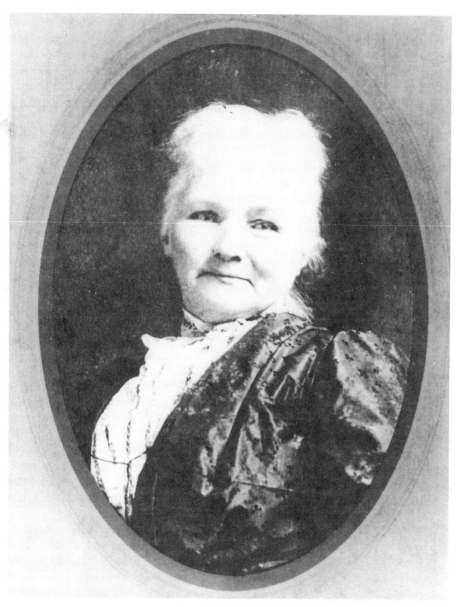

Mother Jones. Photo courtesy of West Virginia State Archives.

strong mind and quick tongue. He was a teetotaler, and she drank freely. She gloried in strikes, while he found them uncivilized. Nevertheless they remained friends.[1]

In 1900 she was seventy years old with a careworn face, a homely eloquence, and a deep, reverberating voice.[2] She related to coal miners by praising and scolding them. When their loyalty to the union flagged, she roused them by speaking in the plain, sometimes impolite words a mother might use to a beloved but erring son. She also communicated with miners' wives and daughters. Her age, her slight figure, and the hardship that showed in grey hair and wrinkles were as eloquent as her words. Hardworking, hard-pressed women could see themselves in the mirror of her face.

In her motherly persona, she took up the cause of the silk strikers but treated them as vulnerable children. With public demonstrations and emotional rhetoric, she drew attention to the youth and gender of the workers. In her analysis of the strike and its meaning, she stressed the position of these workers as female dependents in coal-mining families. While she blamed employers for exploiting the labor of young girls, she placed much responsibility for their hard lives on the shoulders of their fathers. She supported the young women's demands for better wages and working conditions, but she also undercut their sense of self-determination by defining them emphatically as their fathers' daughters.

Near the end of 1900, workers at the Klots silk mill in Carbondale walked off their jobs, triggering a more widespread strike in 1901. Extant records of the Klots enterprise contain information about the Carbondale plant and its workforce. A study of these laborers and the silk strike of 1900–1901 reveals much about work, gender, and family in the anthracite region of northeastern Pennsylvania. Mother Jones' actions and speeches during this strike offer insights into the ideology of family relationships in the labor movement.

At the time of the strike, Mother Jones plainly expressed her outrage at capitalist entrepreneurs who employed young girls in textile mills. Speaking to the UMWA in January 1901, she lamented the fact that fathers could no longer protect their daughters from capitalist exploitation. Pennsylvania hard-coal miners had long been accustomed to sending young sons to work in the coal breakers. "But my friends," she announced, "the capitalistic class has met you face to face today to take the girls as well as the boys out of the cradle."[3]

Speaking as a mother, she implored the members of the UMWA to defend these "helpless children," who went like lambs to the

"altar of capitalistic greed." Of the business men who employed miners' children she said:

> They have built their mines and breakers to take your boys out of the cradle; they have built their factories to take your girls; they have built on the bleeding, quivering hearts of yourselves and your children their palaces.[4]

During the Pennsylvania strike she repeatedly characterized silk manufacturers as robbers and silk operatives as their young and tender victims.

In some ways, Henry D. Klots fit the image she conjured of the greedy entrepreneur. Like many silk manufacturers he came to the anthracite region to take advantage of fuel, transportation, proximity to New York markets, and a large pool of young female workers. The region's first silk mill opened in Scranton in 1873,[5] and hundreds of others followed. Klots opened his throwing mill, which produced silk yarn and thread, on Belmont Street near Carbondale's city limits in 1895. Before his death in 1914, he extended his holdings over a wide geographical area, eventually building plants in

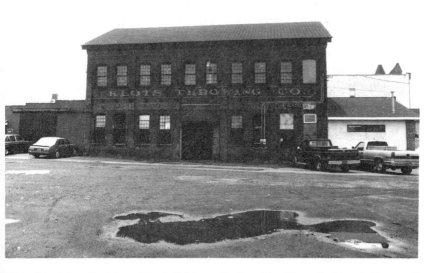

Klots Throwing Company, Dundaff Street, Carbondale. Photo by Bonnie Stepenoff, 21 July 1991.

Scranton, Archbald, and Forest City, Pennsylvania, as well as Fredericksburg and Alexandria, Virginia. When all these plants were operating, the total number of employees averaged between five and six thousand. Klots' company became one of the largest organizations in the American silk industry.[6]

Klots was an absentee owner. He lived in New York City where he belonged to the Manhattan, Princeton, and New York yacht clubs, the Apawamis Club of Rye (New York), and the Larchmont (New York) Yacht Club. Until his death from appendicitis he was a prominent member of the Silk Association of America, the most important organization of silk manufacturers. According to the *National Cyclopedia of American Biography*, "In politics he was a Republican and in religion an Episcopalian. Yachting and golf were his outdoor recreations."[7] A typical example of the Gilded Age elite, he probably would not have been comfortable living in Carbondale, a bustling small city on rugged terrain north of Scranton. When he did reside there briefly in 1899, he stayed at the Hotel Anthracite.[8]

To manage his Carbondale plant and eventually a large group of mills, he depended upon a Hungarian immigrant named Marcus Frieder. Heavy-browed and intense, Frieder mastered the complexities of the industry and traveled from mill to mill, managing the far-flung enterprise. While he oversaw plants in several states, Frieder lived in Carbondale with his wife, seven daughters, and a son. His son Leonard joined him in the business, remaining with him through the Great Depression. For a time his daughter Margaret served as bookkeeper in the Carbondale plant.[9] After the death of Henry Klots, Frieder became president of the company.[10]

The Klots silk mill in Carbondale employed many young females, but not so many children as Mother Jones suggested. At the turn of the century the Klots Throwing Company's Carbondale plant routinely employed more than 450 people,[11] of whom approximately sixty percent were female. Fewer than five percent were adults over twenty-one, but only a tiny fraction were children eleven or younger. About ten percent were twelve or thirteen years old.[12] Census data for 1900 reveals that about sixteen percent of the hands were older minors eighteen to twenty-one. More than two-thirds of Carbondale's silk mill operatives were fourteen to seventeen years of age. Nearly all the silk workers lived in households headed by their parents and, in that sense, were children. But most were hardly babes pulled from the cradle. They had reached an age when they might reasonably demand a certain degree of control over their lives.

Young unskilled workers could handle most of the tasks in the throwing mill, which were simple, repetitive, and required little training. About sixty employees worked as reelers, who tended machines that unwound filaments of imported silk from skeins and stretched them on multisided wheel-like swifts. More than one hundred workers were winders, whose job involved tending machines that wound the superfine filaments of silk onto spools, bobbins, or cones as required during various stages of production. Approximately sixty-five employees were doublers, who watched the machines that combined two or more strands to create yarns of varying thicknesses—although even a heavy silk yarn was so fine as to be barely visible to the naked eye. One hundred and forty were spinners, or twisters, whose task was to put the proper amount of twist into the strands of yarn.[13] In creating various types of yarn, the winding, doubling, and twisting operations might be repeated several times. All these processes were noisy, demanding, and relentless. To relieve operatives of the necessity for leaving their machines, bobbin carriers scurried around the factory floors fetching bobbins, spools, cones, or other needed equipment.

Other employees, many of whom were adults, performed ancillary but essential tasks. About sixteen men worked in the machine shop or on the factory floors keeping the complicated throwing machinery running. These men, the machinists, were the best paid and probably the most highly skilled employees of the company. Other ancillary employees included the storeroom laborers and bundlers, who received shipments of raw silk and packaged finished yarn for shipment. A small group of men worked in the accounting office, assisting the manager. Three employees acted as watchmen, protecting the valuable contents of the plant.

Klots Throwing Company records for the Carbondale mill in January 1905 reveal a striking division of labor along gender lines. Males worked nights; females worked days. Males worked as bobbin carriers; females worked as machine tenders. Males worked in the storeroom, machine shop, and accounting office. Of the bundlers, who packaged the yarn for shipment, approximately half were male and half female. Bobbin carriers, also called bobbin boys, tended to be male, but in the Klots plant there were a few females among them. Females worked on the factory floor. Many but not all of the reelers were female, and company records leave the gender of some of them in doubt. In 1903 nearly all of the 188 winders and doublers employed were women or girls.[14]

The time book for January 1905 records the job assignments (see table) which indicate that management made an effort to keep the

genders separate and to protect females from the dangers of night work.

Job	Female	Male	Unknown
Winders	99	0	14
Doublers	48	2	1
Day spinners	19	44	2
Night spinners	0	30	2
Bobbin boys	16	46	3
Reelers	25	0	2
Banders	18	1	1
Bundlers			6
Machinists	0	17	3
Watchmen		1	1
Power/account		3	4
Total	225	144	39

Wages in the Klots mill were very low. Silk workers in Paterson, New Jersey, earned much more than their counterparts in Pennsylvania. A government study published in 1911 offered evidence that Pennsylvania silk mills paid operatives little more than half what they might have earned in New Jersey. For instance, in New Jersey mills, according to the study, reelers earned about twelve cents an hour. In Pennsylvania mills on the average, reelers earned about seven cents an hour.[15] Klots Throwing Company records indicate that reelers earned .0666 cents per hour in 1903, and the rate had risen to only about seven cents per hour by 1910.

The lower wages in Pennsylvania mills in general and the Klots mill in particular related directly to the higher proportion of females and children employed there. In New Jersey mills the reelers were nearly all male, while in Pennsylvania mills they were nearly all female. In New Jersey mills fewer than twenty percent of reelers were under sixteen years of age, while in Pennsylvania nearly forty-five percent were under age sixteen.[16]

These small wages paid to young female workers provided needed income for northeastern Pennsylvania's laboring families. The 1911 government study found that in many of Pennsylvania's silk milling towns the principal industry was coal mining. Carbondale had more diversity than most towns—with heads of households finding employment in coal mines, railroad car shops, and machine shops (see study, p. 26)—but still depended on coal. The study found that most silk workers came from the families of coal miners and mine laborers. Of the families studied the average per

Klots Throwing Company Building, Eighth Avenue, Carbondale. Photo by Bonnie Stepenoff, 21 July 1991.

capita family income, excluding the wages of children, was $2.03 per week (see study, p. 297). A silk worker earning seven cents an hour and working a fifty-five hour week could bring home $3.85 per week, more than earning her keep.

Unmarried young women and men went to work in the silk mills to help support parents and siblings. By a vast margin silk workers were neither husbands nor wives but single young people living at home who contributed to the family income. Even adult silk workers in their mid- to late-twenties or older commonly still lived with the families into which they were born. A few were boarders or residents in the houses of relatives. Only a very few were either self-supporting or heads of households, and these few were generally not factory operatives but bookkeepers, clerks, machinists, or managers.[17]

Workers at the Klots mills in Carbondale identified in the 1900 census exemplified a pattern of life in which fathers and minor children went out to work while mothers remained at home performing household tasks.[18] Many had brothers or sisters working in the mill. Others had siblings working in the coal breakers, the railroad yards, or commercial establishments. Only a tiny number had mothers who worked outside the home, and all but one of these mothers

worked in domestic occupations, such as housekeeping or doin̦
laundry. One mother informed the census taker that she worked a̦
a janitor.[19]

Fathers of silk workers labored in various occupations. Abou̦
forty percent of Carbondale's silk operatives in 1900 were the off
spring of coal miners, coal mine laborers, or men who worked i̦
occupations related to the anthracite mines or breakers. Five per
cent were the children of railroad workers. Other fathers worked i̦
skilled and unskilled occupations including carpentry, shoe repai̦
and stone masonry.[20] All these heads of households depended fo̦
their livelihood upon the anthracite mines, the coal breakers, th̦
railroad, or from strictly local businesses such as construction
Their occupations reflected the lack of real economic diversity i̦
Carbondale.

About seventeen percent of silk workers lived in female-heade̦
households, left fatherless by death, divorce, or desertion. Thi̦
grim statistic reflected not only the short life span of miners work
ing in unhealthy or dangerous conditions but the temptation fo̦
frustrated males to escape the rigors of their situation by simpl̦
running away. Typically in these female-headed households, sev̦
eral children went out to work while the mother remained at hom̦
performing domestic tasks. For example Jennie Gries, sixteen, an̦
her younger sister Emma, age fourteen, helped support a widowe̦
mother. An older brother, eighteen, had a job in the mines. Theș
siblings were native-born of Irish parents. Their mother owned th̦
home where they lived.[21]

Single mothers rarely worked outside the home, but sometime̦
took in boarders to help make ends meet while their minor childre̦
went out to work. For example, silk workers Alice Nelson, eighteen
and her sister Lizzie, sixteen, lived in a female-headed househol̦
A thirty-year-old brother worked in the mines. Three younger chi̦
dren went to school. Their Irish-born mother, who was illiteraț
owned a home and took in a boarder.[22] The Mitchell girls, Mary
Ann and Annie, also helped support a single mother. Sixteen-yea̦
old Mary and fifteen-year-old Ann were spinners in the mill. Anni̦
age thirteen, was a bundler. There was one younger sister. A coa̦
miner boarded with the family in a rented house.[23]

Study of sample groups from the United States census for Ca̦
bondale in 1900 reveals that certain types of families were mor
likely than others to send minor children to the silk mills.[24] A ra̦
dom sample of 216 Carbondale families yielded a total of twenț
six families (about twelve percent of the sample) with children ag̦
eighteen or younger in gainful occupations. Comparing the familie

f child workers with the random sample of all Carbondale families
ielded few significant differences. Factors such as a father's occu-
ation or absence had only a minor effect on the choice to send
hildren out to work. Twelve percent of the families of child labor-
rs came from female-headed households, but female-headed
ouseholds accounted for about eleven percent of the population as
 whole. Miners were more likely than railroad workers to send
hildren out to work. Twenty-three percent of the child-laboring
amilies were headed by miners or coal mine workers, while only
welve percent were headed by railroad men. But mining and rail-
ɔading each accounted for about nineteen percent of the
orkforce.

Ethnicity played a minor role in the decision to send children out
ɔ work. Irish families accounted for forty-six percent of those with
hild workers and only thirty-nine percent of the general popula-
on. But child workers came fairly randomly from English, Ger-
ɪan, Welsh, and other ethnic groups. Most of Carbondale's silk
orkers were native-born children of immigrant parents. Only thir-
en percent of workers were themselves foreign-born, but nearly
ghty percent had foreign-born parents. The most numerous ethnic
roups were Irish, English, Welsh, German, and Austrian, in de-
ending order, and this distribution closely reflected that of Car-
ɔndale as a whole.[25]

The most significant factor affecting the decision to send children
ɹt to work was family size. In other words, families with many
ɪinor dependents tended to send one or more of those minors out
 earn wages. Twenty-five percent of families in the general sample
 Carbondale's population had four or more children at home. But
xty-five percent of those families that depended on minors' wages
ɪd four or more children. Offspring from smaller families had a
uch greater chance of remaining in school and out of the work-
ɹrce through adolescence. Eldest children in large families fre-
ɪently went to work to help support their younger siblings.

The typical silk worker had three or more siblings. More than
xty percent of Carbondale's silk hands lived in households with
ɹur or more children (a figure that corresponds closely with the
ɟure for Carbondale families sending children out to work in any
ɔcupation). Most commonly the family had five or six children.
ɪmilies of seven, eight, nine, and even ten children were com-
ɔn.[26] For instance Mary Howard, a doubler in the mill, had nine
ɔlings at home. Her sisters Maggie and Tressa, age sixteen and
urteen, also worked in the silk mill while six younger children

attended school. Their Irish-born father worked as a day laborer while their mother Mary tended to the housekeeping.[27]

The Klots mill employed several sets of siblings including the three Howard girls, suggesting that young workers often helped obtain jobs for their brothers and sisters. For instance Gertrude Wisley, age eighteen, worked as a bundler. Her seventeen-year-old sister Mary worked as a winder and a brother James, age fifteen, also had a job in the mill.[28] Mary Woody, seventeen, and her younger sister Rose, fifteen, both worked as winders in the mill. Twin sisters Annie and Margaret Kearney, age 22, helped support the family of a coal miner by working as reelers for Klots.[30]

When fathers were missing or disabled, older daughters sometimes remained in the household to help support their siblings. Annie Brown, age twenty-eight, was considerably older than most of her co-workers, including her sister Katie, age seventeen. These young women lived in a complicated household headed by an apparently disabled or unemployed father. Two brothers, Michael and Patrick, were miners. A married sister, Maggie Jordan, and her two children lived in the household. Maggie worked as a domestic servant. Annie may have put off marriage herself to help support the family.[31]

Young adults in their twenties and thirties sometimes remained in the households of parents who needed the wages they brought home. Katie Walsh came from a female-headed household in which several older siblings held jobs. A brother, twenty-six, was a coal miner. A sister, twenty-two, was a printer and another sister, nineteen, was a dressmaker. One sister, seventeen, was not employed. At the age of fifteen, Katie worked in the mill. Three younger children remained in school. Their Irish-born mother owned the home in which the family lived.[32]

Sons as well as daughters showed loyalty to parents and siblings by remaining at home and contributing to the family income. Silk worker Ann M. Callahan, seventeen, had a father and three brothers in the mines. Her Irish-born father was a miner. His eldest son, age thirty-three, was a mine laborer. A brother, fourteen, was a door tender and a younger brother, twelve, was a slatepicker. Two younger sisters stayed at home, where they probably helped the mother with the backbreaking work of cleaning and doing laundry in a coal-mining household, while Ann went to work at the mill.[33]

Mothers and older siblings sometimes worked to help keep younger siblings in school. The mother of Mary and Anna Doyle worked as a dressmaker. Sixteen-year-old Mary was a winder and fifteen-year-old Anna also worked in the mill. At thirteen,

younger sister remained in school. Their sixteen-year-old brother had a promising position as an apprentice plumber. Three younger children in this Irish-American family did not work but attended school.[34]

Education could improve a child's future prospects, although in general Carbondale's young people had limited occupational choices. The twenty-year-old brother of silk worker George Keopler found work as a telegraph operator.[35] A few male silk workers managed to rise from bobbin boys to machinists or mill supervisors. The twenty-year-old brother of silk hand Robert Mennig succeeded in becoming an electrical engineer.[36] But these were the fortunate few, not the many. The older male siblings of silk workers most often worked as miners or manual laborers.

Females had even more limited opportunities, but some did find ways to move up in the world. Occupations of females over eighteen years old listed in the Carbondale census for 1900 included seamstress, dressmaker, milliner, teacher, silk hand, and bookkeeper. A few young female silk workers rose through the ranks to become foreladies, receiving nearly twice the wages of most operatives. By 1900, twenty-year-old Natie Wood and eighteen-year-old Loretta O'Kief held supervisory positions in the mill.[37] Older sisters of silk hands occasionally found work as salesladies and dressmakers. A few found skilled jobs in printing plants as compositors and printers. But most of Carbondale's female silk workers could look forward only to becoming the wife of a coal miner or manual laborer and perhaps the mother of a silk mill hand.

In the late nineteenth and early twentieth centuries, life in Carbondale and much of northeastern Pennsylvania demanded that some children forego an education beyond the elementary grades and go out to work in mills. Testimony of manufacturers before the United States Industrial Commission in 1901 confirmed that employers often preferred to hire young workers because they commanded lower wages.[38] They worked cheap.

Families chose to send children rather than mothers out to work to supplement household income. Even in female-headed households, children and not mothers went out to the mill. There are many possible explanations for this choice. An obvious one of course was that employers sought and hired child workers. Mothers stayed at home for valid reasons. Families tended to be large. Childbearing and child care consumed a great deal of an adult woman's time and energy over a very long period of her life. Cooking, cleaning, and managing the house for a large family hardly left time for other occupations. In particular, being the wife of a coal miner was

an exhausting job. Miners could not go off to a restaurant or cafeteria for lunch. Wives had to deliver food to them or send the children with lunch parcels. Mining was sooty, oily, dirty work. Some employers provided washrooms for workers, but most men went home to bathe and clean up. If the family was lucky enough to have indoor running water it probably came from a single tap in the kitchen. Wives would then carry it in buckets to the tub. Many wives had to carry water for bathing and household tasks from an outdoor pump. Finally, laundering a miner's coal-blackened clothes on a washboard was a time consuming, backbreaking, and knuckle-bruising task.[39]

Living near the mines, breakers, and culm piles of the anthracite region caused real problems for homemakers. Particles of soot hung in the air and blew in through doors and windows, coating furniture, clothing, and linens. Housecleaning under these conditions was an especially arduous duty. Miners' wives hauled fuel for heating and cooking from waste piles of coal outside the breakers. Photographs of these women pushing wheelbarrows full of coal with children riding on top or clinging to their mothers' skirts attest to the rigors of life in the anthracite region.

Mothers who stayed home in Carbondale as in other cities, towns, and villages of eastern Pennsylvania did so to toil, serve, and add to the economic resources of the household. A miner could not function without someone to clean his clothes and prepare his meals. A miner's wife sometimes performed these services for several men including male relatives, sons, and boarders. In the more unfortunate households, a miner's wife might support several boarders or take in washing for several families. By gathering fuel from waste piles, raising a few chickens, and growing some vegetables in a garden the wife who did not "work" could add a crucial portion to the household economy. In the crudest of terms, a wife could also bear and bring up children who could then go out to work and bring their wages home. When times were hard, when a breadwinner was injured, when a father gave up and deserted the family, or when a husband's wages simply did not meet the family's needs, these tough strategies could mean the difference between death and survival.

Debate raged for many years over the adequacy of miners' wages. In the best of times and working to his full physical capabilities, a miner might earn enough to support his family. Miners' helpers and other laborers could never expect to support the average family. As the census for Carbondale reveals, many families were larger than the average size of five members. Furthermore, miners

could not always count on working to their full potential. There were slumps and layoffs, setbacks, and disasters. Miners suffered injuries, illness, and death. The simple fact that seventeen percent of Carbondale's silk mill workers lived in female-headed households attests to the vagaries of a miner's life. Miners who tried and failed to support their families sometimes relieved the pressure by simply leaving home. Others succumbed to ill health or the inherent dangers of their occupation. Whether or not a vigorous miner's optimum wages theoretically could sustain a family is hardly a valid point of argument. In fact and in many cases, their wages did not suffice.

Powderly and Jones railed against the inadequacy of miners' wages and the necessity for children to work in the mills. Both believed in the concept of a family wage, that is, a wage sufficient for an individual male breadwinner to support a wife and children. Both feared that new immigrants, women, and children entering the workforce exerted a downward pressure on wages. To protect families and children, both believed that any available jobs should go to male heads of households. Powderly feared that conditions in the

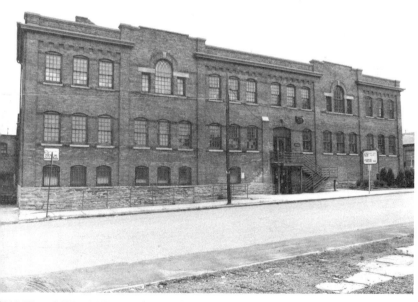

Old Klots Mill, 101 Poplar Street, Scranton. Photo by Bonnie Stepenoff, 21 July 1991.

hard-coal region might lead to revolution, but he probably did not envision a revolt led by young female workers.

In December 1900 Klots workers, many of whom were female, did rebel by walking off their jobs, demanding that the company start using accurate scales to measure the output of pieceworkers and stop docking workers' wages when breakages in the fine silk fibers caused production delays. On 4 December, strikers called on Marcus Frieder, the manager, insisting that he change these practices. Frieder refused, but the strikers held firm.[40]

Soon after the strike began, UMWA members began pushing for a quick settlement. A committee of men from various unions in the city visited with Frieder on 6 December and tried to negotiate an agreement. After this meeting the union men counseled the young silk workers to accept Frieder's offer. The male union members were attempting to deal man-to-man with the silk mill superintendent. In this way they fulfilled the fatherly role, taking charge of the affairs of their daughters. But their daughters balked.

At a meeting in McTighe's Hall on South Main Street in Carbondale, strikers listened as the committee of unionists explained the mill owner's position. According to the *Scranton Republican*, Frieder had promised to pay night hands as much as ninety-five cents and day hands as much as seventy-five cents per shift on a piecework basis. This, the union men urged, was a fair day's wages. As the newspaper reported it:

> The men were convinced by Superintendent Frieder that the mill hands who worked faithfully all day on piece work made good wages, while those who loafed were not able to earn as much, and at the end of the month expected as much as the ones who worked hard.[41]

The strikers conceded that Frieder had "met the committee like a gentleman," but they firmly refused his terms. The top pay of ninety-five cents per shift would go only to the "night shift boys" and would be based on productive output. Day shift workers, mostly female, would receive no raise in pay at all according to Frieder's terms as the strikers understood them. The night workers and day workers, males and females, had gone on strike together and resolved to stick together. They had written to Mother Jones, asking her to send them a charter to form a local union. In a written statement they asked, "What would 'Mother' Jones say if she sent it and it had to be sent back?"[42]

The young silk workers questioned the ability of older men from

other unions to do their negotiating for them. In a defiant public statement they argued that the men who visited Frieder

> knew nothing about silk, the way it's spun, the frames, the crates, the weight, or anything connected with it, and, of course, Mr. Frieder, being an educated man and manager of this mill, knew just how to draw them to his side of the case.[43]

With this forthright comment, young female silk workers claimed an understanding of their own business that their self-appointed male protectors did not share. These young women knew their own minds. There were limits to their willingness to defer to father figures, including bosses.[44]

Recognizing the determination of the silk workers to defend their own interests, various locals of the UMWA held meetings and offered their support. Committees of mine workers visited the fathers of silk hands and urged them to let their children join the strike.[45] Silk strikers attended meetings of the mine workers to put pressure on the fathers of those silk hands who remained on the job.[46] By doing this they tacitly recognized the power of fathers to control the actions of their daughters. But they also exercised their own power to put pressure on powerful males.

In mid-December a group of strikers waited at the door at six o'clock for the day shift workers to leave. When the workers headed home, strikers accompanied them along Belmont Street, making a raucous noise with fifes and drums,[47] parading in a way they had seen their union fathers do. Here the girls showed daring and initiative. And they enjoyed some success. These efforts resulted in the shut down of Klots and the expansion of the strike to Scranton and other towns.

As the strike spread "like wildfire" in late January and early February 1901, male organizers tried to exercise control over the silk workers. Strikers and their supporters held mass meetings in Scranton. Male organizers urged weavers to form a branch of the Silk Weavers of America and all other workers to join a local of the textile workers. However, the Scranton daily paper commented: "To organize the silk workers is a difficult task, as the bulk are girls from 12 to 16 years of age and are very enthusiastic."[48]

Events heated up as young female workers at Scranton's Sauquoit Mill walked off their jobs. The *Scranton Republican* reported that on 31 January the superintendent offered a pay increase of from eight to twelve percent. But on that same day 150 "girls"

walked out and on Friday three hundred more went on strike. The newspaper commented:

> The Sauquoit strike was almost exclusively confined to girls between the ages of 13 and 17 years of age, and they made it decidedly interesting for those who persisted in remaining at work, as was demonstrated by their actions yesterday morning, when they tried to prevent other girls from going to work. These girls were working by the piece and had no grievances, but yesterday afternoon they decided to stand by the younger girls in the mill, and about 4 o'clock they took their lunch baskets and walked out, making the tie-up complete, more than 3,000 now being out.[49]

These young strikers were feisty and insistent about preventing their co-workers from breaking the strike, and by mid-February five mills had closed down after about twenty-eight hundred workers left their jobs.[50]

Silk workers followed the example of Mother Jones in loudly asserting the rights of workers. For the past year, since early 1900, Jones had been using her blend of strident rhetoric and motherly sentiment to rouse anthracite miners to action. John Mitchell, president of the UMWA, brought her to northeastern Pennsylvania in February and again in September to encourage unity among striking miners.[51] To do this, she organized miners' wives into a militia wielding brooms, beating on tin pans, and yelling "Join the union!"[52] Jones believed women had an important role to play as nurturers and motivators of union men, but not as workers.

Already a familiar figure among miners' families, she arrived in Scranton during the silk strike in mid-February 1901 and organized several parades and demonstrations. A local headline noted that "She Roused Them Up" with mass meetings and fiery speeches. She said the girls were living under a system of robbery and demoralization of body and soul. She knew how they suffered, and they would continue to suffer until they joined unions and remained firm. On wages, she understood that some of them were paid but two dollars per week, which was "not enough to feed one of the dogs of the robbers."[53]

Jones, identified in the Scranton paper as "Mrs. Mary Jones of Wilkes-Barre" (a city south of Scranton), went to Paterson to study conditions in the silk mills there. Returning to Pennsylvania, she reported that things were much better in Paterson. One major difference she observed was the gender of workers in the mills. "The child labor law is better enforced [in New Jersey] for one thing, and

there are more men at work than seen in the silk mills here . . ."[54] Male heads of households often worked in the Paterson mills, commanding much higher wages than Pennsylvania's young females. Jones far preferred a situation in which males worked and supported female dependents.

She castigated parents for bringing children to the Pennsylvania mills. In a speech in Scranton she said,

> It is astonishing to find so many girls of exactly 13 years of age at work in the mills here, and we are going to look into it. The parents are really at fault. They make oath their children are 13 years old, when in many instances we can prove by the record of births that they are under 10.[55]

This speech seemed to indicate a lack of sensitivity to the problems of fathers, who struggled against layoffs, injuries, and disease in order to earn a steady income, and mothers who labored to keep households in order.

The conservative Scranton paper echoed Jones' sentiments, berating parents who filed false affidavits in order to place their children in the mills. After quoting Jones, a writer for the *Scranton Republican* theorized that child labor laws were ineffective in that city because of the evasiveness and greed of parents. The writer further argued: "If child labor cannot be had adult labor will supply it at adult wages."[56]

Blaming the parents for the labor situation was hardly fair. Mill owners threatened repeatedly during the strike to close down their operations if workers insisted on a higher pay scale. Clearly management was unwilling to pay "adult" wages. As the owner of the Cambria Mill at Dunmore pointedly stated:

> There is the best of feeling, and everything is fully understood between us [management and workers]. But if this trouble is going to keep up, and we are obliged to accept the strikers' wage scale, we shall have to go out of business. It will pay me better to take my mill back to New Jersey than keep on.[57]

In the month following the end of this strike, silk mill owner Franklin Allen testified to the Industrial Commission that his industry had come to Pennsylvania precisely because of the availability of child labor.[58]

Faced with these threats from the industry, even Jones capitulated. The possibility of mill owners leaving the region dampened the enthusiasm of UMWA members who had supported the strike. Cooperating with local clergymen and business leaders, UMWA lo-

cals helped to negotiate the settlement that sent their children back into the mills. By the end of April, even Mother Jones urged girls to accept a settlement.[59] The strike ended on the last day of April, with some workers gaining pay increases of between eight and ten percent based on timework and other workers gaining small increases in the piecework rate. Workers also won Saturday afternoon holidays with pay (reducing Saturday work in some mills from seven hours to four hours).

Female workers won some small victories in this strike. Significantly, the mostly male night shift showed solidarity with the mostly female day shift workers in refusing Frieder's first settlement offer. According to the final settlement, female hands gained the right to apply to foreladies (female supervisors) rather than foremen when they needed to go home sick.[60] The reason for this demand remains unclear, but may have reflected a desire for confidentiality and a reluctance to reveal certain health problems to male supervisors.

Although Jones supported a settlement that sent young girls back to the mills, she continued to fight against child labor. During and after the strike she organized parades and demonstrations that put the labor force on display. The youngest strikers headed a parade on 8 March, prompting the *Scranton Republican* to comment that there were "nearly 500 of an age not beyond wearing short dresses."[61] Mother Jones led a group of older girls in the procession, which reportedly included nearly three thousand marchers. After strikers accepted the settlement, Mother Jones arranged another protest against child labor by staging a "victory" parade of little girls accompanied by boys who belonged to the newsboys' and bootblacks' union.[62]

Jones, the personification of motherhood, insisted upon portraying the silk strike as a children's strike. In an article published 13 April 1901 in *St. Louis Labor*, she asserted that most of the strikers were "little tots ranging from 8 to 14 years of age."[63] This was certainly an exaggeration. Study of the workforce at the Klots mill, where the strike began, reveals that most strikers were probably between the ages of fourteen and twenty-one, with only a minority of children under fourteen. Of course there was no excuse for exploiting child labor. But Mother Jones made no distinction between silk workers who were twelve or thirteen and those who were eighteen or twenty, portraying them all as "tots" and thus denying them the status of adult actors on the historical stage.

By characterizing the strikers as helpless waifs, Jones undercut their ability to take determined action to improve their wages and

working conditions. While no one would argue that eleven- or twelve-year-olds should work in mills rather than attend school, the majority of silk workers were older adolescents and young adults of an age to begin taking responsibility for their own lives. Because most of them were female, however, fathers and other adult males intervened and tried to control their activities. Mother Jones reinforced the father's position by turning attention from the issues of wages and working conditions to the issue of child labor. The problem then became not the injustice of paying such low wages to silk workers, but the injustice of employing females in the mills. The solution became not a better deal for the female workers, but a better deal for the fathers who, in Jones' view, should support them.

When silk workers walked off their jobs in 1900 and 1901, they expressed a desire to act and speak for themselves. Being young and female did not prevent them from initiating actions aimed at improving their wages and working conditions. But age and gender did affect the ways in which UMWA members and labor leaders interpreted and responded to their actions. As fathers and brothers of the silk workers, UMWA members took control of the strike, although strikers protested that miners knew nothing about the silk industry. As a mother figure within the union, Jones reinforced the desire of fathers to support and protect their daughters. Jones and the miners kept the silk strike firmly within the UMWA family. By defining the silk workers' protest as a children's strike, Jones turned attention from issues of wages and working conditions to issues of parental responsibility and control—again, keeping it in the family.

3

Silk Workers and the Anthracite Strike of 1902

These babes know their friend. There is not one of these children so ignorant, not one of them so lost to natural instincts, that he does not know who loves him. There is not one who would not run from a railroad president to the open arms of John Mitchell; and they are right.

—Clarence Darrow, closing address to the
Anthracite Coal Strike Commission,
15 February 1903

John Mitchell, president of the UMWA, was a father figure for miners and their families in the anthracite region. Born in Illinois, Mitchell went to work at age twelve in the Braidwood coal mines. In the 1890s he worked as a lobbyist for the miners, advocating child labor laws and other reforms in Illinois. As president of the UMWA, he came to eastern Pennsylvania to organize the hard-coal miners. Historian Robert Wiebe noted Mitchell's "habit of dressing in priestlike garb, his commanding presence, and his apparently unshakable calm in a crisis."[1] Many local priests became his friends. Immigrants responded to his kindly, upright demeanor. A conservative leader who spoke of cooperation between labor and capital, he won people's trust with measured speech and visible compassion.[2]

Mitchell, still fondly called "Johnny" by residents of the region, rallied the struggling, hardworking, quarreling, and sometimes desperate working men to join the union. With astonishing success he courted new and old immigrants, Catholics and Protestants. He elicited support from the clergy and even from businessmen, who earnestly wanted peace in the region. During the strike of 1900 he managed to win the support of the capitalist Mark Hanna and the conservative *New York Times*. He took his case directly to J. P. Morgan. The negotiated settlement resulted in a ten percent wage increase and other concessions to the miners. Johnny was a hero.

56

John Mitchell, President, UMWA, 1898–1907. Photo courtesy of Pennsylvania Historical and Museum Commission, Bureau of Historic Sites and Museums, Anthracite Museum Complex, MG 369.

Despite his preference for friendly negotiation, Mitchell led 150,000 mine workers in the famous Anthracite Strike of 1902. According to biographer Craig Phelan, Mitchell opposed the strike as too risky, but the rank and file dragged him into the fray.[3] For six months the workers stayed out of the mines, creating an energy shortage that seriously threatened the national economy. Their courageous stand against arrests, court actions, and the intimidating presence of the state's National Guard truly constituted a moral victory.

Mitchell, who hated the idea of strikes, finally won an offer of arbitration from President Theodore Roosevelt, and the men returned to the mines.[4] Miners and their families rejoiced at the acceptance of a mediated settlement. The President created the Anthracite Coal Commission to hear testimony from mine owners and strikers. Conditions in the anthracite region received national attention.

Pennsylvania anthracite miners celebrated a hard-won victory in

Mass meeting of miners and families listening to Mitchell at Priceberg, PA, 1900. Photo courtesy of Pennsylvania Historical and Museum Commission, Bureau of Historic Sites and Museums, Anthracite Museum Complex, MG 269.

autumn 1902. Perhaps they rejoiced prematurely. But they had rea-
sons. They had stayed out of the mines and stood their ground
against the big coal corporations, the police, the courts, and the fed-
eral government. They had won the respect of the President, who
promised to listen to their side of the story. Considering past uses
of state and federal power against strikers at Homestead, Pennsylva-
nia, and Pullman, Illinois, this was a real victory. The UMWA jour-
nal proclaimed that the anthracite coal strikers had held out against
big business and the government and proven their manhood.[5]

Wives, daughters, and sisters of the miners took pride in this
achievement. When the people of Mahonoy City heard the news,
workers blew the steam whistle in the local brewery. Fire engines
clanged through the streets. Women rushed out of their houses
weeping and clapping their hands. Children romped at the edges of
a spontaneous parade, led by the miners' marching band.[6]

Young girls who watched this demonstration learned what it
meant to be a labor hero. A sentimental poem in the *United Mine
Workers' Journal* attempted to capture the emotions of a victorious
miner, spying his young daughter in the crowd. The poem "Papa
on Parade" described a fragile blond child observing a joyous pro-
cession in which her father marched. When she spied him, she re-
acted with delight:

> "There's papa; there he comes!" she cried.
> Her voice was like the trill
> Of birds that sing in June; then flute-like,
> clear and shrill,
> "Here, papa, here I am!" she called,
> and then the little miss
> With dainty fingers touched her lips
> and wafted out a kiss.[7]

The poem presented an idealized portrait of an innocent girl-
child in the tradition of Little Eva. The poet described her hair as
"wavy golden," her eyes as blue, and her lips as babyish and pouty.
She laughed guilelessly at a clown and shrank back in fear from a
cart-dog. These descriptive terms suggested that she was com-
pletely open, completely vulnerable, a tender and diminutive crea-
ture who needed protection.[8]

In contrast to this soft female child, the miner in the poem was
tall, muscular, and strong. The poet depicted him as large and pow-
erful, the natural protector of the tiny, vulnerable female child. This
man did have one weakness, however, and that was his attachment
to his daughter. In the poet's words:

The man was tall and big and strong,
 his muscles stood like steel;
But deep within his mighty chest his
 heart knew how to feel;
A smile was on his bearded lips; a tear
 shone in his eye;
He gently waved his massive hand as
 he went marching by.

The miner in the poem had proven both his bravery and his love
by taking actions that he hoped would make a better world for his
child.

Miners and their families who read this poem must have known
that reality differed from this ideal. Not all miners were vigorous,
mighty, and invulnerable. Many had suffered injuries. Others suf-
fered from debilitating lung diseases. Many could not earn enough
money to support their families.

Not all miners' daughters were innocent little blond creatures
with dainty fingers and pouty lips. Many young girls in the anthra-
cite region went to work at an early age in cigar factories, knitting
mills, and silk mills, where they learned harsh language and rude
habits. Some of them became deaf from the noise of the machinery;
some became lame from standing for so many hours at a stretch.
Others had tired, unhealthy looks from working the night shift to
help support their parents and siblings.

During hearings in Scranton in the winter of 1902–3, some min-
ers' daughters had a chance to tell their stories. All sorts of people
appeared as witnesses before the Anthracite Strike Commission.
Owners and managers spoke of profits and expenses, unreliable
workers, and the harsh demands of doing business in a competitive
economy. Miners told of crooked scales, harsh bosses, unsafe con-
ditions, injuries, illness, and the problems of trying to support their
families on the wages that the owners paid. Young boys who
worked in the coal breakers, picking slate out of the rivers of coal
that tumbled down metal chutes, told of long hours, severed fingers
and hands, and their families' need for their meager wages. Young
girls, the sisters of these boys, described their work in the silk mills
that had recently sprung up in nearly every village, town, and city
in the hard-coal region.[9]

Clarence Darrow, attorney for the strikers, used his eloquence to
draw attention to their cause. In speeches quoted in the *New York
Times*, Darrow condemned mine owners for underpaying their
workers and forcing them to send their children to the mills. Using

highly colored language, he described the pain of parents who sent their children out to work in the coal breakers and the textile factories.

> Let me say this, that until you, Mr. Railroad President, or you, Mr. Lawyer, will take your child by the hand and lead him up the breaker stairs and sit him down to pick at that trough of moving coal, until you will take your pale girl to the silk mills, let me speak for the children of the poor.[10]

He blamed the mine owners for the child labor situation, stating that the wages they paid were so low that miners could not support their families.

Darrow called several young silk workers to the witness stand. Members of the strike commission reacted with anger and horror as the girls told of working twelve-hour shifts in the silk mills, walking to work in the evening and returning home in the morning tired and spent. Some of the commissioners vented their wrath on the parents. Darrow placed the blame squarely on the mine owners. The girls themselves simply described their lives, placing blame on no one.

Theresa McDermott, the first to testify, said she was only eleven, going on twelve, and she had worked in a mill for about four months. Theresa was the daughter of a miner. She worked the day shift, starting at seven o'clock in the morning and quitting at six o'clock at night. For those eleven hours each day she stood on her feet tending a silk reeling machine. Her wages for this fatiguing job were two dollars per week.

Theresa went to work after her father got hurt in the mine. He was laid up for about and month and could not work. Judge George Gray, chairman of the Anthracite Coal Strike Commission, questioned her about her family situation and elicited testimony to the effect that she was the oldest of four children and that her mother was living. Her father was back at work in the mine since he had recovered from his injuries and the strike had ended. Theresa planned to quit her job soon, perhaps the following week.

Helen Sisscak, not quite twelve years old, testified that she had been working in the Cambria Silk Mill in Dunmore for one year. She worked nights. Helen, who was Polish and could not speak English, communicated through an interpreter. Her father had worked as a miner in this country for more than ten years, but had only recently been able to bring his family here to live. To help support the family Helen worked as a bobbin carrier for three cents an hour.

She had a certificate that made it legal for her to work. But the cer-
tificate said that she was thirteen years old.

Annie Denko, a thirteen-year-old silk worker, responded to Dar-
row's questions her about her life at work and at home. Judge Gray
of Delaware, chairman of the commission, became indignant during
her testimony, sometimes interrupting her with angry outbursts.[11]
Darrow asked:

"Do you work days or nights?"

"Nights," she answered.[12]

The issue of night work for females, especially young females
was one that could arouse the passions of progressives like Darrow
who tended to believe that night work endangered the health and
morals of immature girls.

"What time do you go to work?"

"I start work at half past six."[13]

Chairman Judge Gray had apparently misheard her previous an-
swer, because he asked, "Half past six in the morning?" Annie
must have been confused, perhaps intimidated by her surroundings
in the superior court room. "Yes, sir," she answered. The lawyer
continued the questioning:

"Twelve hours?"
"Yes, sir."
"Do you work twelve hours?"
"There."
"How far to you live from your work?"
"I live way up at No. 7. Takes half an hour to walk down to the
mill."[14]

She lived in close proximity to a mine in the town of Dunmore
just north of Scranton and a few miles south of the mining town of
Carbondale. The lawyer elicited further answers about her comings
and goings:

"Do you walk back home again?"
"Yes sir."
"You are about thirteen hours altogether going and coming to the mill
and working?"
"Yes sir."
"Anybody go with you from your home to the mill?"
"No, there is only two boys going with me."
"You go home at half past six in the morning?"
"Yes sir."
"Winter and summer?"

"Winter and summer."
"How long have you worked there?"
"I am working there over a year."
"Have you worked nights for a year?"
"Yes, I am working now on night shifts, one week on days."[15]

Darrow asked if her task required her to stand up or sit down. She replied that she had to stand up. She was a twister, which meant she tended a noisy, clattering machine that brought one or more strands of silk together and twisted them to form a yarn for weaving silk fabric. During her long shifts she watched the machines that unwound the filaments of silk from reels or swifts, combined and twisted them into yarn, and wound them onto cones or spools. She would remove the finished spools and remain alert for broken strands. Because she stood for so many hours on end she might have become lame, as many silk workers did. Because the machines were so noisy she would probably suffer hearing loss.

The lawyer and the judge questioned her about her family life. Annie informed them that she was the oldest of five children. None of her siblings went out to work. The family rented a four-room house with two rooms up and two rooms down. They did not rent it from the coal company. In other words it was not a company house. By 1900, company housing was no longer prevalent in the coal region.[16] Miners frequently rented or bought with the help of a mortgage two-story frame houses of the type in which Annie lived. Her mother kept house and her father worked in the mine. She did not know what wages he earned, but her wages amounted to a little more than five cents per hour, or sixty-two and one-half cents for a twelve-hour shift.

Judge Gray wondered aloud what sort of father would send his young daughter out to work nights in the mill. While admitting that economic hardship might drive someone to this extremity, he obviously placed blame on the parents for allowing this to happen:

> There is no use in disguising the fact that it may be a necessity, but there must be many cases in which the fathers allow this and give their own consent to coin the flesh and blood of their children into money to help their income when there is no absolute necessity for it.[17]

He demanded the opportunity to question the father.

In his angry outbursts, Judge Gray revealed his basic assumptions about the nature of family life. The father in his view must be the breadwinner. If the father failed in that capacity he must be lazy, morally lax, or a spendthrift. The judge seemed not to care how

difficult it might be to support a large family on a miner's wages. Whatever sacrifices he had to make, the father should do so. His view reflected the ideal of the steely, invulnerable male worker who happily slaved to support those who depended upon him, especially those females who depended upon him.

Darrow viewed the matter somewhat differently. Without questioning the idea that the father should be the sole breadwinner, he argued that the employer should pay the breadwinner a wage sufficient to support his family. Thus, when Gray insisted on questioning the Annie's father, Darrow suggested that perhaps the commission ought to speak to her employer.

An interesting interchange followed during which the judge and attorney seemed to argue in circles. Judge Gray asserted that the employer could not hire children if the father did not offer them for hire. On the other hand, retorted Darrow, the father could not send them to the mill if the employer did not take them. Judge Gray admitted that the social condition that allowed this was "a very sad one." Nevertheless he demanded to question the father.

Two days later the attorney for the mine workers called John Denko, Annie's father, to the stand. He was a miner employed by the Gypsy Grove Colliery in Dunmore. Records in Darrow's possession confirmed that Denko had earned fourteen hundred dollars in fifteen semi-monthly periods, or eight and one-half months. But two miners and two laborers shared this money most of the time under the butty system, in which a miner and his butty collected a lump sum, divided it, and paid their own helpers. Denko's own wages were therefore only a fraction of the sum that appeared in the company's books.[18]

Darrow asked the miner why his little girl had to go to work in the silk mill. There was no simple answer. Denko testified that he had changed jobs within the past two years. He had only been earning decent wages since the summer before the commission's hearings, and he had a store debt to pay. When an injury kept him out of the mine for three weeks, he could not make payments on his debt. That was why he sent the little girl to work. Then during the strike he was out of work again, so the child had remained at the mill for more than a year and a half.

Annie had to cope with many problems. She came from a family of eleven children; six of them had died, and five were living at the time of the hearings. Four of her siblings died in one year. The commission did not question the father as to the cause of his children's death, but infectious diseases such as diphtheria plagued the anthracite region.

John Denko explained his predicament:

> Well, gentlemens, I was in bad position. I got six small children buried inside of five years, and my wife was in asylum for pretty near two years. Then I have five to keep the same time she was away, you know.[19]

The wife's confinement to an asylum must have complicated the family's life. Certainly a mother who had lost six children in five years might understandably have an emotional breakdown. But in a miner's household the loss of the mother would almost certainly place added burdens on the children, especially the female children. A miner's wife normally provided meals for the family; in most cases she carried or sent a lunch to her husband at the mine. Keeping a miner's clothes clean was a backbreaking task. Housecleaning in the sooty environment of a coal town consumed much of a woman's time. Annie, being the eldest and a girl, would almost certainly have assumed household duties while her mother was away in the asylum.

The mother, having apparently recovered from her grief, had returned to the household. But surely she still needed help with the younger children and with other household tasks. Her life could not have been much easier than Annie's—or John's.

No one on the commission questioned the fact that this mother sent her young daughter out to the mill instead of going to work there herself. In the minds of the commissioners the responsibility for bringing home wages belonged to the father. During the hearings no one suggested the possibility of wage work for the mother. Given the hardships of this woman's life it might have been cruel for anyone to do so.

Annie's father did not exaggerate when he said his life was very hard. He tried to explain his situation:

> I was in bad position. When I got the job in Gypsy Grove with a fellow named Martin Gallagher, I didn't make so much in the chamber, but then that is the first of August when I started making good wages. Then I got the heading and air way, for sure I was making good wages then, but I was about $76 in debt with the store bill, so they sent the girl to the mill to help me pay the debts. I got hurt and was laid over three weeks on it. That is the reason I had to send the little girl to work.[20]

The chairman asked this question:

> Was that little girl you sent to work your oldest child?
> [Denko] Oldest child now; but I have two boys older; they are dead;

they are not alive, they are dead. I have three going to school now, one boy going on twelve years, one going on nine and one going on seven; three going to school now.[21]

Judge Gray refused to believe that the man really had to send a child out to work. He apparently clung to the image of the muscular, invulnerable miner who could brave all hardships in order to provide for his children. The miner, thought the judge, should have protected his daughter and solved his own problems. "Do you not think you could have kept her home and worked out the debt yourself?"

Denko told him again that it was a very big debt. And furthermore, he argued, she wanted to go to work. The judge could not accept this. He could not believe that a young girl would choose to work or that a father would allow her to work, especially on the night shift. He continued grilling her father:

"Did you know she was working at night?"
"Yes."
"She has been working at night all the time?"
"Yes, sir, and there is lots more."[22]

Denko certainly told the truth when he said there were lots of other girls working nights in the mills. Some mills arranged their operations so that no women or children worked at night. But there were no legal restrictions on children's night work. Annie at thirteen was of legal employment age.

The judge tried to play on the father's sense of responsibility. "Do you not think that is pretty hard on a little girl of that age?"

Denko insisted that Annie had taken some responsibility for her own actions. "Well, she had a chance for the day shift, but she wanted the night shift herself."

Perhaps this was John Denko's rationalization. It may be that Annie chose the night shift because she could earn a few pennies more per shift. She may have felt pressured to choose it so that she could help her mother at home during the day. Her father may not have wished to acknowledge the necessity for it.

The chairman clearly remained unconvinced by Denko's testimony. Again he asked:

Do you not think you could have gotten along and kept her out of the mill, that you could have gotten along somehow or other and kept her at home and sent her to school?[23]

At this point Denko reached for a different argument. Annie wanted to work because she wanted to buy things. Clothes. She wanted clothes like American girls. "When she see another girl dressed up, I cannot help it, she wants to get dressed up like Americans; I cannot help it."[24]

Here Denko brought up a tangle of issues that complicated Annie's young life. First there was the problem of Annie's individual will. The judge's question implied a belief that the girl's father had, or should have, complete control over his daughter's life. Denko denied this, saying Annie had choices, and she chose to work. His statement was probably self-serving and probably false. But what if it were true, or partially true, or true in the sense that Annie had a mind of her own, and her father knew it? The judge dismissed this out of hand.

Secondly, Denko broached the idea of individual striving for material gain. Annie wanted to work, he said, so she could buy things. While the judge, like most capitalists, would have found this sort of ambition acceptable in a male, or at least in a male of the middle class, he did not accept it in a young working-class female. He seemed to believe that Annie and her family should be content with the most frugal of lifestyles, scarcely above the level of subsistence. This assumption must have underlain his argument that in spite of injuries, layoffs, and store debts, John Denko should have found some way to support his family on his own wages.

Thirdly, Denko introduced the idea of assimilation. Annie, child of an immigrant family, wanted to buy clothing, and she wanted those clothes because they would make her look and feel like an American girl. The judge and other progressives would have preferred to see Annie in a public school, learning American middle-class values. But Annie associated being an American with looking like one.

If Denko told the truth, if Annie really wanted to work to buy clothes "like American girls," then clearly she took a position very different from that of the judge. She did not work simply out of obedience to her father. She had her own goals. She wanted more out of life than the judge felt she should expect. She could see that other girls in Dunmore and nearby Scranton possessed more than she did in the way of clothes and small luxuries. She could board a streetcar and ride downtown to gaze into shop windows at the vast variety of goods produced in industrial America. According to her father's testimony, she wanted material things and was willing to work for them.

Annie's testimony, the judge's response, and the father's con-

fused self-justification spoke volumes about gender and class relationships in industrial society. As young as she was, Annie accepted as a matter of course the fact that she needed to earn wages. Other girls of her age and class did so every day. The middle-class judge viewed this as an outrage. In his view "little girls" should not go out to the mills, and fathers who sent them there, no matter what the circumstances, could not win his sympathy. In justifying his action Denko first tried to argue economic necessity. When that failed to move the judge he insisted that his daughter had a will of her own. She wanted to work because she wanted the wages. She viewed those wages as a way to improve her life. Again the judge showed no sympathy. Little girls simply did not earn wages. It was the father's duty to improve his daughter's life.

Hostility toward working-class parents was common among middle-class progressive reformers. Ardis Cameron found that in Lawrence, Massachusetts, local reformers complained often about the devious schemes used by laboring families, especially immigrant families, to keep their children in the mills.[25] Working-class parents felt justified in expecting children to contribute to the family income. More and more in the twentieth century, middle class observers viewed that expectation as cruel.

Would the judge's position have been different if Annie had been sixteen or eighteen or twenty years old? A reading of the trial transcripts in the context of attitudes expressed by Mother Jones and others shows that her gender as well as her age affected his thinking. All female workers were working "girls". Girls grew up to find husbands. Until they did, fathers were responsible for their care and protection. It seems unlikely that a judge would have given any more credence to the argument that a female of eighteen or twenty had a mind of her own and deliberately chose to work for wages.

Significantly, however, the judge supported the rights of young girls to an education. No one in the courtroom argued that Annie Denko should be sent away from the mill simply to remain in the home and help her mother. Darrow and the judge argued forcefully that these young girls belonged in school. No one suggested that their gender precluded them from enjoying the benefits of an education. Labor leaders and middle-class reformers agreed on this point. While denying the possibility that young females might want to improve themselves through work outside the home, they encouraged the same young girls to improve themselves through education. The reformers may have viewed education as a means of teaching middle-class values, but girls who went to junior high and high school also learned valuable, sometimes marketable skills.

During the Anthracite Commission hearings the needs and aspirations of female workers remained secondary issues. Annie and the other young girls testified at the commission's hearings in support of their fathers' demands for higher wages. Their own needs remained submerged. Like Mother Jones, Darrow and Judge Gray defined the male breadwinner as the key wage earner and protector of females and children in the household. If Annie Denko had desires of her own, the point certainly got lost in the central drama of the miners' struggle to support their families.

The miners won a victory, and this made an impression on their daughters. The gains amounted to a modest ten cent hourly increase in wages, a nine-hour day (not the eight-hour day they wanted), and the creation of a mechanism for settling labor disputes. This wage increase would not eliminate the need for secondary wage earners in miners' families, however. Miners' children would continue to report to the silk mills and coal breakers.[26] But their fathers' heroic struggle left an impression on them.

In the words of muckraking journalist Francis H. Nichols, the silk workers of northeastern Pennsylvania continued to live in the "coal shadow."[27] Writing for *McClure's Magazine* in 1903, Nichols eloquently expressed the middle-class reformers' view of a child's life in the anthracite region. He described parents of these children as Irish or Welsh-Americans or "foreigners," uneducated, who pinned their hopes on the union. Children of the coal miners in 1902 had lived through two great strikes that had shaped their perception of reality. Nichols pitied the children and disdained their fathers' talk about the rights of labor.[28]

Nichols observed that both girls and boys emulated their fathers' labor militancy. The breaker boys had their union, he wrote, as did the girls who worked in the silk mills. Girls were just as zealous as boys. Weekly union meetings were great events, requiring girls to dress as they would for church. Betraying his gender bias, he wrote:

Pale-faced little girls "assert their manhood" quite as often and as vigorously as do stalwart coal-begrimed miners.[29]

He had a half-disguised contempt for both the male and female unionists, but obviously perceived female union activity as especially grotesque.

While colored by his class prejudice, Nichols' observations revealed that young girls in the anthracite region emulated their fathers. Clarence Darrow, Judge Gray, and the UMWA poet may have viewed them as fragile beings, passive recipients of their

fathers' support and protection. Nichols described them as lively and active creatures who often viewed their fathers not as protectors but as role models. Darrow believed they would run like babes to John Mitchell's arms. Perhaps they were more likely to flock like soldiers to his militant banner.

This Nichols viewed as "painfully ludicrous,"[30] almost an offense against nature. The reason for their behavior, he reasoned, was that they had been deprived of a childhood. He viewed them as sullen and prematurely old. They had no playmates and no games; they worked at an early age and played at unions. Strikes were the most exciting events of their lives. Boys learned only one trade and received no education that could prepare them for life outside the mines. Mill girls married young. They spent their lives within the coal shadow.

The answer, for Nichols, was education. He deplored the fact that schools in the anthracite region sometimes served as union halls, and children attended sporadically. Truant officers failed in their duty. Schools were the only institutions that could rescue these children from their fate, teach them new skills and values, and allow them to find a better future. But schools in the region failed to save children from the mills and the breakers.

The anthracite region remained a troubled area of concern to journalists and reformers. Peter Roberts' book on the social life of the hard-coal counties, published in 1904, painted a gloomy picture of surplus labor and dangerous dependence on the coal industry. He reported that the region was home to 143,826 mine employees, all of whom were male. Another 60,000 males and 20,000 females worked in the professions, trades, transportation, domestic work, and manufacturing. But these occupations also depended on the anthracite economy. Thus in the anthracite coal area a total of 630,000 people depended upon the mines either directly or indirectly.[31]

Roberts noted that the mining industry placed the whole burden of supporting the family on its men and boys. In Scranton and Wilkes-Barre, he reported, females made up about twenty percent of the wage earners. Outside these two cities the percentage was much less, approximately five percent. As a result of this, boys went to work at an early age, and girls rushed into marriage to relieve economic stress in the home. He believed, like the early boosters of the silk industry, that it was necessary to find productive employment for the female population.[32]

A conservative writer, Roberts attributed much of the unrest in the region to the ignorance and shiftlessness of new immigrant populations. He believed that mining was disagreeable work and that the more intelligent and ambitious males eventually left the region

to pursue a better life. This led to a decrease in the Anglo-Saxon population. New immigrants, Italians and Slavs whom Roberts viewed as "foreigners," rushed in to replace Irish, Welsh, and English workers. Roberts viewed these new immigrants as inferior in intelligence and ambition.[33] Unfortunately many labor leaders and reformers of the time, including Powderly and Mother Jones, shared Roberts' fear that new immigrants would crowd out established workers, bringing down wages and the standard of living.

Troubled times followed the victory of 1902–3. The depression in 1903 brought pressure for wage reductions in the coal industry. A conciliation board settled disputes with owners in the anthracite region, and miners did not always agree with its rulings. Disturbed by a decline in UMWA membership, Mitchell toured the region in summer of 1905. His charismatic presence helped lift membership from thirty-four thousand to eighty thousand. In August he addressed 150,000 people at Wilkes-Barre with President Roosevelt on the platform.[34]

By 1906, divisions within the organization threatened Mitchell's leadership position. Membership numbers fluctuated. After rancorous debate in 1906, the miners renewed the 1903 agreement with little or no change.[35] This was a modest victory over owners anxious to reduce wages, but Mitchell's power was declining. Among his strongest critics was Mother Jones, who opposed the 1902 settlement, believing that Mitchell had capitulated to economic and political forces unfriendly to labor.[36]

In 1908 Mitchell stepped down as president of the UMWA and incurred the wrath of militant unionists by accepting employment with the National Civic Federation (NCF). Mitchell's affiliation with the NCF, which began before the 1902 strike, is an important indicator of his character as well as an omen of the future of unionism. According to historian David Montgomery:

> In its heyday [1902–05], the NCF offered a means of settling disputes that was less hazardous than reliance on sympathy strikes and boycotts, and it also imported into industrial controversies the businessmen's style of dealing with one another.[37]

Mitchell felt comfortable dining and fraternizing with captains of industry, but other union members viewed this as treachery. In 1911 he resigned from the organization under pressure from the union. In subsequent decades, as the political climate changed, labor leaders would again hobnob with business tycoons and presidents as Mitchell had done.

Despite disagreements with some of his associates, he never gave up his ties to unionism. In 1910 he became an officer in the Militia of Christ for Social Service, a group of Catholic trade unionists pledged to uphold "the Christian order of society and its progressive development."[38] Between 1911 and his death in 1919, he was active in the National Child Labor Committee and the national Women's Trade Union League, among other organizations.[39]

Long after he led the great strike of 1902 and after he retired from leadership of the UMWA, John Mitchell influenced the thinking of workers in the region. Whenever he visited the anthracite fields, men, women, and children would parade in his honor, carrying banners proclaiming him "Our Lincoln".[40] As Lincoln had become a symbol of freedom for black slaves, Mitchell became a symbol of liberation for anthracite miners, whose union freed them from the total domination of the coal bosses. Like Lincoln, however, Mitchell was a somewhat reluctant and conservative liberator. He feared socialism and rejected the militancy of the Industrial Workers of the World (IWW), whose members were called "Wobblies." Like Powderly, he clung to a belief that hardworking individuals could win wealth and success within the framework of American capitalism. He never viewed himself as an enemy of the bosses. Even during the 1902 strike he approached, cajoled, wooed, and finally won concessions from the business establishment.[41]

In many ways, Mitchell was a tragic symbol of the beleaguered workers of the hard-coal region. A gentle man who suffered from persistent health problems, Mitchell did not fit the image of the labor hero. More a conciliator than a fighter, Mitchell used speech to inspire compassion. He had genuine sympathy for the young boys who worked in the coal breakers, and he made it a crusade to get them into the schools. Even when more militant leaders pushed him aside, he moved his fellow UMWA members to tears with stories of suffering children in the mines. After his farewell speech in 1908, he left the convention hall with miners chanting, "God bless you, John."[42]

Mother Jones and John Mitchell provided female silk workers with a mother figure and a father figure. By example, Jones taught them that women could be outspoken and militant. By her words though, she taught them that they needed and deserved the loving support of their fathers. John Mitchell showed them that labor unity and militancy could work, that they could stand together for justice. But he also provided a powerful image of a compassionate father who could carry their burdens for them. In coming years, however, many of them would come by choice or necessity to take up their own burdens.

4

Family Loyalty and the Labor Protest

She stood among the surging crowd
 that lined the ancient street,
Where Labor's hosts by thousands
 marched with steady, tireless feet.
Her hair was wavy golden when the
 truant sun shone out;
Her lips had not forgotten yet their
 rosy baby pout.
Her little feet were tapping as the
 band went booming by;
The silver-flowing tide of men
 she watched with eager eye. . . .

"There's papa; there he comes!" she cried.
 Her voice was like the trill
Of birds that sing in June; then flute-like,
 clear and shrill,
"Here, papa, here I am!" she called
 and then the little miss
With dainty fingers touched her lips
 and wafted out a kiss.

The man was tall and big and strong,
 his muscles stood like steel;
But deep within his mighty chest his
 heart knew how to feel;
A smile was on his bearded lips; a tear
 shone in his eye;
He gently waved his massive hand as
 he went marching by.

<div align="right">

—John M. Hull,
United Mine Workers' Journal,
30 October 1902

</div>

John Brophy, Pennsylvania miner and UMWA leader, learned his craft in the early twentieth century at his father's side. He took pride in his father's skill at handling the pick and shovel, his good judgment in keeping the workplace safe, and his courage in facing danger. Awareness of danger was in Brophy's words, "the over-all condition which control[led] his life."[1] Miners' craftsmanship gave them a sense of pride and independence. Their dangerous work made them feel powerful but also vulnerable, and fostered feelings of solidarity. Brophy compared miners to sailors, who toiled together in close quarters at the mercy of grand and hostile natural elements. The difference according to Brophy was that sailors were isolated for long periods in a world of men, but miners spent part of their day in their own communities with their families.[2] In the anthracite region, worker solidarity and workers' protests developed in a context of family life.

John Bodnar studied workers in the anthracite region and found that family ties were stronger than, and sometimes undercut, loyalty to the union.[3] Ardis Cameron, studying Lawrence, Massachusetts, discovered that the behavior of laboring women had meaning and coherence only in the context of family and community life.[4] Bonds among workers were strong, but family relationships were stronger. Both male and female workers could be aroused to militancy or dissuaded from it by their perception of their families' needs.

Many of Pennsylvania's silk workers lived in the families of miners or other workers in industries dependent on the coal mines. Daughters did not go down into the mines, but daughters as well as sons lived in the miners' world. They saw fathers and brothers come home grimy and exhausted. They could not help but observe the pride, fear, and solidarity that characterized the miner's life. They lived through the strikes and not always as spectators, but as vocal supporters of the men's protests. Sometimes they engaged in protests of their own.

In the early years of the twentieth century, silk workers continued to strike for better wages. When employees of the Empire Silk mill at Simpson, just outside Carbondale, walked off their jobs in the spring of 1903, various leaders stepped in to settle the dispute. The Empire weaving mill was a customer of the Klots Throwing Company, therefore mill superintendent Marcus Frieder took an active interest in ending this strike. Frieder acted as an intermediary between the managers of the Empire mill and local leaders of the UMWA, who intervened on behalf of the silk strikers. Through these negotiations, workers won their half-holiday but no increase in pay. Managers accepted no loss in granting the half-holiday be-

ause the workers earned wages on a piecework basis.[5] This negoti-
ted settlement reflected the tendency of the UMWA, under
Mitchell's influence, to cooperate with management, although
ome labor leaders called for more class-conscious protests.

The longest and most widespread strike in the Pennsylvania silk
mills began in July 1907, when thousands of operatives, including
many boys and girls between twelve and sixteen, walked off their
obs. Summer heat helped instigate the protest, which focused on
the length of the working day. As a reporter for the *Scranton Re-
ublican* admitted on 25 July:

> The main question in the trouble is the time.
> Ten and a half hours in a hot mill on a sultry day
> is more than any child of tender years can endure,
> the strikers claim.[6]

The question ignored by the reporter, peculiarly, was how many
hours in a hot mill on a sultry day should a child of tender years
endure?

Silk mill managers continued to insist that the demand for an
eight-hour day, even for children, would drive them into bank-
uptcy. The Klots mill in Carbondale operated on a six-day, fifty-
even-hour work week (ten hours on weekdays and seven hours on
Saturdays).[7] The average work week for Pennsylvania and New Jer-
ey silk mills was fifty-five hours.[8] Manufacturers argued that they
ould not grant the eight-hour day and continue to compete with
mills in other states that operated on ten-hour shifts. Some mill
managers reportedly believed the strike was part of a temporary
"epidemic" of unrest and would soon die out.[9]

The strikers, many of whom were women and girls, remained
peaceful and committed to their purpose. The *Scranton Republican*
ommented on the orderliness of the strike and noted that its leaders
vere "girls," who pushed for an eight-hour day. On the early dem-
onstrations in Scranton the newspaper commented:

> The girls who are leading the movement for an eight hour day are advis-
> ing their fellow workers to maintain the strictest order. It is mainly
> through their efforts that no disorder has prevailed. Outside of the girls
> gathering in groups, one would hardly know that a strike involving close
> to 2,000 girls and boys was in progress."[10]

By August the strike had spread to more than twenty-five mills in
Lackawanna and Luzerne counties. First to leave their jobs were
more than six hundred employees of the Sauquoit Mill in Scranton.

Other Scranton mills on strike were the Alfred Harvey mill, Benare mill, Black Diamond mill, Simpson mill, Renard mill, and the Scranton branch of the Klots company. The strike spread rapidly to other towns in the anthracite region including Olyphant, Mayfield Dunmore, Dickson City, Wilkes-Barre, and Taylor. In Carbondale the employees of the Empire Silk Company and the Klots Throw ing Company walked off their jobs. In all the strike involved more than five thousand silk workers.[11]

During this strike many workers joined the United Textile Work ers (UTW), a union established in 1900 and associated with the American Federation of Labor (AFL). National president John Golden sent organizer Harry Miles to the region late in July to as sist local organizer Hugh Frayne. Holding mass meetings in Scran ton, these men organized employees of the Harvey, Klots, and other mills. One reporter, commenting on a union meeting, noted:

> At the meeting yesterday afternoon, one might well be struck with the needs of the girls—for girls they were, and more on the order of chil dren than girls even—for a vacation. Peaked face girls in short dresses sat side by side with young ladies robust and strong and seemingly well able to undertake the arduous work of silk weaving, and everyone pres ent was enthusiastic for organization.[12]

UTW organizer Miles also noted and decried the prevalence of child workers in the mills. He estimated that seventy-five percent of girls working in the Pennsylvania silk mills should not have been there because they belonged in school. "They should be at school," he said, "in the playground enjoying God's sunshine."[13] Miles ar gued that the years between fourteen and sixteen were the most im pressionable years of a girl's life and that they should be spent learning and growing. He described conditions in the silk mills as detrimental to the girls' physical and mental health. Work in these mills, he said, was bad for a man, worse for a woman, and "positive slavery for a girl of tender years."[14] He expressed confidence that unions would be able to rescue young girls from the mills—not im mediately—but ultimately.[15]

Miles' stated intention of unionizing young women and then "rescuing" them from the mills reflected the ambiguous attitude of the AFL's unions, including the UMWA, toward female workers Skilled male workers feared that the availability of female labor would lower male wages. Unskilled and unorganized women posed the biggest threat. Employers took advantage of cheap, docile labor Organizing women workers might save them from the worst form

f exploitation. The ultimate goal, however, was to "save" them
om participation in the workforce. This was the way to preserve
mily life and also save the male laborer from cheap competition.
lixed with self-interest was a real desire to protect women from
tolerable and dehumanizing conditions in the mills.[16]

By mid-August the *Scranton Republican* reported that the strike
as no longer a spontaneous, undisciplined effort. "Every silk
orker between Carbondale and Forty Fort is now a member of the
nited Textile Workers."[17] This was not entirely bad news for man-
gement and for the business community. The UTW was a conser-
ative union that sought compromise with management whenever
ossible. In support of this conservative position, UMWA locals
rew their support to the strikers and eventually helped to push
rough a negotiated settlement.

The unions, the silk manufacturers, and the frightened communi-
es compromised to settle the strike by arbitration. Right Reverend
Monsignor T. F. Coffey, pastor of St. Rose of Lima Church in Car-
ondale, agreed to act as arbitrator. The AFL organizers accepted
s decision as binding for at least the next two years. The Harvey
nd Simpson mills had already granted strikers a fifty-four-hour
eek and a readjustment in wages. Workers, organizers, and other
embers of the community may well have been frightened by the
ated intention of the Bliss Silk Throwing Company to move its
erations out of Pennsylvania.[18] In any case the arbitrated settle-
ent ended the strike, sent workers back to the mills and granted
em a fifty-four-hour (six-day) workweek.[19]

Not everyone accepted this conservative form of unionism. In
05 Mother Jones signed the manifesto that proclaimed the cre-
ion of the Industrial Workers of the World (IWW), a radical work-
s' organization. The manifesto denounced the AFL and called for
e union of all industries, uniting skilled and unskilled labor.
other Jones soon distanced herself from the Wobblies, whom she
ewed as too extreme and too visionary. But the IWW flourished
the early years of the twentieth century and opened up union par-
cipation to ethnic and racial minorities who had never participated
fore. Elizabeth Gurley Flynn joined the IWW as an organizer in
06, but even this radical group sent mixed messages to female
orkers. The Wobblies criticized the AFL for excluding women,
t also asserted the importance of keeping women in the home.[20]

The high-water mark for the IWW was the successful strike of
xtile workers in Lawrence, Massachusetts in 1912. In January of
at year a group of Polish women walked out of a mill to protest
ductions in pay. By mid-January twenty-five thousand operatives

of many different nationalities had walked out, showing solidarit
with the women. IWW organizers rushed to Lawrence when th
strike was in progress. Joe Ettor and Big Bill Haywood used fir
eloquence, and organizational genius to guide and strengthen an a(
tion that already had strong support in working-class neighbor
hoods.[21] National publicity exposed police brutality and inspire
sympathy for the strikers and their children. In mid-March, mi
owners capitulated, offering a twenty-five percent increase for th
lowest-paid workers.[22] The IWW gained ten thousand member
more than sixty percent of them women, in Lawrence,[23] and pr
pared for new battles in the textile industry.

After the victory in Lawrence, the IWW burst into Paterson t
support a spontaneous walkout that began in late January 1913 .
the Henry Doherty Silk Company. Within a month more tha
twenty-five thousand silk workers left their jobs. By June a grou
of Greenwich Village intellectuals had persuaded one thousar
workers to plead for their cause in an artistically triumphant but t
nancially unsuccessful pageant at Madison Square Garden. Em
tions swirled to a crescendo as Paterson police arrested leaders ar
brutishly attempted to quell the strike while mill owners stubborn
refused to negotiate.[24]

Leaders of the IWW, which had its greatest strength in the We
and Midwest, tried and failed to mobilize silk workers in Pennsy
vania. Previous IWW drives had organized some Pennsylvan
steelworkers, but by 1913 the "one big union" idea was dormant
the state.[25] Some Pennsylvania silk operatives including Hazlet(
weavers and Allentown dye workers did walk off their jobs. B
most continued to report to the mills. The great Paterson strik
ended in the summer of 1913 when hungry strikers could hold o
no longer. Paterson mill owners, many of whom owned branch fa
tories in Pennsylvania, claimed the victory.

Paterson strike leader Elizabeth Gurley Flynn attempted to an
lyze the strike's failure on 31 January 1914 in a speech before th
New York Civic Club Forum. One of the problems, she stated, w
the fact that there were so many mills and mill owners in Paterso
There was no single common enemy upon which to make a dire
attack. Secondly, she said, many of the owners had annexes
Pennsylvania:

> 300 manufacturers, but many of them having annexes in Pennsylvan
> meant that they had a means whereby they could fill a large perce
> age of their orders unless we were able to strike Pennsylvar
> simultaneously.[26]

But most of Pennsylvania's silk workers remained on the job throughout the Paterson strike.

Scranton's newspapers gave scant attention to events in Paterson. On 17 May the *Scranton Truth* printed an article stating that members of AFL unions would not support the strike and that it was "very unlikely that the strike [would] be successful."[27] On 7 June 1913 the *Scranton Times* and the *Scranton Truth* each printed brief articles on inside pages about the pageant in New York City. Each article noted the dramatic presence of Hannah Silverman, the seventeen-year-old "Joan of the Silk Strike."[28] The *Scranton Republican* did not cover the event. There was no Carbondale newspaper at that time. In general, northeastern Pennsylvania workers remained unaware of or unmoved by national publicity and the attempts of leaders to win their support.

Why did Pennsylvania's silk workers decline to join the strike? They were certainly no less and possibly considerably more aggrieved than Paterson's workers. Wages in Pennsylvania were lower and working hours were longer.[29] Many Pennsylvania weavers tended four looms at a time. When mill owners attempted to introduce the four-loom system in Paterson, workers balked. This innovation helped trigger the great strike.[30] Why did it not cause the same reaction in Pennsylvania?

Were Pennsylvania's silk workers simply more docile than those in Paterson? In explaining the failure of the strike, some analysts have argued that because so many of Pennsylvania's workers were young and female they were disinclined to join the struggle. History undermines this argument. Young female workers and even children went out on strike in 1901 and 1907. If anything, the workforce in 1913 was older and theoretically more likely to take decisive action. In any case, as Ardis Cameron has shown, women are quite capable of radical action.[31]

If silk workers in the anthracite region were willing to take direct action in 1901 and 1907, why did they continue reporting to the factories throughout the troubled winter, spring, and summer of 1913? Wages and working conditions are not the answer. Gender and age cannot explain the workers' decision not to take action. The answer must lie in the history and culture of the anthracite region and the Lehigh Valley.

The great anthracite coal strikes of 1900 and, more dramatically, 1902, had a powerful, unifying effect on the region. During the 1902 conflict between labor and capital, struggling families witnessed a massive uprising of working men, a powerful appeal to unity by a young and earnest leader, and a full-scale government

investigation that brought to the courthouse in Scranton a cadre of famous lawyers and commanded the attention of President Theodore Roosevelt. This was a compelling drama. No matter that the final settlement brought only modest gains to the miners and their families. The workers won a highly publicized and exceedingly precious victory. In the minds of the miners and their families, UMWA president John Mitchell symbolized that victory.

For many years the union and especially Mitchell retained the loyalty of anthracite families. Even though UMWA membership declined, the union maintained a strong presence in the region, playing an important role in resolving disputes. In some cases union officials prevented strikes. At other times they provided relief to strikers and often helped negotiate settlements.[32]

There were strong emotional ties to Mitchell. Annually on 29 October, John Mitchell Day, miners in the region stayed off the job, sacrificed a day's wages, and celebrated victory (in the earlier strike of 1900) with huge parades.[33] Men, women, and children came out *en masse* to honor Mitchell. Photographs in Mitchell's personal papers show huge crowds lining city streets as horses, carriages, bands, and marching columns of union men paraded.[34] According to historian William J. Walsh, children carried banners proclaiming him "Our Lincoln" and "Hurrah for John Mitchell, he sent us to school."[35] In 1908, Mitchell himself asked the anthracite miners to restrain the celebrations, which he feared were costing them money they could not well afford.[36]

These annual dramas reminded working families of their victory and reinforced feelings of solidarity among union men, their wives, sons, and daughters, and also provided a dramatic form of entertainment for hardworking men, women, and children. Ironically the dramas may have dissipated some of the anger workers felt about low wages and poor conditions by creating a holiday atmosphere and glorifying a victory that resulted in only minor gains for working families. The men who paraded wore their best suits, and young girls came out in their Sunday dresses. The power of these spectacles could hardly be lost on young silk workers, who lived in the households of the heroes on parade.

Of course there were challenges to Mitchell's dominance. Mother Jones became his bitter enemy. John Brophy, who was learning his craft and rising to power in the early twentieth century, would become a radical voice in the UMWA in the 1920s. By that time, however, John L. Lewis, a Welshman from the Midwest, had taken control of the union with Brophy as his severest critic. Lewis lacked

Mitchell's gentleness and compassion but shared his willingness to compromise with corporate power.[37]

In 1913, silk workers in Hazleton tested the power of the miners' union. When twelve hundred workers walked out of the Duplan silk mill in Hazleton in February 1913 during the Paterson strike, both the IWW and the UTW responded to calls for help. UTW organizer Sara Conboy and IWW organizer Frank Daniels addressed the strikers at several meetings. On 16 February, IWW executive board member Ewald Koettgen drew attention to the fact that Paterson workers earned nearly twice as much as Pennsylvania workers in similar occupations. He urged the workers to demand uniform wages. If they did not do so, he said, competition would bring Paterson's wages down.[38] By 12 February the majority had voted to join the IWW.[39]

Hazleton differed in several important ways from other towns in the region. Strip mining occurred extensively in the Hazleton vicinity and the work process differed from that in underground mines. Workers followed behind a steam shovel to drill and load the exposed coal. Immigrants and their sons predominated in the workforce. Company towns, company stores, and company housing were much more common there than elsewhere in the coal region. Strip-mine workers in the Hazleton area initiated the labor insurgency that led to the Lattimer Massacre, when law enforcement officials killed nineteen immigrant workers in the fall of 1897.[40]

In 1913, Hazleton officials reacted quickly to quell the silk strike. Duplan management threatened to close the mill and stoutly refused to negotiate with IWW leaders. Machinists and loom fixers backed management by condemning the strike. Daniels' rhetoric of class struggle brought criticism from the press. After a scuffle on the picket lines on 28 February, police arrested him for disorderly conduct. Local clergymen vehemently condemned the IWW's use of picketing, verbal abuse, and, supposedly, violence.[41]

Amid rising passion, legendary IWW leader Bill Haywood addressed a public meeting in Hazleton on 16 March. The next day a group of pickets attacked several skilled workers with stones and clubs. Police arrested nine young women, who shouted to the crowd that "iron bars could not stifle their freedom." Mass picketing continued for several more days in an atmosphere of menacing tension.[42]

At a raucous meeting on 21 March, Haywood criticized the UMWA and Sara Conboy accused Haywood of replacing the American flag with an anarchist banner. The crowd, supporting the IWW, hissed and yelled at Conboy and cheered Haywood when he de-

claimed that "our flag symbolizes the red blood that flows through the veins of the working class, which will ultimately mean emancipation from wage slavery. We will not scab under the American flag." This meeting was a victory for the IWW, but its effects were only temporary.[43]

Behind the scenes, Hazleton citizens, UMWA officials, and AFL textile leaders held meetings and discussed possible ways to end the strike. The local clergy and press supported these efforts by constant criticism of the IWW and its methods. By the end of March Sara Conboy had returned to Hazleton and enrolled more than four hundred strikers in the UTW. Her organizing efforts stressed loyalty to God and the flag, and appealed to conservative members of society including the clergy.[44]

Scranton newspapers offered little or no coverage of either the Paterson or Hazleton strikes. On 2 April the *Scranton Truth* reported that IWW strikers in Paterson were considering accepting support from the AFL even though in the past the two organizations had been adversaries. The article contained an ominous quotation from Adolph Cohen, a Paterson mill owner, threatening to move out of Paterson rather than dealing with radical unionists. Cohen reportedly stated:

> We cannot recognize this organization [the IWW]. They are being led by insane anarchists and Socialists. They don't know what they want. We will keep our mills closed forever and go into another state or business before we give in to them.[45]

The same issue of the same newspaper reported that Scranton's board of trade had persuaded a New York company to open a new silk weaving mill in Scranton.[46]

On the following day the *Scranton Truth* reported that the silk strike in Hazleton had come to an end. After ignoring the strike in previous issues, the paper devoted one column inch to the news that twelve hundred operatives would return to the Duplan silk mill the following Monday. The paper reported that the employees would receive pay raises of from ten to thirty percent and a reduction in working hours from fifty-eight to fifty-five hours per week.[47]

While picketing continued, workers began returning to the mill and the UTW negotiated with Duplan management. Fearing violence, parents accompanied young workers to the mill when it reopened on 4 April. The IWW's famous firebrand, Elizabeth Gurley Flynn, spoke to a meeting on 6 April and called the new contract

the worst she had ever seen. Controversy and agitation continued but the strike was over.[48]

The strikes of 1913 posed a dilemma for families and communities that depended on the silk industry. Families needed the wages of daughters and sons who worked in the mills. Communities were aware of threats by silk mill owners to move plants rather than deal with labor agitation. While Paterson workers stayed off the factory floor, the Scranton Board of Trade busily persuaded a large silk firm to open a plant in Pennsylvania.

Pennsylvania's silk workers had demonstrated a capacity for agitation, but the tendency in Pennsylvania was to settle disputes through negotiation. In 1901 and 1907 silk workers in Carbondale and Scranton had vigorously expressed their dissatisfaction with wages, hours, and conditions. Gender and youth did not prevent them from striking, engaging in demonstrations, and speaking out boldly against management. When they did so, however, they sought and received the support of their fathers, brothers, and neighbors who were members of the UMWA and other craft unions. These men gave their support but not without a price. Essentially the conservative, male unions reined in the passions of the strikers and pushed for peaceful negotiations with management. Mediated settlements resulted in small gains for the silk workers but may have undermined any real possibility of change in the industry.

Paterson was different from Pennsylvania. Silk in Paterson was a primary, not a secondary, industry. Since the 1880s silk weavers and other operatives there had fought the inroads of mechanization, de-skilling, and the cheapening of labor. Many heads of households worked in silk factories. If young single men and women worked as silk operatives, chances were that their fathers did too.[49] Paterson had a strong radical and socialist tradition. In 1913 its workers were prepared to embrace the IWW's militant, political unionism.

The crucial factor influencing the decision of Pennsylvania's silk workers not to join the IWW strike was not that so many of them were young and female, but that so many of them lived in households headed by coal miners or mine laborers. Young males and even adults who worked in Pennsylvania's silk mills tended to live at home with their parents and contribute to the support of their families. By taking jobs in the mills and bringing home their wages these young men and women expressed great loyalty to their parents and siblings. It would have been difficult for them to put aside this loyalty and join the IWW in the face of parental opposition.

Family loyalty outweighed self-interest among many of these workers. A young woman who put off marriage in order to help

support her parents was not likely to disavow her parents and join
the IWW. Young workers in Hazleton briefly embraced the IWW
message, but parents and community members intervened to bring
them back to the UTW and UMWA fold. Rebellious young workers
soon returned dutifully to their jobs (often escorted by mothers and
fathers, fearing Wobbly violence) and accepted a negotiated settle-
ment. Other young men and women in other Pennsylvania towns
simply declined to participate in a strike that had such dangerous
potential to divide their families.

Was this behavior the result of harsh domination by unsympa-
thetic fathers or heartfelt family loyalty among young female silk
workers? Some feminist historians such as Heidi Hartmann have
described all modern economic, social, and familial relationships in
terms of an implacable and unyielding patriarchal power structure.
Seen in this light, the aforementioned poem "Papa on Parade"
would be a cynical piece of propaganda aimed at manipulating the
emotions of young girls. But the poem's emotional message was
double-edged. Yes, the poem suggested that young girls should ad-
mire and be submissive to their fathers. But the poem also placed a
huge burden on fathers to cherish and protect their female children.

In real life neither the father nor the daughter could conceivably
live up the poem's ideals, although in many cases it seems that
fathers and daughters tried to do so. Although some fathers shirked
their duty, most men in the coal regions stayed with their families
and attempted to support them despite the economic odds against
them. Conversely, many daughters in northeastern Pennsylvania
dutifully brought home wages in an attempt to shore up an econom-
ically endangered family.

Pennsylvania coal miners' daughters resisted radical unionism.
They stayed in the mills in 1913. Several years later another strike
in the Lawrence textile mills gave birth to a new labor organization,
the Amalgamated Textile Workers of America (ATWA). The ATWA
castigated the UTW for its complicity with management. Silk
workers in Allentown and Reading, two industrial towns on the Le-
high River on the southern edge of the anthracite region, joined the
ATWA and engaged in strikes in the early 1920s,[50] but the anthra-
cite region remained quiet.

Coal miners, according to John Brophy, had a strong sense of
solidarity but they also had deep feelings of pride and individuality.
The qualities Brophy admired in his father included skill and judg-
ment and the control he had over his own immediate work environ-
ment. He depended upon ventilation systems and the general safety
of the mine, but it was up to him to set the pace of work, make the

proper use of explosives, and place the timbers to shore up the roof.[51] Miners could band together for mutual benefit. But the experience of mining gave them a tendency toward self-reliance and the desire to pull themselves up by their own bootstraps. Powderly expressed this feeling and could never separate himself from the American ideology of self-help.

Family loyalty and the ideology of self-help militated against radical unionism but gave young silk workers the strength to work, help their families, and find other roads to a better life. Radical change did not come to the Pennsylvania silk industry in 1913, but change did come. Gradual change can have a revolutionary impact on the lives of communities. In the early twentieth century, young female silk workers were poised for a different kind of revolution.

5
The Progressive Era Campaign Against Child Labor in the Pennsylvania Silk Mills

> Is it not strange that in this costly silk,
> As exquisite as a flower, I should be sad?
> —Florence R. Mastin, *The Masses*, June 1916

A poet writing for *The Masses* in 1916 contemplated her silk dress and described a vision of innocent young girls laboring in factories to create the elegant bodice adorned with artificial flowers. With unabashed sentiment, Florence Mastin wrote:

> Last night I dreamed And now I know . . .
> *They* came, —
> A ghostly crowd of girls with eyes too bright
> And wistful—Ah! I could not hide my tears!
> One child, as vivid as a slender flame,
> Was fashioning June roses with her shears.
> Their crimson petals left her young lips white.[1]

In iambic pentameter the poet expressed middle-class discomfort with the knowledge that production of a wide array of consumer goods depended on children's labor. This discomfiture had its origins in a disturbing conflict between a romantic view of childhood and the demands of material progress. By focusing on her silk dress, the poet also drew attention to her own status and gender, raising questions about her own place in a society that put young females to work in industrial plants.

The poet's crisis of conscience dramatized a tendency to define child labor as a moral issue. Catholic leaders viewed many labor issues as belonging to the moral realm. In the late nineteenth century, Pope Leo XIII had issued an encyclical "On the Condition of Labor" in which he disapproved of child labor and asserted the

right of every adult male worker to a wage "sufficient to support him in reasonable and frugal comfort."[2] Many Catholic clergymen extended this position to encompass a family wage, insisting that the employer had a moral obligation to pay the working man a wage that would maintain himself and his family. Assuming that employers had a vested interest not only in the subsistence but in the self-propagation of the worker, employers had a rational reason to support the worker's family. Appropriate wages had to reflect the normal conditions of human life, and according to the Catholic position, "These suppose the laborer to become the head of a family."[3]

John A. Ryan, interpreting the Catholic position in 1906, attempted to define the term "living wage" as a wage that would provide food, clothing, and shelter for the laborer and his family until his children reached sixteen years of age or became self-supporting. Ryan assumed that the wife of the laborer would not engage in

Schoolhouse at Scranton, ca. 1900. Photo courtesy of Pennsylvania Historical and Museum Commission, Bureau of Historic Sites and Museums, Anthracite Museum Complex, MG 369.

work outside the home and neither would his children before age sixteen. Furthermore, a living wage should provide opportunities for amusement, recreation, education, religion, and some kind of insurance against accidents, sickness, and old age.[4]

A wide array of people from settlement-house workers to union organizers joined the crusade to end child labor. Jane Addams of Hull House and Florence Kelley of the National Consumers League denounced child labor on humanitarian grounds and portrayed child workers as stunted in body and spirit.[5] Mother Jones, eloquent spokeswoman for the United Mine Workers, described child workers as slaves of capitalistic greed.[6] As the movement to end child labor grew stronger, this diverse group of supporters generally agreed upon the central idea that all children belonged in school and not in the workplace.

Francis H. Nichols' articles on Pennsylvania's child workers described industrial labor as a danger to children's developing character. He put forth a bleak view of childhood in anthracite towns where the coal breaker and silk mill dominated the landscape. His "Children of the Coal Shadow" traded their young dreams for pay envelopes and union cards at tender ages. The breaker boys and the silk mill girls eagerly joined unions and steadfastly attended meetings. They proved themselves by going on strike. Labor leaders called it "asserting their manhood." But girls as well as boys engaged in this activity. Their gender as well as their youth inspired Nichols' indignation.[7]

Schoolhouses in Pennsylvania's hard-coal region sometimes served as union halls, a concept that Nichols found abhorrent. He believed schools should teach middle-class values, not union ideology. The "Children of the Coal Shadow" certainly did not conform to the Victorian idea of well-scrubbed, pampered children reciting their lessons, gamboling in gardens, and saying their nightly prayers. These children were unschooled, unruly, unwashed, budding unionists. Nichols' article in *McClure's* clearly expressed the idea that these young people needed a public-school education to save them from the union's corrupting influence. [8]

Labor leaders were more likely to agree with Nichols' argument than subvert it. Unions opposed child labor for both humanitarian and practical reasons. The American Federation of Labor, founded by craft unionists in 1886, viewed child labor not only as a social evil but as an economic force that increased competition for jobs and put a downward pressure on wages. Child labor was cheap labor. With increasing mechanization, employers often chose to

hire unskilled children and adolescents instead of skilled adult workers.

While generally reluctant to take political stands, the AFL came out stridently against child labor. In May 1903 the *American Federationist* published an article by William S. Waudby, a special agent for the United States Department of Labor. Waudby reported that there were more than 1,750,000 child workers in the United States. Pennsylvania, he stated, did not enforce its child-labor laws. Little girls in the silk mills worked for what he termed the "miserable pittance" of $1.80 to $2.10 per week.[9] In conclusion he insisted, "I say that society owes an education to these children, and they *must have it*; the self-preservation of the human race demands it!"[10]

Mother Jones, a renegade in other ways, agreed firmly with the AFL on this issue. Using her powers as an organizer, she continued to bring the issue vividly to the attention of the American public. In the summer of 1903 she came to Philadelphia to support striking textile workers. When she learned that thousands of the strikers were children, she led a band of young marchers from Philadelphia to Long Island, New York, where President Roosevelt was vacationing. In a letter requesting to meet with the President, she wrote:

> These little children, raked by cruel toil beneath the iron wheels of greed, are starving in this country which you have declared is in the height of prosperity—slaughtered, ten hours a day, every day in the week, every week in the month, every month in the year, that our manufacturing aristocracy may live to exploit more slaves as the years roll by.[11]

Despite this plea the President refused to see Jones and her mill children, and the crusaders returned to Philadelphia in defeat. For more than a month her march to New York kept the issue of child labor in the newspapers of New York, New Jersey, and Pennsylvania.[12]

The UTW urged its members to support the AFL position on child labor and "start agitation in their various localities."[13] Delegates to the union's convention in 1905 adopted a resolution to fight for legislation in all states and "to co-operate with all associations having the object [of] the abolition of child labor."[14] Because of the large number of women and children employed in the textile industry, this union placed special emphasis on political action for protective legislation.

Progressive reformers campaigned for legislation to end child labor. Several organizations lobbied for state laws against the em-

ployment of children. The Society for the Prevention of Cruelty to Children (SPCC), founded in 1875, attacked the problems of vagrancy, homelessness, and child labor. Beginning in 1904 the National Child Labor Committee (NCLC) hired Lewis Hine and others to gather data on children and work. Traveling thousands of miles with his camera, Hine shocked the public with images of boys harnessed to wagons in the coal mines, exhausted young girls tending machines in textile mills, and newsboys sleeping in subway stations. The Pennsylvania Child Labor Association not only worked for legislative reforms but visited school superintendents to check on attendance and truancy.[15]

The NCLC used public disapproval of child labor to win legislative battles. Basing its recommendations on existing laws in Massachusetts, New York, and Illinois, the committee urged a minimum age of fourteen for employment in manufacturing, sixteen in mining. In the first two decades of the twentieth century nearly every state, including Pennsylvania, passed legislation setting a minimum age for employment (which varied from twelve to sixteen) and regulating hours and conditions for young workers. Pennsylvania's child-labor bills required proof of age and employment certificates for young workers. The statutes also excluded illiterate children under sixteen from certain jobs, prohibited night work for males under sixteen and females under eighteen, and limited working hours for young people to a ten-hour day and a fifty-eight-hour week.[16]

As pressure for reform increased, community leaders who had welcomed the silk mills to the anthracite region faced a painful dilemma. Agitation against child labor threatened the local economy. Successful campaigns to reduce or eliminate child labor in states other than Pennsylvania had resulted in a loss of needed industries. In New England for example, reformers had won battles for protective legislation that applied to female and child workers. One unfortunate result of the victory was the movement of cotton mills to the southern states. Silk strikes in the Scranton area in 1901 and again in 1907 brought threats from mill owners to leave the region.[17] These were not idle threats. Labor troubles in New Jersey had prodded silk mill owners to move their operations from that state to Pennsylvania.[18]

Books and articles continued to expose labor conditions in the silk industry. In his 1909 book, *The Bitter Cry of the Children*, socialist John Spargo cataloged the evils of child labor and pressed the cause of compulsory education. Of work in the silk-winding mills, Spargo reported that the hot, moist atmosphere required to

keep the fibers supple frequently caused the mill girls to faint. Children working in dye shops often had their skin permanently stained with toxic substances. But the moral atmosphere of the factories, according to Spargo, was at least as poisonous as the physical environment.[19] A prominent illustration in his book depicted a young female silk worker with a sullen, work-hardened expression on her face.

Spargo contrasted twentieth-century child labor with traditional forms of apprenticeship and domestic industry. The advent of machine production had altered the relationship of children to their labor. Work in factories did not prepare young people for a productive life. Spargo insisted:

> On the contrary, it saps the constitution of the child, robs it of hope, and unfits it for life's struggle. Such child labor is not educative or wholesome, but blighting to body, mind, and spirit.[20]

Journalist Florence Sanville, who went undercover in 1910 to expose conditions in the Pennsylvania silk mills, censured parents for failing to keep their children in school. The law was powerless, she asserted, because parents pushed their offspring into the breakers and the mills at an early age. Although new statutes against child labor offered some protection and school officials fought to keep children in classrooms, working-class parents often pressured their offspring to earn wages. Boys often went into the coal breakers, girls into the silk mills. Sanville wrote:

> For those children whose teachers are persistent enough to hold them within the protection of the law the possibilities of school life continue until they are fourteen; for others—and in Pennsylvania these have numbered uncounted hundreds—at eleven or twelve years old the way is blocked, brutally and impassably, by an eternal succession of days and nights of toil.[21]

Sanville, a moralistic and earnest woman, studied silk workers and their families for two summers and published accounts of her experiences in 1910. As a crusading journalist she went undercover and obtained jobs in silk mills. She found the labor numbing and the working conditions oppressive. Most silk mill hands worked ten- or eleven-hour shifts with only a brief lunch break. Even during this break many silk workers could not escape the noise of the machinery because the factories often had no lunchrooms.[22] In many mills employers provided no seats at all on the theory that the opportunity to sit down encouraged laziness. Some mill owners

painted the windows shut, excluding any possibility of relief from summer heat.[23] Long, exhausting shifts left young female workers with little energy for intellectual or spiritual recreational pursuits, although mill girls did engage in a variety of social activities. After ten or eleven hours of standing at a machine, Sanville noted that some young women wanted only to soak their feet in a basin of water and drop into bed.[24]

Sanville presented a Dickensian picture of life in Pennsylvania's anthracite coal mining towns. In stark terms she described the spiritual damage caused by the grim surroundings, the skeletal coal breakers, the huge piles of waste coal, the stark mills, the sooty streets, the poorly built and haphazardly scattered houses, the railroad yards, and the ubiquitous saloons.

Working girls found little solace in their home life. Houses were often cramped and crowded. Conditions of sanitation and hygiene shocked the middle-class observer. The girls often washed in small basins of cold water, which were shared by large families. In some homes, males and females took their baths in the kitchen. Dental hygiene was practically unknown, as were dentists. Toothache was a common problem. Most women over thirty had false teeth.[25]

Despite these conditions, the silk mill girls shared active social lives, a lively camaraderie, and a sense of personal freedom that surprised Sanville. During breaks and quiet periods at the factory, the girls passed the time by gossiping, talking about their social lives and their "fellers" (boyfriends) in ways that shocked the middle-class reformer.[26] After working hours, a mill girl might find fun and companionship at ice cream parlors and other gathering places. Even silk mill workers who lived in small towns had wide opportunities for leisure activities. Streetcars connected most of the cities, towns, and villages of the anthracite region, offering the chance of escape to theaters, parks, and dancing pavilions.[27] Such unsupervised recreation, Sanville feared, might "stunt her youth and foredoom her womanhood."[28]

Historian Kathy Peiss studied the leisure activities of working-class women in New York City in the late nineteenth and early twentieth century and found that young single wage-earning women sought and enjoyed commercial leisure activities that remained unavailable to homebound married women. Earning their own money gave them some discretion over leisure-time spending. Friendships made on the job carried over into associations with other women, and single men, their own age.[29] Some working women, Peiss found, used leisure activities to "express a sense of personal independence, sensuality, and the rejection of parental authority."[30]

Sanville condemned the types of recreation offered to young men and women in the coal mining communities. The "nickelettes" or motion picture shows offered cheap entertainment of a "degrading" nature. Dance halls and outdoor dancing pavilions gave young girls the freedom to mingle not only with local boys but also with travelers and strangers. In Sanville's view, these activities may have posed threats to the girls' virtue.[31] Viewed in a different light, these social activities may have given the girls a taste of joy and freedom and helped them to define themselves as independent individuals with lives outside their parents' homes.

In a small mining village, Sanville boarded with a woman named Mrs. Wilson, her eight-year-old son, and her sixteen-year-old daughter Nellie, who worked in a mill. The husband and father, a Welsh-born miner, had abandoned his family, leaving his wife "a gaunt, nervous woman, morbidly absorbed by the subject of her deserting husband."[32] Despite her unhappy circumstances, however, Nellie had courage, buoyancy, and a zest for life.

Nellie took for granted a system of values and a code of behavior that the middle-class Sanville found disturbing. One evening, Nellie explained her mother's absence by matter-of-factly stating that she had gone to attend the forced marriage of a nephew to a girl he had made pregnant.[33] Then cheerfully she launched into an exposition of social relationships between boys and girls, which Sanville forbore to relate in detail. Nellie did say, however, that girls met their male friends outdoors and went with them to movies, dances, and ice cream parlors. This dismayed the visitor, who could not comprehend this "remarkable custom" of free association of the sexes outside the confines of the home.[34] Sanville fretted about Nellie's lack of moral standards, blaming this on her home life.

Although Nellie was sixteen, Sanville viewed her as a child. Nellie's frank speech and lively social life disturbed the middle-class reformer, who believed young girls were fragile, innocent creatures in need of protection. This romanticization of childhood and especially of girlhood prevented the writer from appreciating the strength and independence Nellie displayed in working hard at a job, making friends, and exploring the world around her. The one ray of hope Sanville perceived in Nellie's life was the fact that she had received an eighth-grade education.[35] Keeping girls like Nellie in school for longer periods might instill middle-class values in them they would not learn in the mills and dance halls.

While Sanville fretted about Nellie's moral life, the federal government conducted a systematic study of conditions in the silk industry. The study, published in 1911, exposed conditions in thirty-

six Pennsylvania silk mills. Volume four of the nineteen-volume
*Report on Condition of Woman and Child Wage-Earners in the
United States* clearly demonstrated that Pennsylvania mills relied
on child labor to a far greater extent than the older, more estab-
lished silk industry in Paterson, New Jersey. The 1911 report re-
vealed important differences between the workforce of the silk
industry in the two states. In Paterson's mills, investigators found
that only about seven percent of employees were children under
sixteen years of age. However, in the Pennsylvania mills the survey
reported that more than twenty percent of workers were under six-
teen, and more than seventy percent were under twenty-one years
of age.[36] The Pennsylvania mills also had a much higher percentage
of female workers. Of the female workers in the silk mills of Penn-
sylvania and New Jersey, the vast majority were unmarried. In
Pennsylvania more than ninety-five percent of female silk workers
were single, while in New Jersey the figure was approximately
eighty-two percent.[37]

The study clearly showed that the youngest workers were the
cheapest workers. Silk manufacturers divided the processes of mak-
ing silk thread, silk ribbon, and silk fabric into tasks, and allocated
those tasks to workers according to their age. Wages for the differ-
ent tasks reflected not only complex and elusive variations in skill
requirements, but the age of the workers most likely to perform
those tasks. For instance, broad-silk weavers, mostly adults over
sixteen years of age, earned an average of $7.15 for a fifty-five-hour
work week. In comparison, reelers, many of whom were children
under sixteen years of age, earned an average of $3.80 for a fifty-
five-hour work week.[38]

Child labor was a bargain. According to government figures, the
average yearly wage for adult males was $485.11; for adult females
$345.44; and for minors of either sex, $143.64 at a time when the
average annual rent paid by the head of a household was $165.[39]
Clearly this wage differential made child workers attractive to mill
owners, while the general level of wages made it difficult or even
impossible for a family to subsist on the single income of even one
of the highest-paid operatives.

With a new awareness of social conditions among the nation's
children, the federal government took halting steps to regulate child
labor. In 1912, President William Howard Taft signed a bill creating
the Children's Bureau, a research agency charged with studying
child welfare. Under the leadership of Julia Lathrop, the small,
poorly funded agency investigated infant mortality, poverty, child
health, and children's work. The bureau's campaign to promote

child health was more successful than its crusade against child labor. In 1916, passage of the Keating-Owen Act represented the first federal attempt to legally restrict child labor. Within nine months, however, the Supreme Court declared the act unconstitutional, ruling that it limited freedom of contract.[40]

Government efforts to end child labor met with strong resistance in Pennsylvania and elsewhere. Employers continued to flout state laws and hire young workers. Families who needed the wages of secondary breadwinners filed false affidavits, lying about their children's ages. Many people who opposed child labor in principle refused to support federal legislation against it. Even members of the AFL and NCLC were not unanimously in favor of federal restrictions. The Catholic church, which took a strong position on childhood and the family, opposed federal restrictions on child labor as a possible threat to family autonomy.[41]

While reformers waged their campaign against child labor, silk manufacturers continued to recruit young female workers. On 12 February 1913, during the great silk strike in Paterson,[42] silk mill managers took a stand in Pennsylvania against proposed state child-labor bills. Attorney H. C. Reynolds, representing the spinning and weaving companies of northeastern Pennsylvania, criticized the bills and defended industry practices. Reynolds argued that many plants moved to the state from Paterson because of "labor advantages." Brazenly he contended that youthful workers functioned best in the throwing, or spinning, mills because:

They work with strands of silk as fine as a gossamer web and their fingers tie the broken ends of these strands so perfectly that you and I cannot see the knots. It would work a great hardship on the silk industry to take these young girls out of our plants.[43]

Reynolds scoffed at the idea that regulating working hours and conditions for young workers would increase school attendance. The schools, he said, were already overcrowded.[44]

The National Child Labor Committee studied the silk industry in 1914 and reported on its youthful workforce. In cooperation with the National Consumers League, the NCLC examined the lives of wage-earning girls in Wilkes-Barre, Pennsylvania. Of approximately 256 girls surveyed, 202 were employed in silk and lace mills. General survey results indicated that approximately forty percent of Pennsylvania girls age fourteen to sixteen were employed in industry while sixty percent were in school. The silk industry depended upon girls under sixteen for 12.5 percent of its

labor force. More children of miners worked in industry than children of men in other occupations. Approximately half of the families of the Wilkes-Barre factory girls received less than two dollars per week per capita income. Nearly all the girls' parents made use of the girls' wages. Of the girls' mothers, over eighty percent were at home, and only eleven percent worked outside the home, with the remaining being deceased (5.9 percent) or deserters (0.7 percent).[45]

The Wilkes-Barre study revealed much about the girls who worked in the Pennsylvania mills. Only fourteen percent of the girls reported that they had an opportunity to choose other work. A majority favored dressmaking as the most desirable occupation. But few apparently had this option open to them. Most would have preferred to remain in school, with many expressing the desire to pursue the "business course." But most left school out of necessity to add to the income of their families.[46]

In 1914, Edwin Markham published *Children in Bondage*, an impassioned indictment of child labor. Markham pointed to the silk industry as an exploiter of children. He painted a sad portrait of children forced to work all night in weaving mills. "The children at the frames must stand all night, always alert, always watchful of broken threads, nimble to let no loose end be caught in with other threads."[47]

Like Florence Mastin, Markham painted an idealized portrait of little girls as fragile creatures with wistful eyes. Mill work, he implied, stole childhood away from young girls:

> Nor must any loose curls or dangling braids adorn the heads of the little mill folk. Braids or curls are for the picture-book children, or for the little misses who wear the silk, not for the little workers who spin the silk. Childish things must be put aside by our little army of wage-earning children.[48]

Clearly, Markham envisioned a picture-book life for little girls, even those who might have to grow up to earn a living.

The ogre that threatened these wide-eyed youngsters was the engine of the industrial economy. Quoting Peter Roberts, a critic of social conditions in eastern Pennsylvania, Markham drew attention to the dangers of mill work for tender young women:

> The Rev. Peter Roberts, for years a resident of the anthracite regions, states that he has seen little girls before the silk-frames, their short skirts tied close with string, so that they should not catch in the wheels and drag the child into the jaws of the machine.[49]

Markham's villains included silk manufacturers who hired children, and parents who sent their offspring out to work. He wrote:

> The manager of a silk-throwing plant in South Bethlehem declares: "The coal-fields is the ideal place for a silk-throwing plant. You get rent cheap, and coal cheap, and labor cheap, and parents don't object to having their children work nights."[50]

To Markham's list of rascals, Florence Mastin added consumers who demanded fine textiles and clothing manufactured with child labor. Mastin, unhappy in her silk dress, had a nightmare vision of a young girl:

> Who flashed her slender needle in a dream,
> Looked up at me. Her eyes were dark with pain.
> Then I awoke and it was sunny morn—
> But in the dawn there was for me no gleam,
> —And I can never wear the dress again.[51]

The young girls in Mastin's poem were dreamy, passive creatures like Markham's small angels with golden curls. Other writers like Nichols and Sanville depicted a different sort of working child, feisty, assertive, ready for action, and seeking independence. Mastin's image evoked sympathy. With her portrait of Nellie, Sanville sought to inspire alarm. Sympathy for exploited young laborers was certainly warranted. Even Sanville, however, expressed admiration for Nellie's strength of character. Nellie was no wistful little angel and work had not drained her of spirit.

Mastin understood her own role as a privileged woman benefiting from children's labor. By focusing on her silk dress she turned her attention inward. The young girls who came to her in the dream did not speak. They only looked at her with pained, wistful eyes. She did not question them or even see them as real girls with real personalities; she saw them only as victims. Her reaction to their sad faces was to question her own values. By vowing never to wear it again, she vowed to reconsider her own position in society. Well-to-do women dressed in silks were not passive beneficiaries of men's pursuit of wealth, but active participants in an unjust system. In her poem however, the young female workers remained passive and mute. If they had spoken, what might they have said?

6
Hope for This Girl

When we left that town in mid-July it was with many misgivings
in our hearts for the future of the headstrong and undisciplined
though warmhearted girl, against whom—with hundreds of girls
like herself—the influences of society, home, and industry
seemed to have leagued themselves in deadly array. And even
with her temperament, and with the ill-advised thrusts of a self-
absorbed and weak mother, Nellie had certain staying qualities
which may yet prove her salvation. Also, she had at least the
advantage of school training until she was fourteen—won for
her by an unusual display of strength on her mother's part.
 —Florence Sanville, 1910

In the town of Homestead, a community of twenty-five thousand
in western Pennsylvania, Margaret Byington studied working-class
families in 1907–8. Site of a violent strike in 1892, Homestead de-
pended substantially on steel for its economic base. Byington noted
that the industry employed only males and that there was no corre-
sponding local industry that hired females. Some young unmarried
women found factory jobs in nearby Pittsburgh, but most remained
at home attending junior high and high school. The schools offered
courses in dressmaking and domestic skills, but also commercial
and business courses. Some girls took advantage of these vocational
classes. A few working-class girls even attended business college
in Pittsburgh and learned clerical skills. The morning train from
Homestead carried a group of female office workers into the city.
This was a sign of changing times.[1]

As historian Alice Kessler-Harris has pointed out, individual
women structured their lives in response to community and family
circumstances and shifting economic conditions as well as in dim
recognition of a larger social ideology.[2] In the late nineteenth and
early twentieth centuries, a wide array of forces helped bring about
changes in women's workforce participation. Among these were a
decline in birthrate,[3] shrinking family size, and the creation of new
opportunities for female workers in fields such as nursing and cleri-

cal/secretarial work. Bureaucratization of government and industry created new opportunities for female workers with skills in reading, writing, typewriting, and bookkeeping.

In Carbondale, where the silk strike began in 1900–1901, working class women adjusted their lives to family needs and larger social forces. Like Homestead, Carbondale was a small industrial city that depended on heavy industry, coal, and railroads for its economic base. Carbondale was overshadowed by Scranton as Homestead was overshadowed by Pittsburgh. Unlike Homestead, however, Carbondale had an industry that employed female workers. Working-class girls and young women often went out to the mill rather than remaining at home and in school. But in Carbondale between 1900 and 1910, working-class women changed their behavior in response to changing times.

Physically and in gross economic aspects, Carbondale grew between 1900 and 1910. Population increased from 13,586 in 1900 to 17,040 in 1910,[4] and local businesses prospered. The economy continued to depend upon coal, the railroads, and the silk mills. Because of the rigors and dangers of the coal industry, working-class families often required the wages of sons and daughters to supplement those of the father. Sons trudged to the coal breakers, while daughters reported for work at the silk mills. But, as the following statistics will show, the work force in the mills changed in a significant way.

Carbondale's workforce typified that of the anthracite region. A government report identified a sample of silk workers as falling into these ethnic categories:

Pennsylvania Silk Workers[5]

American	31%	English	5%
German	17%	Irish	22%
Slavic	12%	Welsh	8%
Other	5%		

The 1910 census for Carbondale yields the following data on the ethnic identification of silk workers:

Carbondale Silk Workers[6]

American	43%*	English	7%
German	9%	Irish	14%
Slavic	10%	Welsh	6%
Italian	2%	Unknown	9%

*listed in census as native/native parents.

The ethnic identification of silk workers changed to some extent, albeit not dramatically, between 1900 and 1910. In both census years most of Carbondale's silk workers were native-born, although many had immigrant parents. By 1910 a substantial minority had Polish fathers. A few came from Italian families, and a few more were Slovenian or Hungarian. One was a Russian Jew.[7]

The labor force reflected changes in the ethnic composition of Carbondale. Census data for 1910 reveals a decline in immigration from England and Ireland and a surge of arrivals from Italy and Eastern Europe. Of the total of more than seventeen thousand residents, nearly eight thousand were native-born of native parents, while more than six thousand were native-born of foreign parentage, and about three thousand were foreign-born. Of the most recent immigrants (the foreign-born), the largest number (951) came from Italy. Next in numbers were the Irish (517), English (514), and Welsh (303). Sizable numbers came from Russia (229), Germany (190), and Austria (100).[8] Some of these immigrant families sent members to the silk mills. But silk workers tended to be native-born and identified with American, Irish, German, or English ethnic groups.

Nearly all of the workers were unmarried, and most lived in the homes of their parents. Like the workers of 1900, the new workers contributed to the support of families headed by coal miners, railroad men, other laborers, and their widows. Approximately one-third were the children of coal miners and coal mine laborers. Fathers of silk mill hands also worked as carpenters, shoemakers, house painters, teamsters, and bricklayers. About twenty-two percent of silk mill workers in 1910 lived in female-headed households (compared with seventeen percent in 1900).[9] Of the small minority (about sixteen percent) of Carbondale's silk mill employees not living in the households of their parents, only about a dozen were heads of their own households and all of these were male. None of them were mill hands. They were superintendents, foremen, bookkeepers, clerks, and machinists. About a dozen of those silk workers not living with their parents lived as boarders in other people's homes. Another dozen lived with relatives.[10] With very few exceptions silk workers were secondary wage earners contributing to the support of parents and siblings. This pattern of labor had survived the turmoil of strikes, demonstrations, and the push for social reform. But it did not survive unchanged.

Only a few individuals who worked in the Klots mill in 1900 remained employed there in 1910. Rose Woody, who had reached the age of twenty-four, had risen to the status of forelady. Perhaps the promotion was her reward for being one of a tiny number of loyal

employees who reported for work during the 1907 strike. Rose, who was unmarried, still lived in the home of her father, a railroad fireman.[11] Twin sisters Annie and Margaret Kearney still worked in the mill. Neither one had married. To the 1910 census taker, they reported their age as twenty-nine, although their age in 1900 had been listed as twenty-two. As unmarried daughters of a miner, they were possibly unwilling to pass the thirty-year milestone.[12] William Sullivan, who worked in the mill at the age of twelve, became a foreman by the age of twenty-two. His older brother Daniel also worked in the mill as a machinist. Their father was a shoemaker. Neither of the sons was married; both lived in their parents' home.[13]

Like Rose Woody, the Kearney twins, and William Sullivan, many of Klots' newer employees were in their twenties. For instance Anna Dietz, age twenty-one, worked as a bundler. She was native-born of German parents and lived in a household headed by her mother. Two of her sisters worked as domestic servants. One brother age seventeen was a laborer. Four younger children were also in the home.[14]

Mary McDonald, a twenty-eight-year-old mill worker, remained in the home of an unemployed father. An older sister worked as a clerk in a store. Four brothers age fifteen to twenty-three also brought their wages home. A seventeen-year-old sister also lived at home but did not have a job.[15] Presumably she helped mother keep house and provide meals for this large family.

It was still common in 1910 for several children from the same family to work in the mill. For example Nellie Boots, age sixteen, and her sister Anna, age fifteen, both had jobs in the Klots mill. These girls were the native-born daughters of a Polish miner.[16] Lizzie Proetzsch, twenty-three, held a supervisory position as a forelady. She earned fifteen cents per hour, twice as much as the doublers who worked on her shift. Of German parentage, Lizzie lived at home in a household headed by her mother. Two younger sisters worked as silk weavers. A fifteen-year-old brother was a grocery clerk. There was one younger child in the family.[17] Mark and Joseph Collins helped support their single mother and three younger siblings. Both Mark, age twenty, and Joseph, age seventeen, were shipping clerks in the mill. Their mother owned the house in which they lived.[18] Sarah and Bessie Edmunds were daughters of a Welsh miner. Their wages helped support four younger siblings. Sarah was twenty and Bessie was nineteen.[19] Kitty and Florence Merrick also came from a coal mining family. Their father was apparently deceased, but their seventeen-year-old brother worked as a miner. Kitty, age twenty, and Florence, eigh-

teen, both had jobs in the silk mill. One younger sibling also lived in the home.[20]

New workers shared many characteristics with the workers of 1900. Close study of the 1910 federal census for Carbondale reveals these similarities. In 1910 as in 1900, the majority of silk workers was female. The proportion of females had increased by 1910 from sixty-one to sixty-nine percent. Most of the workers were native-born. Nearly half of them had native-born parents and another thirty percent were native-born of foreign parents.

Life in the silk mills went on as usual except for one important change. Carbondale census data reveals a dramatic shift in the age range of silk workers. In 1900–1901, when Mother Jones led strikers' parades, only twenty-one percent of Carbondale's silk workers were eighteen years of age or older. Ten years later, fifty-eight percent of these workers were adults at least eighteen years old.[21] The accompanying tables for 1900 and 1910 graphically depict this change.

In 1900 the average age of silk workers was sixteen and the median was also sixteen. Ten years later the average age of silk workers in Carbondale was twenty, and the median age was eighteen.[22] Again it should be noted that only a very few of the workers identified in the 1900 census remained listed as silk workers in 1910; the increase in age cannot be attributed to the aging of the same individuals. The change occurred in the general population of silk workers during this period, and this difference was extremely important.

In 1900, workers age eleven to seventeen constituted seventy-nine percent of the labor force in Carbondale's mills. By contrast, in 1910 only forty-two percent of Carbondale's silk workers were under age eighteen. Youngsters between fourteen and seventeen constituted sixty-eight percent of the work force in 1900 and forty percent in 1910.[23] Clearly, young workers continued to play a significant role in Carbondale's silk industry. Just as clearly, the workforce was getting older.

What caused this change? Had some Pied Piper appeared to lead all the child laborers out of Carbondale? Did changes in the law have something to do with this? Had the factory inspectors become more vigorous in enforcing labor regulations? Did coal miners earn more money? Were they now able to support their families on their own wages? Were fathers suddenly more provident? Were employers less greedy? Did they suddenly change their hiring policies and seek older workers? Was Carbondale an oddity, or were the changes

in Carbondale part of a general trend? How did this change come about?

The change that occurred among Carbondale's silk workers exemplified a general trend in the non-farm workforce in the United States. Statistical evidence indicates that in the nation as a whole the number of wage workers age ten to fifteen increased in the decade between 1890 and 1900, but decreased between 1900 and 1910. The accompanying "Wage Workers" table demonstrates the change.

Wage Workers in Non-Farm Occupations in U.S.[24]

Year	Workers Age 10–15	Age 16–44
1870	765,000	not reported
1880	1,118,000	not reported
1890	1,504,000	16,162,000
1900	1,750,000	20,223,000
1910	1,622,000	26,620,000

Of course this change did not affect everyone. Many children and adolescents continued to trudge through the factory doors.

No Pied Piper had led all the child workers from Carbondale. The Klots mill continued to employ some minors under age fourteen. Thirteen-year-old Albert Corrigan worked nights as a spinner.[25] In all, the 1910 census for Carbondale listed one eleven-year-old, three thirteen-year-olds, and sixteen fourteen-year-olds as silk mill workers, although not all of them worked for Klots. But this was truly a dramatic reduction from 1900, when two eleven-year-olds, eight twelve-year-olds, sixteen thirteen-year-olds, and forty-four fourteen-year-olds were listed as working in silk mills.[26]

The laws in Pennsylvania had changed. In 1901 the Pennsylvania General Assembly passed a compulsory school attendance law requiring that all children between the ages of eight and sixteen attend school. However, the act did not apply to children between the ages of thirteen and sixteen who could read and write and who were gainfully employed. The law required working children to obtain a certificate from a principal or teacher verifying their literacy.[27]

Factory inspectors did attempt to enforce the law but employers and parents often disobeyed it. For instance in May 1903, Deputy Factory Inspector E. W. Bishop charged A. E. Burdick, superintendent of the Harvey silk mill at Olyphant, with violating the provision requiring work certificates. Burdick pleaded guilty with extenuating circumstances, claiming that most of the girls he em-

ployed told him they had certificates, but that the certificates were in the hands of their former employer. The court fined Mr. Burdick fifty dollars and costs.[28] In 1905 the state factory inspector reported that inspections of 16,589 factories had revealed more than forty-one thousand employees between the ages of thirteen and sixteen, approximately half of whom were girls. Most of these worked legally, but nearly three thousand of them had no certificates or affidavits. Of these, 107 proved to be illiterate and were therefore barred from wage labor.[29] Many of the young workers who had certificates apparently could have obtained them illegally. In 1907 the *United Mine Workers' Journal* reported that for a fee of twenty-five cents to a crooked justice of the peace a parent could obtain a certificate for almost any child.[30]

In 1905 the general assembly passed a law specifying that no child under fourteen years of age should be employed in any establishment.[31] Four years later a new law required that minors between the ages of fourteen and eighteen obtain certificates for employment. The 1909 law, which barred minors from certain dangerous occupations, became the model for future Pennsylvania statutes regarding the employment of minors. This law allowed males but not females over fourteen to work at night and limited minors to a ten-hour workday.[32] However, these provisions coincided with common practices in the silk industry.

Changes in the law undoubtedly had an effect on employment policies in the silk industry, but by themselves they do not explain the marked change in the workforce in Carbondale's mills. Legal restrictions would explain the drastic reduction in the number of eleven-, twelve-, and thirteen-year-olds in the mills, although Albert Corrigan worked in the Klots mill, apparently illegally. But the number of fourteen-year-olds, who were still legally employable, also fell substantially as did the numbers of fifteen- and sixteen-year-olds.[33] Conversely, the number of adult workers eighteen years of age and older rose tremendously, as the tables for 1900 and 1910 show.

Were miners and other male laborers better able to support their families in 1910? The answer to this question would appear to be no. The great anthracite strike of 1902 resulted in a small wage increase for miners and some improvement in working conditions. However, between 1903 and 1910 the miners won no further increases in wages. In 1912 the cost of living for a family of six in the anthracite region was estimated to be about seven hundred dollars per year. A miner working to his full physical capacity might earn eight hundred dollars per year. But a mine laborer making

$2.50 per day and working an average of 257 days would earn less than $650 per year.[34] Mining was still a hazardous occupation, which meant that injuries and illness often limited laborers' earning capacity. Widows of miners frequently had to depend on their children for support.

The wages of silk workers rose, but only very slightly.[35] Wages in 1910 were not the "adult" wages that Mother Jones envisioned for adult workers. It would not have been possible to support a family on the income of a mill hand or even a foreman or forelady. In 1910 many Klots workers earned about five-and-one-half cents an hour, just as Annie Denko did in 1902, although more were earning seven or eight cents per hour. Klots workers in 1904 earned between three cents and nine cents per hour, and this had changed very little in 1910. Foremen and foreladies earned between fifteen and twenty cents per hour with no apparent gender differential. The only Klots employees who could and did support families were males who worked as loom fixers, machinists, or in management positions above the level of foreman.[36]

Legal changes do not fully explain the change that occurred in the division of labor in families between 1900 and 1910. Many families continued to depend on the labor of several of their members for survival. Fourteen- to sixteen-year-old children could still legally go out to work and many still did. But their numbers were dwindling. Instead, older minors and adults reported to work at the silk factory and brought home their wages. This meant that many unmarried daughters in their twenties and even thirties contributed to the support of parents and siblings.

Did employers respond to new legislation by refusing to hire younger workers? During the early years of the century many employers had evaded or ignored the law. But perhaps they could see the handwriting on the wall; perhaps a few fifty dollar fines gave them a scare. Perhaps they refused to hire younger minors. But the evidence indicates that they continued to seek the cheap labor of children and adolescents. As New York, New Jersey, and Pennsylvania tightened child labor laws, silk mill owners opened branches in southern states where child labor remained more readily available. The 1911 Senate report on female and child labor in the silk industry reported that the silk "throwsters [operators of throwing mills] are casting their eyes southward, where the laws are more liberal in age and hours. Many have gone; many will follow."[37]

Despite the risk of losing the silk throwing industry, Pennsylvania families began keeping their children out of the mills and in the public and parochial schools. Whatever it cost them, families in

Carbondale and other towns and cities kept their children in school past the elementary grades. By 1915 the Pennsylvania Bureau of Industrial Statistics reported that more than ninety percent of the state's children age ten to fourteen regularly attended school. Expanding the range to include children age ten to seventeen produced the figure of seventy-three percent.[38] Even allowing for optimistic reporting the situation had certainly improved since 1899–1900, when figures indicated that in many cities and towns more than half the children age ten to fourteen apparently failed to attend school.[39]

Between 1900 and 1910 the Catholic Church focused a great deal of energy and effort on a campaign to build schools and convince families of the desirability and in a sense the sacredness of a scholastic education for children. In church magazines, priests urged their colleagues to impress upon members of their congregations the importance of "that first great step in life."[40] High-ranking clergymen instructed parish priests to persuade married men and women of the necessity of sending "children punctually to school, clean and neatly dressed, and provided with the necessary books and writing materials."[41] This educational campaign, coupled with a great increase in the number of parochial schools and a growing Catholic population, resulted in a rapid growth in attendance. In 1901, *The Catholic School Journal* proudly reported a total attendance of 1,002,516 in Catholic elementary and secondary schools.[42] A decade later attendance had grown to 1,270,131, an increase of 267,615 or twenty-six percent.[43] In the anthracite region and Lehigh Valley the church founded three teaching orders between 1901 and 1909: the Bernardine Sisters in Reading in 1901, the Lithuanian Sisters of St. Casimir in Scranton, 1907, and the Sisters of St. Cyril and Methodius in Scranton, 1909.[44]

In the first decade of the twentieth century, clergymen and social reformers managed to drive home their message that preadolescent and adolescent children needed and deserved a scholastic education. As previously mentioned, two outspoken critics of child labor, John Spargo and Florence Sanville, passionately expressed their conviction that teenage children belonged in school.[45] In all likelihood their writings reached the middle classes in the anthracite region. The labor organizer Mother Jones, who also insisted that children and adolescents should be in the school yard and not on the factory floor, presumably reached a working-class audience of mine workers and Irish immigrants. The Anthracite Coal Strike Commission hearings featured daily in the local press brought the issue of child labor to the front page. The rough questioning of Judge Gray caused John Denko to apologize and try to justify his

ecision to send a twelve-year-old child to work.[46] Reformist writngs, demonstrations, exhortations, and inquisitions combined to elp change attitudes among workers in northeastern Pennsylvania. Fathers of silk mill workers heard about the evils of child labor rom union leaders. Both the American Federation of Labor and its ffiliate, the UMWA, came out publicly and strongly against the mployment of children in factories and mines. In 1903 a special ssue of the *American Federationist* focused on the question of vorking youngsters. Commenting on the results of the Anthracite :oal Strike Commission hearings, contributor Kellogg Durland vrote:

> The investigation of the Anthracite Strike Commission has focused the strong white light of publicity on many evils which have flourished in the anthracite mining counties of Pennsylvania, but on none more deplorable, or more unpardonable than that of child labor. To snatch at a current catchword, it is veritably the shame of Pennsylvania.[47]

n 1907 the *United Mine Workers' Journal* urged its members to ake a firm stand against "child slavery in the Wyoming Valley."[48] Vhile most fathers did not become public critics of child labor, ome may have combated the evil by keeping their own children in •ublic school.

Mothers played a key role in adopting new strategies for family urvival. In order to keep children in school, mothers had to find dditional sources of income. The practice of taking in boarders vas not common but not unknown in Carbondale. Some mothers ɔok in laundry. Home-centered businesses helped some mothers •ridge the gap between domestic and working life. Journalist Flornce Sanville wrote about a matron named Mrs. Evans who kept "a ittle penny candy and cigar store which she had added to her .ouse."[49] This particular establishment provided an alternative to ιe local saloon for young men wishing to play dominoes or checkrs, drink ginger ale and root beer, and smoke. Domestic busiesses, especially candy stores, provided one outlet for women to nter the public life of mining communities and influence recretional behavior.

A small but growing number of mothers went out of their homes ɔ work. The Carbondale census for 1910 compared with that for 900 reveals that a slightly greater number of mothers of silk workrs had begun to earn money as dressmakers or laundresses. One iarried woman, Mrs. Sims, age thirty, the wife of a coal mine !aorer and mother of four children, went out to work in the silk mill. he mother of silk winder Loretta Fox, age twenty-three, supported

two younger daughters by keeping a candy store. Loretta brough
her wages home to add to the income of this female-heade
household.[50]

Sanville described the relationship between one silk worke
called Nellie and her mother. Nellie's mother, Sanville reportec
displayed an unusual level of determination in insisting that he
daughter be allowed to remain in school. Her father reportedly ha
persistently tried to send her out to work. Her teacher and mothe
stood their ground against him.[51] Eventually her husband deserte
her and Nellie had to go to work. But by that time Nellie did hav
an eighth-grade education. Sanville did not describe the mother'
feelings about that, but felt it might be Nellie's salvation.[52]

Nellie's story contrasts with that of Annie Denko, who went t
work at an early age. Annie's mother would not or could not stan
up for her daughter because of grief and mental illness. Althoug
Nellie's mother was reportedly a timid, nervous woman, she mus
tered the strength to look out for her daughter's interests. Annie'
mother had many other children to worry about. Nellie had just th
one brother. Nellie's lot was hard. But in Sanville's estimation, th
fact that she had received an education gave her some hope of finc
ing a better life.

Not all of Nellie's co-workers shared her educational advantage
Many were younger than sixteen. But Sanville saw signs of change
While deploring the continuing use of child labor, she observe
some important signs of improvement in employment patterns. I
particular, she commented, factories employing females on th
night shift had, "with the growth of public sentiment in the matte
become comparatively rare."[53] She also predicted that recei
changes in the law would lessen the evil of child labor.

Nellie represented a new type of silk worker—older, better edu
cated, more worldly-wise, and perhaps more independent tha
many of her predecessors. With her energy and sense of freedor
one can easily picture her taking her place on the picket line c
marching in a parade, participating in strikes, and standing up fc
her rights. As Sanville reported, she worked to help support hc
mother and brother, but also had a sense of herself and the will t
go out and find some enjoyment in life. She worked hard, but th
toil had not taken the spirit out of her. Older than many of her cour
terparts in the mill, perhaps these extra years of maturing and a
tending school had helped her become a more confident youn
woman.

Evidence indicates that Nellie was typical of Pennsylvania's si
workers by 1910 because real change had taken place in the mil

etween the early years of the century, when Annie Denko went to
ne mill, and 1910 when Sanville published her reports.

Who made the decision to change the pattern of wage labor in
amilies? Reformers railed against the evils of child labor. Union
:aders urged their rank-and-file members to take a stand against it.
athers certainly had something to say about who went out and
)oked for work. At least a few fathers in northeastern Pennsylvania
xpressed their opinions by walking out on their families as Nellie's
ather did.[54] Mothers held the primary responsibility for rearing
nildren, so it seems likely that they played a key role in deciding
) keep those children in school. This according to Sanville was
ue of Nellie's mother.[55] But what about Nellie?

What role did working-class daughters play in shaping their own
:stinies? Some, according to census data, remained in their par-
nts' home well beyond adolescence in order to help support their
blings. These adult women showed great loyalty to the families of
ieir birth, but evidence indicates that they also insisted upon a de-
:ee of personal freedom. From Sanville's reports it appears that
lder adolescents and adult women who worked for wages assumed
 somewhat independent mode of life despite their continuing at-
chment to the family. Nellie and her friends socialized freely,
ent out to movies and entertainments when they chose, and even
itiated male-female relationships without the blessing or supervi-
on of parents.[56]

Hard economic circumstances limited the choices these girls
)uld make in their lives, but they did make choices. By staying in
hool an extra year or two they could acquire skills that might pos-
bly open doors to jobs, not in the mills but in offices, hospitals, or
tail establishments. Young silk workers questioned in the Wilkes-
arre study in 1914 expressed a desire to stay in school and pursue
e business course.[57] Many were unable to do so but the desire was
ere.

Every morning in western Pennsylvania a train left Homestead
rrying young women to offices in Pittsburgh. There were trains
 northeastern Pennsylvania, too, and young working-class women
ho hoped for a ride.

Table One

Carbondale Silk Workers, 1900

11%

21%

68%

☐ Adults over age 17

▨ Adolescents aged 14-17

■ Children aged 11-13

Chart prepared by Louise Bodenheimer.

Table Two

Carbondale Silk Workers, 1910

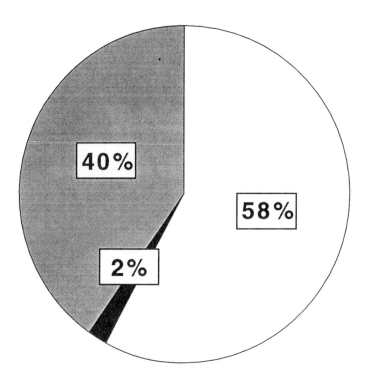

40%

2%

58%

☐ Adults over age 17
▨ Adolescents aged 14-17
■ Children aged 11-13

Chart prepared by Louise Bodenheimer.

7
Mothers, Daughters, and Choices

To break away from the training of the mind, take up routine work, and acquire skills in finger movement and endurance is not to the liking of our modern girls. Sometimes I wonder where the future factory workers are coming from, if the state authorities continue to raise the educational requirements and the boys and girls reach an era when they no longer want to work at anything except "white collar" jobs.

—Warren P. Seem, "Scientific Management Applied to Silk Throwing," *Textile World*, 17 July 1926

New opportunities arose for women seeking work in the 1920s. Historian Gerald Zahavi found that the Endicott-Johnson shoe factories in southeastern New York state, close to the Pennsylvania line, hired increasing numbers of women after 1900 and that by 1927 women made up thirty-five percent of their total workforce of more than fifteen thousand. A few of these female employees began working before reaching the age of sixteen, the legal age for employment under New York state law, but most were adults, and a considerable number (about half) were married.[1] Corporate president George F. Johnson, reacting to criticism for hiring married women, spoke up for the hardworking wife who was "willing to help her young husband" by earning wages.[2]

Zahavi found that women from rural New York and nearby Pennsylvania sought jobs with Endicott-Johnson for several reasons. In the early twentieth century the company instituted a system of corporate welfare, providing aid for injured and disabled workers, setting up savings plans, and offering amenities such as dining rooms and rest lounges. Married women found these benefits attractive. Young single women sought work in the shoe factories as a way to experience freedom from parental authority while sending some of their wages home. For some girls the relatively high wages made it possible to save for secretarial, teaching, or nursing school.[3]

Increasingly through the early decades of the twentieth century, American girls who finished high school had opportunities to obtain clerical, nursing, or teaching positions which freed them from the repetitive drudgery of the mills. This change is evident from statistics. In 1910 approximately thirteen percent of female workers held clerical jobs and about nine percent held professional positions. By 1930, these figures had risen to twenty-nine percent and thirteen percent respectively.[4] This change resulted in part from the increasing professionalization of medicine, law, and business, creating the need for clerical workers to support the work of doctors, attorneys, and business managers. Growing attendance in public schools helped to create not only a larger group of educated young people but a greater demand for teachers and other educational personnel.

These changes in education, medicine, and business affected not only the middle class but the working class. A White House commission meeting in the early 1930s noted a dramatic change in the behavior of working-class families in the United States between 1900 and 1925. Cautiously remarking upon a downward trend in the number of children age ten to fifteen employed in gainful occupations, the members of the Subcommittee on Child Labor acknowledged that many might still be illegally employed. With unrestrained enthusiasm, however, the group reported that high school attendance was increasing by leaps and bounds. In 1900 only about eight percent of young people age fifteen through eighteen were enrolled in high school. By 1920 the figure had risen to twenty-nine percent, and by 1925 enrollment had soared to forty-seven percent.[5]

Although in the 1920s the silk industry continued to employ the highest percentage of child workers of any manufacturing enterprise, times had definitely changed. The 1910 census showed that silk and other textile mills employed well over half of all child laborers in Pennsylvania, with the silk industry employing the highest proportion (14.9 percent) of workers under sixteen. Between 1910 and 1920, however, child labor in Pennsylvania decreased by as much as forty-two percent. By 1930 a Women's Bureau study of two Pennsylvania cities (Allentown and Bethlehem) concluded that fewer children and more adult women were reporting to work in the silk mills. In 1900, the study said, girls under eighteen predominated in the industry. But by the 1920s, the study found that in some mills older women outnumbered girls under eighteen by two to one.[6]

Changes in Carbondale's silk work force mirrored these general

trends. Some hard-pressed families continued to send their children out to work and silk mill managers continued to hire them. The 1920 census for Carbondale lists four thirteen-year-olds and twenty-one fourteen-year-olds working in silk mills, showing little change from 1910. However, more than thirty-five percent of the 259 silk hands listed in the 1920 Carbondale census were adults over twenty years of age, up from thirty-two percent in 1910. The average age of workers rose from sixteen in 1900 to twenty in 1910 to twenty-two in 1920.[7] Interestingly, the number of silk workers between the ages of seventeen and twenty-one decreased between 1910 and 1920.

The Age Range table shows the changes in age distribution among Carbondale's silk workers between 1910 and 1920.

Age Range	1910	1920
Age 11–13	4 (1.7%)	4 (1.5%)
Age 14–15	41 (17%)	51 (20%)
Age 16–17	53 (22.5%)	74 (28.5%)
Age 18–20	61 (26%)	34 (21%)
Over 20	76 (32%)	95 (36.6%)

Census data for Carbondale in 1920 shows that in general the youngest silk workers came from immigrant families. Of the twenty-five silk workers listed as being thirteen or fourteen years old, sixteen were immigrants or children of immigrants. Half of these were Italian; one fifth were Slavic, and one fifth were Irish.[8]

Among immigrants and children of immigrants at work in Carbondale's mills, ethnic identification changed significantly between 1910 and 1920. The number of workers whose parents immigrated from Italy increased from two percent to fifteen percent. The Carbondale Silk Workers table reveals the change.

Carbondale Silk Workers[9]

Ethnic ID	1910	1920
American	43%	50%
Italian	2%	15%
Irish	14%	15%
Slavic	10%	7%
English	7%	7%
German	9%	4%
Welsh	6%	2%
Unknown	9%	-

In general the number of workers from older immigrant groups (English, German, Irish, and Welsh) remained stable or declined while the number of workers from a new immigrant group (Italians) rose appreciably.

Carbondale's mills continued to employ a high number of native-born workers. According to census data, fully half of Carbondale's silk workers in 1920 were native-born of native-born parents, an increase from forty-three percent in 1910. Only ten percent were foreign-born, a decrease from seventeen percent, but forty percent were native-born of immigrant parents, an increase from thirty-two percent.

Changes in the silk workforce reflected general changes as well as continuities in Carbondale's demographic makeup. Study of a random sample of 243 Carbondale families listed in the 1920 census compared with the sample group from 1900 reveals some change, but also stability. Italian immigrants and their children accounted for only two percent of the population in 1900, but nineteen percent in 1920. Proportions of other ethnic groups remained generally the same. Irish immigrants and their children comprised twenty-two percent of the population in 1900, twenty-nine percent in 1920; English and Scottish, eighteen percent in 1900, twelve percent in 1920; Germans, seven percent in 1900, six percent in 1920; Welsh, four percent in 1900, five percent in 1920; Slavic people, one percent in 1900, five percent in 1920, and Americans (native-born of native-parentage), thirty-nine percent in 1900, twenty-nine percent in 1920.[10]

Household structure remained substantially similar in 1900 and 1920. Most households were headed by males. In 1900 eleven percent of households had female heads, and in 1920 thirteen percent of the sampled households had female heads. Family size changed little. In 1900 twenty-five percent of families had four or more children; in 1920 approximately twenty-one percent of the sampled families had four or more children living in the home.

Occupational choices changed little for adult males. In 1900 nineteen percent of male heads of households worked in coal mines, and nineteen percent worked for the railroads. In 1920 twenty-two percent of male breadwinners worked for coal mines, and twenty-five percent for railroads. Males were thus even more concentrated in these two major industries in 1920 than in 1900.

Fewer households sent children under eighteen out to work, and more families relied on the labor of adult women. Twelve percent of sampled families in 1900 sent minor children out to work. In 1920, about seven percent of sampled families relied on the wages

of children under eighteen. In many families adult sons and daughters remained at home and contributed wages. By 1920 a substantially larger number of wage earners were adult women (age eighteen or older).[11]

The Carbondale census reveals that by 1920, females eighteen and older who had received a high school education had new occupational choices. Between 1900 and 1920 there was a sharp increase in the number of Carbondale women employed as retail saleswomen, bookkeepers, clerks, and stenographers.[12] All these jobs require some literacy and number skills. Comparing the two random sample groups from 1900 and 1920, the proportion of adult working women employed as saleswomen rose from four percent to twenty-two percent. The proportion of adult female workers employed as clerks or stenographers rose from four percent to twenty-four percent. The proportion of adult working women who held jobs as bookkeepers rose less dramatically from eight percent to twelve percent. Conversely the proportion of women who worked as seamstresses, dressmakers, or tailors declined from thirty-five percent to twenty percent. Percentages in other occupational categories such as silk mill hand changed little or declined slightly as women moved into new types of employment.

Families who struggled to keep children and adolescents in school received their reward when those children gained skills that opened new opportunities. Siblings as well as parents helped to keep school-age children in school. Loretta Malloy, a thirty-one-year-old silk hand, lived at home and contributed her wages to the family. No doubt her long-term employment in the mill had afforded her younger sister the opportunity to attend high school. In 1920 that younger sister worked as a clerk in a doctor's office.[13] With the benefit of an education the sisters of silk workers James Stockman and Gloria Gilhool found jobs teaching in the public schools.[14] Female siblings of other mill hands held jobs as salesladies, waitresses, and stenographers.

Although some of her co-workers might be married women, widows, or independent single women, the typical Carbondale silk worker in 1920 was still a young unmarried female helping to support her parents and siblings. Females continued to comprise more than sixty percent of the labor force in the mills. Of 160 female workers identified in the Carbondale census, 137 were unmarried and living with one or both parents. Seventeen unmarried female workers lived alone or boarded with relatives or non-relatives. Six were married, and three were heads of households. (Of Carbon-

dale's silk workers in 1910, only one was married, and none headed households.)

By 1920 a few mothers went to work in Carbondale's mills in order to support their offspring. Angelina Molinaro, native-born daughter of Italian immigrants and widowed mother of two, held a job as a spinner.[15] Lena Creo, of similar background and also widowed, worked in the silk mill to support three small children.[16] Both women were in their twenties, and both broke with tradition by relying on themselves rather than fathers or male relatives for a living.

General prosperity during the 1920s increased optimism among working-class women and their families. A resident of Carbondale recalling the 1920s some sixty years later told an interviewer that the town came alive on alternate Saturday nights when the miners got paid.[17] Everyone went downtown, rushed to the bank to cash paychecks, and then milled about the busy streets. Theaters and restaurants were jammed. Stores remained open until ten P.M. and offered a variety of merchandise including groceries, shoes, drugs, clothing, and jewelry. Parents shopped for items needed by children attending school. The longtime resident remembered that in the 1920s the schools were full to bursting "with never an empty seat."[18]

After a brief panic in the early 1920s, the silk industry rebounded and enjoyed a period of success. Marcus Frieder, president of the Klots enterprise, reportedly "went to pieces" in May of that year because of a severe drop in silk prices following the boom of World War I, during which he had invested capital in the National Spun Silk Company with plants in New Bedford, Massachusetts.[19] The Klots organization had become one of the largest silk-throwing establishments in the United States.[20] But Frieder was not the only manager who panicked when silk prices fell by more than fifty percent in six months.[21] Frieder and other silk makers faced the possibility of ruin.

Rising demand for silk hosiery, hatbands, ties, and cheap silk thread and fabric saved the industry,[22] although the trend toward short skirts for women reduced the demand for broad silks. As silk manufacturers recovered the losses of the postwar years and reorganized their holdings, production began to rise. By 1925 output of silk and rayon (artificial silk) in Pennsylvania soared to a value of $329,121,000 compared to a value of $86,939,000 in 1914. After 1925 output declined, but even during the Great Depression production remained well above prewar levels. Silk manufacturers survived the initial crisis and prospered in the 1920s by liquidating some inventories, consolidating holdings, and reducing costs. In

1926 the Klots Throwing Company and its subsidiaries reorganized and became the General Silk Corporation with fifteen mills in six states.[23] Its throwing mills in Pennsylvania, Maryland, Virginia, West Virginia, and New Jersey did eight percent of all throwing in the United States in the late 1920s.[24] In addition, the corporation owned weaving mills in Carbondale, Pennsylvania, and Central Falls, Rhode Island, as well as the spun-silk factory in New Bedford, Massachusetts.[25] The Duplan Silk Corporation also consolidated by merging with three other companies, operating plants at Kingston, Wilkes-Barre, and Nanticoke, Pennsylvania.[26]

Silk companies coped with uncertainty by instituting systems of scientific management. Frederick W. Taylor, a Philadelphia-born engineer, became the most prominent advocate of scientific management in the early twentieth century. Designed to increase efficiency and profits, his systematic management techniques also seemed to offer a partial solution to the labor problem. The key to his system was the "time study," a scientific assessment of various tasks measured against the clock. Taylor also advocated curbing the power of foremen by taking away their power to set production rates. He advised using wages as incentives for productivity. Although he did not completely oppose unions, he viewed scientific management as a way to keep workers in line and forestall strikes.[27]

Business analyst Warren P. Seem advocated scientific management for the silk industry. While he favored improving working conditions and offering other benefits like those at Endicott-Johnson, he took a hard line on the need for increased efficiency. He advocated wage incentives for the most productive workers and speedups to put pressure on the less efficient hands.

Seem also recommended that managers enlist foremen and foreladies in the campaign for efficiency. In an article in *Textile World*, 18 December 1926, he recounted his success in initiating a speedup in a throwing mill by choosing a conscientious forelady named Jenny as his ally against recalcitrant female workers. First he convinced Jenny that it was unfair to pay slower workers the same wages as faster workers. Then he pitted workers against one another to determine who could produce the most yarn in the shortest time. He instituted a wage system based on a high rate of performance, and some of the slower workers incurred a reduction in pay. Some of these slower workers were Jenny's friends, causing "many a heartache."[28] Nevertheless Jenny supported his system of scientific management which eroded the bonds among female workers.

Pennsylvania silk manufacturers introduced speedup plans aimed at increasing productivity in both weaving and throwing operations.

Marcus Frieder and his son Leonard, who operated plants in the anthracite region as president and vice president of the General Silk Corporation, participated in this general trend.[29] General Silk's speedup policy, instituted in its weaving plant in New Bedford, Massachusetts, became notorious.[30] In throwing mills the Frieders and other managers tended to replace time rates with pound rates, requiring each worker to produce a certain number of pounds per week. Workers who could not accomplish the set "task" received less pay. Critics of the industry claimed that only the fastest workers could meet or exceed the task, with the result that most workers received less pay than they would have on a time rate.[31] However, during the 1920s general weekly wage rates continued to rise. Statistical data is incomplete, but government reports indicate that the average weekly pay for silk workers in the United States rose from less than thirteen dollars in 1910 to more than twenty dollars in 1929, although wages for silk throwsters were much less in both years.[32]

Owners and managers recognized that the labor force had changed. Writing on the subject of scientific management in throwing mills, Seem recalled that twenty years earlier (in the early 1900s), throwing mills had employed workers as young as twelve. While Seem claimed to be sympathetic to child workers and to welcome legal restrictions on employment of minors, he also maintained that child-labor laws placed hardships on families and reduced the supply of labor.[33]

Seem believed that young people who received a high school education became "too proud to work" at machine-tending jobs in the mills,[34] although their desire for material goods sometimes sent them to the factory's employment office. Deploring the trend toward more years of schooling for working-class youngsters, he expressed the opinion that "modern" girls wanted to have their cake and eat it too. They wanted to earn wages but turned up their noses at factory jobs. Higher levels of education gave them snobbish ideas, encouraging them to accept only "white collar" jobs. While he regretted these changes in working-class attitudes, he urged employers to accept them as facts of life. In keeping with the ideas of scientific management, he urged managers to woo more educated laborers with higher wages and better working conditions.[35]

Pennsylvania silk manufacturers did not abandon the practice of hiring child laborers. In order to cut costs some companies apparently did revert to hiring child workers, but this did not become the general practice. The Duplan plant in Wilkes-Barre reportedly laid

off older employees and replaced them with very young workers who earned only three to six dollars per week.[36] Carbondale silk factories did hire some underage workers and an increasing number of fourteen-year-olds.

Crises in the anthracite industry placed heavy burdens on secondary wage earners, mostly women and children, in northeastern Pennsylvania. Because of a decline in the hard-coal industry, women in the anthracite region faced new responsibilities as well as new choices. Men's opportunities for employment dwindled as hard coal mining slipped into a fateful decline. Between 1918 and 1922 production of anthracite fell from nearly one hundred million tons to less than sixty million tons. Production rose again in 1923, but the long-term trend was downward—fatally downward. In 1932 the industry's output fell below fifty million tons, and by that time there was no real chance for recovery. Fuel oil replaced anthracite for domestic heating, and coke replaced anthracite in steel production. The industry was dying.[37]

Although a few male heads of households found work in silk mills, the silk industry did not provide a significant number of jobs for men laid off from the anthracite mines. The 1910 census for Carbondale identified twelve male silk workers who supported families. By 1920 the number had grown to eighteen in a somewhat larger workforce. Displaced miners fed up with the uncertainties of the industry sometimes went across the state line seeking work at Endicott-Johnson. Zahavi found that hundreds of the company's job applications listed mine shutdowns or strikes as reasons for leaving the last place of employment.[38]

The United States Bureau of Labor Statistics reported at the end of the 1920s that women continued to outnumber men in the labor force of Pennsylvania's silk mills.[39] In 1928 females constituted approximately sixty-one percent of the workforce, a proportion nearly identical to that of 1900 and 1910.[40] Women tended to be full-time workers, while one fourth of the male employees worked less than full time, although men earned higher weekly wages than women. The wage differential resulted partially from the tendency of those men who were full-time workers to put in more overtime hours than women, but substantially from gender-based wage differentials.[41] However, a study by Alfred C. Krause revealed that between 1928 and 1931 the average weekly earnings for men decreased while the earnings of women remained stable.[42]

While child workers continued to report to the mills between 1900 and the 1920s, the number of mature women working in the Pennsylvania silk industry skyrocketed. A study of immigran

women conducted by the United States Department of Labor Women's Bureau in 1925 in the Lehigh Valley revealed that substantial numbers of wives and mothers held jobs in various industries including silk mills. A Women's Bureau report published in 1930 contained data on the change in the silk industry's workforce:

> Girls not yet 18 predominated in the industry in each of the communities reported in 1900. In Allentown and South Bethlehem in that year there were two or three times as many girls under 18 as there were women of 25 or more, but in some of the communities in 1920 the number of older women was more than twice as large as the number of girls under 18.[43]

As the workforce aged, according to this report, the number of employed married women increased substantially.[44]

Rather than hiring child workers, silk companies increasingly sought the labor of adult women, many of whom were recent immigrants. While native-born women continued to find employment in the silk industry, new immigrant groups entered the mills in growing numbers. In the mid-1920s, Women's Bureau researchers found that nearly three-fourths of the female workers in the Lehigh Valley textile mills could not read or write English.[45]

Like Angelina Molinaro and Lena Creo of Carbondale, wives and mothers in the steel-, cement-, and zinc-producing towns of the Lehigh Valley also went to work in silk mills or cigar factories to support or help support their husbands and children. The previously mentioned Women's Bureau study, conducted in 1925 and published in 1930, reveals that these mature, married women reported to work in significantly greater numbers than in 1900 or 1910. Respondents to questionnaires and interviews explained why they went out to work in silk mills and cigar factories, and what they hoped to achieve for themselves and their families. Of the wage-earning women interviewed in this project, about three-fourths were or had been married.[46]

The Women's Bureau study focused on immigrant, not native-born, women. Their status as immigrants certainly increased the need for and the likelihood of their continued participation in the labor force after marriage and childbearing. The percentage of married women was higher in the Lehigh Valley than in the nearby city of Philadelphia.[47] German and Slavic women tended to work after marriage in greater numbers than Italian, English, or Jewish women.[48] But a very large number of immigrant women did work after marriage and childbearing, and they did so to provide a better life for their families.[49]

The Women's Bureau gathered data demonstrating that the wages of male breadwinners in immigrant families could not stretch to support wives and families. Using figures provided by the Bethlehem Family Welfare Association, the bureau calculated the cost of bare subsistence for a family of five for one year (see table).

Food	$ 678.00
Clothing	167.60
Rent	180.00
Fuel	84.00
Total	1,109.60[50]

Common hourly rates for male laborers in the Lehigh Valley amounted to thirty-seven to thirty-nine cents. In order to earn a bare subsistence for his family at those rates, a man would have to work ten hours a day for three hundred days a year. Any one of a wide variety of disasters—layoffs, injuries, illnesses—could make it impossible for a man to accomplish this feat.[51]

Like many women of her time and place, Anna Oborkovitz, a thirty-six-year-old mother of three, went to work in a silk mill in order to supplement the uncertain wages of her husband. When interviewers asked why she went to work, she replied that her husband was unemployed. She had a large family.[52] Anna Oborkovitz had worked and learned a skill before her marriage. As a young single female she had been a weaver. Having acquired this skill she found it natural to continue to work after marriage. Her workforce participation was sporadic. She had worked at various times during her marriage and then stayed home for a while. But at the time of the study she had been working in the mills for the past three years.[53]

Immigrant women who went out to work wanted to earn enough money to keep a roof over their heads and help their families through emergencies such as injuries, sickness, and male unemployment. They feared for the time when they and their husbands would be unable to work and support themselves: "When old we don't want to be on the city. Plenty widows that have no money. It is in my mind, then, to work so long as I can. I have not enough yet, but when too much, then I stop work."[54] The woman who made that statement to the interviewer was only thirty years old. But she looked much older and was worried about the end of her life.[55]

Illness and the fear of it drove many married women into the mills. The staff of a Lehigh Valley hospital conducted a study and found that only a man earning over $125 per month and having not

more than one dependent could manage to pay the hospital bills for a short illness. One or more such illnesses could ruin a family. Many hospital bills remained unpaid.[56]

Some married women went to work so their families could own a home. Home ownership meant status, but it also represented security to families buffeted by the ups and downs of the Pennsylvania economy. Women interviewed made repeated references to the desirability of owning a home and the necessity of working for it:

"To have right my own home."
"A home a little nice, that's all I want."
"This like an alley house where we live—I get better home on better street, bathroom and everything nice."
"It is in my mind I buy a house and garden."[57]

This was the dream, but the dream would not come easily. "If you want a nice home you have to work like the devil for it." "I always work. Didn't have so much money; we have a mortgage yet, that's why I work."[58]

In pursuing the goal of home ownership, wives often accepted a large measure of responsibility. The Women's Bureau report related the story of a silk winder evicted from her rental home. Landlords objected to her five small boys, so she went searching for a house to buy. Her husband, an unskilled laborer, could not afford a mortgage. The wife took responsibility for buying the house and returned to the mill after several years' absence. She earned the money to make improvements in her house including water and sewer connections, plumbing fixtures, and sidewalks.[59]

Many women went to work not just for economic survival, but to improve the prospects of their families. To the question of why they entered the labor force, many of the immigrant women answered in terms of necessity. "Times weren't so good." "Expenses so high." "We were getting behind in everything." "The men were laid off and we needed a slice of bread." "Never know when sickness comes how much it cost."[60] But others answered in terms of aspiration. "To pay for my home some day," said one respondent.[61] Another interviewee, Freda Schiess, who had no children, said she went to work in a silk mill to help her husband. He earned a sufficient living, but she wanted her own home.[62] Caroline Manning, who wrote the Women's Bureau report on the project, concluded that these women had immigrated to America not to live at a subsistence level but to enjoy a higher standard of life.[63]

Working mothers in the Lehigh Valley expressed a passionate de-

sire to keep their children out of the mills and a steely determina-
tion to send those children to school. Again and again the women
interviewed by the Women's Bureau spoke of plans and hopes for
the next generation. "I am still a greenhorn." "My little girl must
be smart." . . . "My boys must go to high school if they have good
heads." "He must not work in the mill but be an American."[64] Im-
migrant mothers associated working in a mill with their own low
status as newcomers. Becoming a "real" American meant escaping
from the mill, and escaping from the mill required education.
Women who cherished dreams for their offspring were ready to
make sacrifices: "We do by our children in school what we can af-
ford." The goal of a widow who worked ten hours a day was to see
her daughter graduate from the normal school: "I no care how long
I work she can teach in a school."[65]

Most of the working mothers surveyed did not send their children
out to work. Of the families studied, two-thirds had two wage earn-
ers, generally the husband and wife.[66] The woman interviewed by
the bureau was the sole wage earner in 156 families, one of two
wage earners in 1,175 families, one of three wage earners in 391
families, one of four wage earners in 145 families, and one of five
or six wage earners in fifty-four families.[67] Women who were the
sole wage earners were most often widows. Most of the women
from two-income households were married women with husbands.
Single women living with parents predominated in multiple-wage-
earner households. The typical family in the study consisted of a
husband and wife, both working, and from one to three children
who did not work.[68] Of all the working mothers surveyed, only
about thirty percent had children who were also employed.[69]

Wage-earning mothers continued to handle most housekeeping
chores with the help of school-age daughters. Wives accepted the
double responsibility of earning wages and keeping house as a mat-
ter of course.[70] Husbands ruefully accepted the necessity of the
wife's financial contribution, but rarely pitched in to help with the
housework.[71] In the households of working mothers, daughters of
twelve and even younger took responsibility for preparing meals,
washing and ironing clothes, cleaning house, and tending younger
siblings.[72]

Working mothers of young children depended on relatives, neigh-
bors, or school-age youngsters for child care. Of the families stud-
ied by the Women's Bureau, approximately one-third of the
children whose mothers went out to work were less than six years
old and therefore not eligible to attend school.[73] These families
faced serious problems in providing care for their children. The

Women's Bureau concluded that half of the children under twelve lacked adequate care in the mother's absence. In a small number of cases the father provided supervision. Grandmothers or other relatives tended the children in about one-sixth of the families. Kind neighbors sometimes helped, with or without pay. A few children went to day nurseries. Some working mothers rushed home at noon to prepare lunch for children who were unsupervised the rest of the day.[74]

In a sense, mothers who went to work sometimes exchanged roles with adolescent daughters who assumed greater responsibility for household tasks and child care. When there was no other baby-sitter, older siblings as young as nine or ten often took responsibility for younger children. Daughters of thirteen and fourteen who might previously have gone out to work in the silk mill instead attended school all day and then rushed home to care for younger school-age children, clean house, and start cooking supper.

Both mothers and daughters in working families faced hard choices. In some cases daughters had to choose between loyalty to parents and the desire to pursue personal goals. Many of them clung to traditional family ties. Some very young women responded to the desperate needs of fathers who lost their jobs. In Carbondale and other Pennsylvania towns, adolescents and young adults dutifully brought their wages home to parents who depended on them. Siblings worked to support one another. But census data, government surveys, and narrative evidence reveal that a small proportion of women did break with traditional patterns in order to achieve greater independence or material rewards.[75]

Mothers in working families sometimes reported to work in the mills in order to secure an education and a new way of life for their children. Married women in the Lehigh Valley who responded to government questionnaires gave many reasons for holding down jobs. Most common among these were a husband's unemployment, insecurity of the husband's job, illness or the fear of it, responsibility for aged parents, paying for a home or furniture, paying debts, or building up savings for old age.[76] However, at least seven hundred of the two thousand women who responded to Women's Bureau interviewers referred to plans for their children and their children's education as reasons for going to work.[77] These immigrant women embraced the promise of a better standard of living in America. Many of them took jobs in the mills so their daughters would not have to.

Changing patterns of family life caused stress and trauma for the people of the anthracite region and the Lehigh Valley. Hard eco-

nomic conditions and readjustments in family life took a toll upon vulnerable individuals. Studying the 1920s and 1930s, John Bodnar found an exceptionally high rate of mental illness among anthracite miners, their wives, and children.[78] The pressure to earn money and contribute to the support of the family in difficult times proved to be too much for some men and women, especially immigrants and their children.[79]

Rising aspirations increased tensions for working-class women. Mothers made sacrifices so their daughters could find better, easier, more fulfilling lives. But in many families no amount of sacrifice could overcome the problems of a declining economy, male unemployment, illness, and debt. Many daughters still went to work to support ailing parents. Many women never escaped from the mills, but continued working as machine tenders in their thirties, forties, fifties, and sixties.

Consider the case of Loretta Malloy, the thirty-one-year-old silk hand who still lived in her parents' household in Carbondale in 1920, and whose younger sister found work in a doctor's office. Did she experience envy and regret? Did she dream of a different and more fulfilling life? And where might she be in twenty years time—still living at home supporting aged parents?

The case of Stacia Treski, as recounted by John Bodnar, also illustrates the limited occupational choices for working-class women in northeastern Pennsylvania in the 1920s.[80] As a young girl in the mining town of Nanticoke, Stacia felt the pull of new hopes and possibilities. The daughter of Polish immigrants, she dreamed of being a nurse, but she knew she had no hope of achieving her dream. "But how could you get to be a nurse? I mean you just couldn't. If you didn't have money you just didn't go to school. We really didn't have any money. My father wasn't working. My sister had a nervous breakdown."[81]

Stacia's older sister shouldered the responsibility for supporting her parents and siblings. The family's economic straits forced this young girl to go to work in a silk mill in the late 1920s or early 1930s. As Stacia recalled during an interview many years later, her father had lost four fingers in a mine accident. He could never go back to work again. He also suffered from black lung disease and there was no workers' compensation for it. His eldest daughter, Stacia's sister, became the sole support of the family. She worked for a year, earning ten cents an hour for ten hours a day, six days a week. Eventually, she could no longer bear it and suffered a nervous breakdown. The family sent her to a mental hospital.[82] When she left the hospital she continued to have delusions of being pur

sued.[83] In an ironic twist on the poem "Papa on Parade," the formerly muscular, steely miner became dependent upon his adoring angelic daughter, and this daughter could not endure the strain.

Stacia Treski's life experience epitomized the tensions between traditional family roles and economic realities in northeastern Pennsylvania. Male parents were supposed to provide for female children. Female children were supposed to be loyal to their parents. Stacia's father could not perform his prescribed role. But Stacia remained loyal. She tried to be both breadwinner and dutiful daughter.

Throughout the Great Depression, Stacia Treski tried desperately to support her invalid father, aging mother, and emotionally scarred sister. In the 1930s, Stacia Treski went looking for a job in the silk mills. But in the midst of the Depression she could not find one. Her only options in Nanticoke were the silk mill or the cigar factory, so she left the region to look for work. Finally she resorted to cleaning houses in a town on the coast. Her parents expected her to send money home to the family, and she complied.[84]

For Stacia Treski, traditional loyalty took precedence over her own aspirations. Her strong sense of duty motivated her to find work and send a large portion of her wages home. The declining anthracite economy forced her to leave the region for economic survival. And yet her ties to the region remained strong. She eventually returned, married, and spent her life there.

Despite her tradition-bound choices, Stacia felt drawn to a different kind of life. In her childhood and adolescence she had aspired to become a nurse. Fifty years later she remembered this desire with emotion and anger. Her early hopes had come into conflict with the hard realities of male unemployment, illness, injury, the lack of social support systems, and the loyalty she felt she owed to her father. In her generation the old patterns of life remained compelling. But another generation would find new ways of living. Stacia herself had learned to dream of better things.

8

Divided Labor

It was Mitchell more than any other one individual who won the anthracite mine workers to membership in the Union, and it was under his leadership that the hard coal workers won their first victories. To the mine workers Mitchell was the personification of united labor.

—William J. Walsh, 1931

By the end of the 1920s, labor in northeastern Pennsylvania was not united. Early in the decade the Amalgamated Textile Workers of America (ATWA) tried to organize Pennsylvania silk workers. ATWA, which opposed the conservative United Textile Workers (UTW), had some success in Allentown but in general its leadership concluded that Pennsylvania was "different."[1] Wages were lower and the workweek longer than in New Jersey, but workers remained unorganized and strikes infrequent.[2] According to historian Alice Kessler-Harris, Pennsylvania may not have been so "different." Kessler-Harris concluded that in the nineteenth and early twentieth centuries the vast majority of female workers did not join unions. In Pennsylvania and elsewhere, girls and young women had learned to look toward education and the hope of white-collar jobs, not to the union, as the way to a better life.[3]

Many anthracite miners lost faith in the UMWA under its new leader John L. Lewis in the late 1920s.[4] Lewis rose to power by wheeling and dealing, cooperated with the Republican federal government, fraternized with industrial capitalists, and suppressed rank-and-file dissent.[5] In 1925, the hard-coal region was one of the union's few remaining strongholds.[6] A long, brutal strike against the anthracite mine companies produced no significant gains for miners. Some miners blamed the strike for the subsequent slump in the anthracite market,[7] although the causes of this slump and the long-term decline of the industry were beyond the control of the union. Disillusioned miners concluded that their old union was

128

hopelessly corrupt and not truly committed to winning justice for its members.[8] John Brophy denounced Lewis as a traitor to the miners' best interests.[9] Membership declined steadily between 1927 and 1933, causing Lewis to doubt if his leadership could survive.[10]

Old loyalties lingered. Writing in 1931, historian William J. Walsh drew a portrait of the anthracite region and its attachment to John Mitchell. Walsh described the imposing statue of Mitchell that stood, and still stands, on the courthouse lawn in Scranton. In chronicling the impact of the UMWA on the society of northeastern Pennsylvania, Walsh characterized Mitchell as the hero of all hard-coal mining families. Mitchell's influence on anthracite miners was greater than that of any other leader.[11] But Mitchell's mystique could not feed hungry children or keep hard-coal families together during the Great Depression.

Without a strong union, miners and their families had little protection from the ravages of the first few years of the Great Depression. Coal companies cut back and concentrated production in a few facilities, reducing employment opportunities for miners. Miners protested these actions and demanded that companies spread the jobs among as many mines as possible. The companies insisted that their major concern was efficiency, not the equal distribution of jobs. The concentration of production continued to such an extent

Carbondale City Hall and Town Square. Photo by Bonnie Stepenoff, 21 July 1991.

that in some towns, such as Tamaqua, Coaldale, and Nanticoke, employment in 1933 had dwindled to one-third of the 1929 level.[12]

The Depression had a frightening impact on communities like Carbondale. On 12 May 1931 the Miners and Merchants Bank closed its doors after a run by panicky depositors. On the day state officials shut down the bank, a local band was waiting to celebrate an expected "victory" over panic. But the band ended up playing "Memories."[13] During the following year the local school board fired all non-resident teachers and reduced the salaries of the remaining teachers by half. Executives of the Hudson Coal Company proposed wage cuts, and the Powderly Mine cut working hours. Local residents held a benefit at the Irving Theater for needy miners. By the end of 1932 local relief rolls had swollen to the point of being unmanageable. The Red Cross distributed flour to hungry families and food to schoolchildren. The high school was overcrowded because young men and women could not find jobs.[14]

Desperate families struggled to cope with economic distress. In a 1994 interview, Dolores (Gonus) Liuzzo of Carbondale remembered her childhood in the 1930s. Her father was an unemployed miner and her mother worked when she could. During the Depression the family suffered extreme poverty. The children tried to help by going out and picking huckleberries in the Pennsylvania hills. There was little relief from misery. Even a ten-cent movie was beyond the family's means, as she recalled. "We were poor. We were so poor we were paupers. If you asked for ten cents to go to the movies, you couldn't go to the movies. We had nothing." (Dolores Gonus Liuzzo, 23 July 1994).[15]

Historian John Bodnar has documented the "family-based culture and economy" of the region in the 1930s. Young daughters and sons went out to work "at a feverish pace" and shared their wages with parents and siblings. Economic and emotional ties within families were very strong, and so was discipline.[16] Males took seriously their role as providers. When hard times prevented them from fulfilling their responsibilities they experienced tension and pain. Bodnar noted a high rate of mental illness among miners during the Depression. Wives and mothers who managed the home and often handled family budgets also suffered from escalating pressures. Daughters who shouldered responsibility for families sinking under economic hardship sometimes could not bear the stress. Both males and females in the hard-coal region experienced high rates of mental illness in the 1930s.[17]

In this depressed economy, female family members wanted and needed work, although many could not find jobs. Women laid off

from the silk industry in northeastern Pennsylvania sought employ-
ment elsewhere. In 1933 the federal Department of Labor studied
women who lost their jobs when two silk mills closed in Philadel-
phia and Bethlehem (in the Lehigh Valley). The 323 women inter-
viewed ranged in age from fifteen to seventy-two, with the median
age being twenty-six at the time of the layoffs. About forty percent
were or had been married. Ten months after the mill closings, fifty-
seven percent had found jobs but thirty-eight percent remained un-
employed. Only five percent had ceased looking for work. Most of
the job seekers went from mill to mill. Help from former employers
or friends sometimes resulted in employment. Of those who did
find jobs, two-fifths returned to the silk mills and about ten percent
found work in other types of manufacturing. Others found positions
in domestic service, beauty parlors, and retail stores. Those who
failed to find work exhausted family savings, resorted to living on
credit, or sought relief from the government.[18]

Between 1929 and 1933 the number of silk workers employed in
Pennsylvania fell from more than sixty thousand to less than fifty
thousand, and wages declined.[19] United States government studies
revealed that average hourly earnings for silk workers nationwide
dropped from about forty-three cents in 1929 to about thirty cents
in 1933. In addition, silk hands worked fewer hours in the typical
week during the 1930s. Average weekly earnings for all silk work-
ers fell from twenty-one dollars in 1929 to twelve dollars in 1933.[20]
In Allentown and its vicinity, workers reported wage reductions
ranging from twenty-five percent to forty-five percent between
1929 and 1931.[21]

Silk mills in Scranton and Carbondale laid off workers or closed
their doors. In 1929, Scranton had thirty silk mills employing 123
salaried officials and 3,864 wage laborers.[22] By 1940, Scranton's
mills employed only 2,322 wage workers (906 males and 1,416 fe-
males), less than two-thirds of the 1929 number.[23] By 1940 the cen-
sus listed only thirty-eight silk workers in Carbondale (twenty-one
males and seventeen females), down from approximately 259 work-
ers in 1920.[24]

Silk workers protested wage reductions by going out on strike in
Hazleton and the Lehigh Valley. In December 1930, Duplan man-
agement quelled labor unrest by threatening to close its Hazleton
plant.[25] Weavers and other workers left their jobs at the Majestic
mill in Allentown in the spring of 1931 after management imposed
a sixteen-and-a-half percent wage cut, the fourth wage reduction in
a year.[26] Fourteen other mills quickly became involved in this
strike. Among the first were Phoenix Silk Manufacturing Company,

Pyramid Silk Mills, Edna Silk Mills, and Allentown Silk Company, and other Allentown mills.

The strike spread rapidly throughout the valley.[27] By 6 May 1931, federal observers reported that the "number of mills involved and the territory affected is constantly increasing and at the present writing there are 33 mills with approximately 6000 workers involved."[28] Two weeks later, United States Department of Labor officials stated that eighty-six hundred weavers, warpers, twisters, winders, and other silk workers had gone out on strike.[29]

Workers, preparing for a long fight, raised money by forming bands and baseball teams, holding fund-raising events, and even raising a crop of vegetables. On 12 June a team of strikers played the Allentown Colored Sox[30] on a local baseball diamond. The Lehigh Band, made up of eleven strikers, furnished music.[31] Later in the month, strikers sponsored an ice cream festival featuring a fifty-piece band. Three thousand people attended that event, at which the strikers auctioned off an "artistically-adorned" fifteen-pound cake.[32] On a tract of land along Tilghman Street in Allentown, strikers raised beans, tomatoes, and potatoes and distributed them to those in need.[33]

Silk workers in Paterson, New Jersey, and Central Falls and Pawtucket, Rhode Island, also walked off their jobs in the spring and summer of 1931. Many New Jersey and Rhode Island silk workers belonged to the National Textile Workers Union (NTW), a much more militant group than the conciliatory AFL-affiliated UTW. In Pawtucket, Pennsylvania-born Ann Burlak earned the nickname "Red Flame" for her flamboyant support of the NTW.[34]

James Marsch, a forty-one-year-old loom fixer from Easton, Pennsylvania, visited Paterson in July and talked to strikers there. Subsequently, NTW leaders came to the Lehigh Valley to try to organize the silk workers there.[35] UTW organizers severely chastised Marsch for his contacts with the NTW and formally read him out of his local union organization.[36]

Local leaders blamed outside agitators for stirring up the violence that erupted in Allentown and nearby cities and towns. In Allentown in early July unknown persons bombed the Majestic Mill, the Phoenix Mill, and a private residence. Nearby in Fullerton, dynamite exploded in the McBride Mill.[37] As some workers returned to their jobs, a group of strike sympathizers called the "Night Riders" committed acts of vandalism.[38] Allentown newspapers reported that this group, operating between midnight and dawn, stoned the houses of workers who reported to the mills.[39] In nearby Slatington a silk worker named Howard Kleppinger reported that at four fif-

teen on the morning of 1 August 1931, someone threw rocks, acid, and paint through the windows of his home.[40] Former miner Alex Pertko, a night watchman at the Pyramid Silk Mill, found a crudely constructed bomb in his home in Allentown. Police attributed the bomb to "radicals" trying to intimidate workers who had returned to the mills.[41]

In a conflict reminiscent of the Hazleton struggle of 1913, militant workers with support from Paterson-based leaders fought to wrest control of the strike from the UTW. A group called the United Front Committee took over a meeting in Coplay, north of Allentown, on 14 July. This group forced UTW organizers Arthur Mc-Donnell and Joseph Steiner from the platform and addressed the crowd. A representative of the U.S. Department of Labor identified the "invaders" as "Communists from Paterson, N.J."[42]

The United Front Committee, headed by June Kroll, a Communist,[43] held mass meetings urging a general strike of all silk workers nationwide and a uniform wage rate throughout the industry. This appeal for a standard wage rate won sympathy among many Pennsylvania workers, who were aware that their wages were generally lower than those in Paterson although higher than those in the southern states. Management continually pressured workers to accept low wages by threatening to move their mills to other towns where even lower rates prevailed. Many strikers felt drawn to the United Front Committee, and loyalty to the UTW began to weaken.[44]

With loyalties divided and anxieties running high, strikers attending a mass meeting on Thursday, 6 August engaged in shouting matches and fistfights. The UTW sponsored this assembly and tried to bar Communists from attending. But a group of militant strikers broke through the guards at the door and attempted to take over the meeting. The UTW quickly adjourned the conference, but a free-for-all ensued. The *Allentown Morning Call* described the scene vividly. "Fists flew right and left, chairs were thrown about the room, some of the strikers jumped out of windows, while men shouted and women screamed."[45] The police arrested Marsch, the Easton loom fixer, as the ringleader of the uprising.[46]

The nationally famous socialist leader Norman Thomas, addressing a crowd the following night, praised the workers for their courage, warned them against dissension in their ranks, and urged them to remain loyal to the moderate non-Communist UTW. Thomas, president of an emergency committee for strike relief, also encouraged the workers to continue fighting wage cuts. He said the crippling Depression had caused paralysis among many workers, and

noted, "It began to look like the American workers would become doormats as they went through the depression period without objecting. And with the workers unorganized why should the manufacturers discontinue cutting wages?"[47] With his characteristically homely eloquence, he urged workers to stick with the UTW. "A man without a union," he said, "is like one without a country—not that they are bad but dumb."[48]

While he encouraged workers to stand up for themselves, he also counseled them to be restrained, law-abiding, and patriotic. His reference to a man "without a country" shrewdly reminded strikers of their duty as citizens to eschew violence and work within the law. By encouraging strikers to stick with the UTW he was also warning them to stay away from the NTW and other more radical organizations. Underlying his call for staunch unionism therefore was a plea for moderation and conciliation.

Some silk workers viewed Thomas' speech as double-talk. They believed the union had betrayed them by caving in to business interests and the police power of the state rather than fighting for workers' rights. The militant James Marsch faction printed posters protesting Marsch's arrest and castigating the UTW. One broadside began: FELLOW SILK WORKERS:—The UTW has exposed itself to the full—TO BE NOTHING OTHER THAN A BOSSES' AGENCY WORKING HAND IN HAND WITH THE PO-LICE—TO BREAK OUR STRIKE. This poster went on to interpret the events of 6 August as a failed revolution quelled by a coalition of the UTW, the local socialist party, and the police. Describing the riotous meeting, the authors of the broadside stated:

> On Thursday night at Liederkrantz Hall, the silk workers decided to oust the fakirs of the UTW out of the leadership of their strike and to take the leadership into their own hands—to bring about a successful conclusion of their 15 week old struggle for BREAD.[49]

Calling themselves the Silk Strikers of Allentown, the protesters accused the UTW and police of starting the riot by arresting Marsch and brutally attacking strikers.[50] These protesters called a meeting for Saturday, 8 August, but their strident pleas fell mostly on deaf ears. The militant group led by the Easton loom fixer was definitely a minority.

In a sequence of events strongly reminiscent of Hazleton in 1913, powerful social groups rallied to suppress radical activity and workers gradually returned to the mills. A citizens committee appointed by the Allentown Chamber of Commerce had already concluded

that the strike was hopeless and the city faced the danger of losing the silk industry unless workers returned to their jobs.[51] Pressured by this group and fearful of radical elements among strikers, the UTW permitted individual shop committees to settle with individual mills, allowing more and more strikers to go back to work.[52]

Clergymen played a prominent role in settling the Allentown strike. On 10 August 1931, Rev. Charles C. Webber preached a sermon in Emmanuel Reformed Church, Sixteenth and Chew Streets, Allentown, advocating a peaceful and equitable resolution to the conflict. The Reverend Mr. Webber urged industrial leaders to introduce democracy and fairness into their factories. The minister set forth three basic tenets concerning employee relations:

> The principle that each human individual has distinct and measureless value as a child of God; the principle that each person in that position is a brother in the vast human brotherhood; and third that the strong are the ones that shall serve the community.[53]

Webber's sermon asserted the basic values of welfare capitalism, based upon the belief that benevolent employers should—and would—establish humane conditions in the workplace, thus eliminating the need for union activities.

In mid-August a committee of clergymen chaired by Rev. Willis D. Mathias, pastor of Emmanuel Reformed Church, held meetings with silk manufacturers and striking employees to bring about a settlement.[54] With local clergymen acting as mediators, strikers came to terms with the managers of several plants, and mills gradually resumed operations.[55] Managers granted very few concessions. But strikers were strained to the limit by the loss of wages and dissension in their ranks. Gradually they accepted whatever they could get from individual employers and voted to return to their jobs.[56]

Representatives of the U.S. Department of Labor who had come to Allentown to mediate the strike admitted their failure to win any significant wage increases for the workers. By 4 August, Fred Keightly, commissioner of conciliation, had reported to his bureau chief H. L. Kerwin that the strike had basically ended. Most mills had resumed operations at least in part even before the riotous meeting of 6 August.[57] Even with the support of Pennsylvania governor Gifford Pinchot, Keightly had not been able to persuade manufacturers to enter into serious negotiations with strikers.[58] By 18 August, Keightly reported that most workers had voted to return to the mills at the wages prevailing at the time of the strike.[59] Although the strikers won no wage increase, they did win the right to return

to their jobs and the right to belong to a union, rights not yet guaranteed by federal law.[60]

By 1932, with his own union in disarray, Lewis had come to the conclusion that workers needed help from the government. During the 1920s the burly individualist had supported Republican laissez-faire policies. After the 1928 presidential election he rejected Herbert Hoover's doomed belief that the economy could recover under its own steam. As early as the mid-1920s, Lewis had begun demanding that the federal government do something to control prices and production and give workers a voice in the management of industry. His pragmatic philosophy and newfound conviction that the government had to do something dramatic to revive the confidence of American workers meshed well with the beliefs of President-elect Franklin D. Roosevelt.[61]

After Roosevelt's election in 1932, miners throughout the country flocked to the UMWA. Lewis understood the new enthusiasm, supported it, and linked it to the government's changed attitude toward unions.[62] The National Industrial Recovery Act (NIRA) of 1933 included Section 7-A, which asserted the workers' right to organize and bargain collectively through their chosen representatives. In coalfields throughout Pennsylvania, UMWA organizers posted signs and shouted, "The law is on our side."[63] Although the NIRA did not survive review by the U.S. Supreme Court, Roosevelt's New Deal continued supporting labor unions. The Wagner Act of 1935 reaffirmed the right of collective bargaining and created the National Labor Relations Board. The Fair Labor Standards Act of 1938 restricted child labor, limited working hours, and established a minimum wage.[64] With the moral support of the federal government, union membership soared.

Some disaffected anthracite miners resisted Lewis' efforts to bring them back into the UMWA fold.[65] Miners and their families, faced with the loss of jobs and income, feared that the UMWA did not understand their plight. Bodnar has observed that anthracite families' hopes centered on the issue of job equalization, an issue upon which Lewis and the UMWA vacillated.[66] After 1930, anthracite miners insisted that mining companies had an obligation to spread work evenly among various collieries rather than concentrate production in a few of the most profitable operations. Miners were more concerned with keeping their jobs than winning higher wages. But Lewis and the UMWA never embraced the issue of equalization and continued to focus their efforts on raising wages and shortening working hours.[67]

A new union, the United Anthracite Miners of Pennsylvania

(UAM), openly opposed the UMWA as being unresponsive to min-
ers' real needs. In 1933 and 1934 the UAM tried to use labor's new
position, established under Section 7-A, to win concessions from
anthracite mine owners and replace the UMWA as the representa-
tive of hard coal miners. Monsignor John J. Curran of Wilkes-Barre
made several trips to Washington to seek support for the new union
from the National Labor Relations Board, with little success.
Throughout 1934 the major coal companies, the UMWA, and gov-
ernment arbitrators combined to undercut the new union.[68]

During a 1935 strike supported by the UAM and opposed by the
UMWA,[69] women and children stoned men who tried to go to work
in Nanticoke. In Plymouth, police arrested five women for beating
a miner on his way to work. In Wilkes-Barre, ten women wrestled
three miners to the ground. Rage and bitterness led families to stone
the funeral procession of a dead strikebreaker and fill his open
grave with tin cans.[70] The violent incidents of 1935 led to the legal
disbanding of the UAM. By 1936, amid continuing violence, resis-
tance to the resurgent UMWA collapsed.[71]

Lewis emerged from leadership in the miners' union to become
the nation's most powerful labor leader. In 1935 Lewis challenged
the old guard of the AFL and joined with John Brophy and others
to create the Committee for Industrial Organization (CIO).[72] Dele-
gates to the 1936 UMWA convention cheered wildly as he called
for a new and stronger labor movement dedicated to organizing the
unorganized mass of American workers. Lewis' old adversary Bro-
phy called the rejuvenated miners' union a "beacon of light for the
workers and those who value the democratic political structure."[73]

Burly and charismatic, Lewis embodied the ideal of the rough,
strong, broad-shouldered, fatherly figure romanticized in the poem
"Papa on Parade." He was also ruthless and opportunistic, a man
who rode in chauffeur-driven cars and ran his union like an old-
time political boss. Like Mitchell, he felt comfortable dealing with
powerful men in industry and government. Like Powderly, he had
an unquenchable belief in the power of individual effort and per-
sonal success.[74] Like Franklin D. Roosevelt, he believed that labor's
representatives and the federal government should take part in run-
ning America's economy, but that America's capitalistic economic
system was fundamentally sound.

In 1936 the labor leader and the President came to the anthracite
region. Not coincidentally they arrived in Wilkes-Barre on October
29, Johnny Mitchell Day.[75] When the Pennsylvania Railroad's spe-
cial train appeared on a spur line into Miner Park, thousands of peo-
ple let out a cheer. Lewis introduced the President, who eloquently

reminded the anthracite miners of their old victories under Mitch-
ell's leadership. The President shrewdly understood that the hero of
1902 still retained a powerful hold on the region even in the 1930s
The obvious connection of this president with Theodore Roosevelt
who had ordered the Anthracite Coal Strike Commission hearings
in 1902, also influenced the region's workers to put aside their fear
and anger and pin their hopes on FDR's New Deal.

The charismatic President revived loyalties that the Great De-
pression had severely undermined. During his historic visit to the
anthracite region, Roosevelt appealed to the workers' emotional at-
tachment to Mitchell. After praising Lewis as a friend and adviser
Roosevelt launched into a paean to the virtues of Social Security
and other programs of his Second New Deal.[76] By calling upon
Mitchell's remembered glory, Roosevelt and Lewis found an effec-
tive way to win the hearts of anthracite people.

New Deal economic and social policies had limited impact on the
silk industry and its workers. Under National Recovery Administra-
tion (NRA) guidelines, silk manufacturers developed codes of fair
competition. In 1935, two years after the silk codes were estab-
lished, Harvey Walton, representing the American Federation of
Silk and Rayon Workers of East Stroudsburg, Pennsylvania, told
New Deal administrators what had happened in his little town. He
praised the NRA ideal of doing away with cutthroat competition but
doubted that the highly competitive silk industry would ever ade-
quately regulate itself as NRA administrators hoped. In his town he
had seen no change in the behavior of management toward workers
Workers' demands for compliance with the codes sometimes re-
sulted in the closing of mills.[77]

According to Walton, silk companies found ingenious ways to
circumvent the NRA codes. Prohibited from cutting wages, one
company changed its legal identity. Local management brought su
perintendents from their Wyoming, Pennsylvania, plant to lease the
East Stroudsburg mill. When the mill reopened under a new name
and supposedly with new management, the company lowered
wages. Walton said

> Legally, on account of the lease and naming it a different name, it had
> to be recognized as a new mill. We know, and I think everybody else
> can understand it was just another chiseling tactic that the manufacturer
> in the silk and rayon industry used to starve the workers.[78]

The most common and most effective tactic used by management
to keep workers in line was to threaten to move, or to actually

nove, to another state where wages were lower. Louise Lamphere
noted in her book on textile workers in Rhode Island that in the
920s and 1930s silk companies moved in to fill a void left by the
lecline of the cotton industry there.[79] The NRA codes included
vage differentials for different states. In some New England states
nd in southern states wages remained substantially and legally
ower than in New Jersey and Pennsylvania. Walton reported that in
ne mill, management told workers that if they did not accept a pay
eduction the mill would move to another town. The workers voted
o accept the reduction. Another East Stroudsburg mill actually did
nove to another town in another state,[80] and this trend was general
hroughout the silk industry.

Despite the protests of people like Harvey Walton, the NRA
odes failed to equalize wages in the silk industry and companies
ontinued to close mills in Pennsylvania and open them in other
tates with lower wage scales. Even during the terrible early years
f the Depression, when the number of silk workers in Pennsylva-
ia and New Jersey declined, the number of silk workers employed
n some New England states and in southern states actually in-
reased. The "Number of Silk Workers" chart illustrates this trend.

| | Number of Silk Workers | | |
State	1929	1931	1933
Pennsylvania	61,544	49,938	49,215
New Jersey	21,419	13,626	10,705
Massachusetts	7,390	6,939	9,278
Rhode Island	7,589	7,060	9,187
Southern states	12,065	14,710	17,296[81]

Jew Deal administrators commented on the flight of mills from
Jew Jersey and Pennsylvania to New England and the South as
ollows:

It is interesting to note that the decline in employment in the principal
[silk] manufacturing states—Pennsylvania, New Jersey, and New
York—has been rather severe, whereas there have been slight increases
in Massachusetts and Rhode Island, and approximately a 45 per cent
increase in "All Other States," which are principally in the south. This
movement may be attributed to several causes, among which are the
attempts of manufacturers in the former states to seek lower wage levels
and to escape labor-union activity.[82]

Armed with the threat of taking mills and jobs elsewhere, man-
gement habitually ignored or resisted union demands even when

these demands were based on federal labor laws. Pennsylvania'
silk workers had to fight continually to induce employers to live u
to their responsibilities under New Deal programs. In the Fall c
1933, Hazleton silk workers battled to organize, but Duplan Mar
agement resisted and made repeated efforts to undermine unio
autonomy.[83]

In the spring of 1934, workers at the Majestic Silk Company i
Allentown began a battle to force management to recognize the
union and meet with their representatives as stipulated under NR
code. Weavers at the mill, which was ninety percent unionized, sht
down their looms on 21 March 1934 and stood on the shop floc
for two hours while their union committee presented their demand
to management.[84] The union, affiliated with Allentown branch, nc
10, American Federation of Silk Workers (AFSW), asked for
twenty percent wage increase and charged that the company faile
to pay the minimum wage established by the NRA code.[85] On tha
day management offered a six percent raise, but the battl
continued.[86]

The immediate cause of the dispute at the Majestic mill was
claim of discrimination by a female weaver named Irene Clark. I
March 1934, Miss Clark alleged that she had not been called bac
to work after a strike in the fall of 1933 and that another femal
worker had replaced her. She further claimed that the mill's super
intendent, M. D. Clader, had discriminated against her because sh
had refused what she believed to be sexual advances. She told ir
vestigators that she had worked at the mill for over two years befor
the strike. About two months after she began working at the mil
she stated:

> she was on her way home when Mr. Clader drove up and asked her
> he could take her home. Being only a block from her home and as h
> car was driving in an opposite direction, she kindly thanked him ar
> continued walking. After that incident Clader had little to say to her.[87]

Miss Clark alleged that after this incident Mr. Clader personall
disliked her and that, because of this personal animosity, refuse
to rehire her. Nathan W. Shefferman, the examiner for the feder
government, agreed with her and ordered her reinstatement.[88]

Miss Clark's discrimination complaint drew attention to conflic
between adult female workers and male managers, and also mob
lized workers at the Majestic mill to tackle the wider issue of th
failure of management to meet with labor's representatives and di
cuss their grievances. In April 1934, Majestic silk workers de

anded a hearing before the Regional Labor Board at Philadelphia,
:cusing the company of violating Section 7-A of NRA by refusing
 meet with Sam Macri, president of the Allentown branch of the
FSW.[89] Bernard Bernstein, owner of the mill, ignored a summons
 appear before the Regional Labor Board on 10 April, and work-
s' representatives charged that Bernstein had defied the NRA ever
nce the silk industry code was adopted. The workers again de-
anded union recognition, a twenty percent wage increase, and ad-
stment of back pay due them under the NRA minimum wage
ale. Nathan Shefferman, mediator of the National Labor Relations
oard, threatened to render a decision the following week whether
ernstein appeared or not.[90]

The owner of the Majestic eventually met with union leaders and
federal mediator in May of 1934. Bernstein defended his wage
ale by arguing that unemployed people came to him and offered
 work for even less if only he would give them a job. He further
aimed that the mill was losing money. Finally, he threatened that
 the union did not stop "hammering" management, he would be
rced to move the mill out of town.[91]

In terms calculated to appeal to the emotions of frightened work-
s, Bernstein offered to keep all his operatives steadily employed
though he did not give in on the demand for higher wages. In the
esence of the federal mediator and union leader he vowed to sign
e NRA agreement providing for a thirty-five-hour workweek,
ith workers to be paid the same amount as they had previously
rned for a forty-hour week. Referring to General Hugh Johnson,
ad of the NRA, Bernstein announced:

As true as God is my judge, and I am a religious man, I'm going to
write to General Johnson and strive to the utmost to keep our people
steadily employed. I will be the first one to put the Majestic Silk Mills
signature to the 35 hour per week code.[92]

Shefferman the mediator accepted Bernstein's promises, admon-
ned Macri to behave more moderately in the future, and urged the
ll owner and union leader to shake hands. Bernstein could not
sist the urge to preach somewhat incoherently to Macri:

Mr. Macri, you can get more flies with honey than with vinegar and that
goes a big way. When you present yourself without any antagonism and
without any malice and without using outside means to paint that indi-
vidual black you have defeated your own purpose and are doing an
injustice.[93]

The federal mediator closed the meeting prosaically, treating th
two male antagonists like boys caught fighting in the school yar
"From now on," he said, "be sure of your case and present it a
man to man."[94] The conflict, which began with a woman's protes
ended with a male confrontation and a settlement favorable t
management.

Neither the revived UMWA nor the New Deal could reverse th
decline of the anthracite industry, stop the silk industry from lea
ing Pennsylvania, or prevent the eventual mass exodus of peop
from a troubled region. The loyalty of anthracite miners to John I
Lewis remained guarded as he continually seemed to misunde
stand their deepest dread, the possibility of losing their livelihoc
entirely as the mines and mills closed down.

Declining employment in both anthracite mining and the silk in
dustry meant that hard times continued in northeastern Pennsylv
nia. In Carbondale in 1940, after a decade of depression and seve
years of the New Deal, twenty-seven percent of the labor force r
mained unemployed. The 1940 census indicated that in Carbondal
1,523 men and 454 women actively sought jobs. Twenty-two pe
cent of the females over fourteen years of age in Carbonda
worked or wanted to work. Approximately twelve hundred of thes
women held jobs. Of these, 182 did relief work in government pr
grams such as the Works Progress Administration (WPA). Abo
454 Carbondale women were looking for work.[95] For these wome
and men, hard times would continue.

Throughout the 1930s miners and their families left the regic
in significant numbers. Between 1930 and 1940 for example, th
population of Scranton declined from 143,433 to 140,404. In th
same time period the population of Carbondale fell from 20,061
19,371.[96] The pace of flight slackened in the late 1930s. But in th
late 1940s and the 1950s, as unemployment spread, the flight
workers became a mass exodus.[97]

Three generations of labor leaders had left a complex legacy
the region. Powderly's commitment to solidarity and labor prote
had never been as strong as his belief in individual achieveme
through education and hard work. Mother Jones had preached mi
tant unionism, but embodied the ideal of the strong mother fightir
to protect her children. Her rhetoric often seemed radical, but h
image tended to reinforce the power of traditional family tie
Mitchell had led a massive labor uprising in 1902, but had quick
shown a willingness to negotiate with corporate leaders. His imag
that of a compassionate father, remained a powerful icon for th
region. Lewis had been strong and charismatic, but never seeme

o understand the workers' fear that the mines, the mills, and their obs would disappear.

Textile unions tried numerous times to organize Pennsylvania's ilk workers with mixed results. In 1907, the UTW led strikes in Scranton, but the arbitrated settlement made no dramatic difference n wages or conditions. IWW organizers exhorted Pennsylvania's vorkers to join the silk strike that blazed in 1913 in Paterson, New ersey, but owners kept nearly all the Pennsylvania mills in operaion. At the time of World War I, Paterson workers complained biterly of the problem of competing with non-union Pennsylvania irms.[98] The Amalgamated Clothing Workers of America (ACWA) ind later the ATWA mobilized workers in Lawrence, Massachuetts, Paterson and Passaic, New Jersey, and Allentown, but had litle success in the hills and valleys of the hard-coal region. New Deal labor policies and a rejuvenated UMWA increased union nembership in the 1930s. Strikes and protests flared in various silk nills. In fall of 1934, Hazleton workers rallied in support of the JTW.[99] But union efforts faltered as workers in the region faced the eal possibility of losing their means of a livelihood.

For women workers the union message often seemed to be that hey did not belong in the mines or the factories but at home and in chool. Girls and young women lost and gained from this philosohy. The emphasis on raising wages of male breadwinners discouriged women from asserting their own rights as workers. But the ong battle against child labor won for many of them the right to a iigh school education. Gradually and in growing numbers they ised their education to find a way out of the home and back into he workplace.

9

Finding a New Way

I worked part-time in the silk mill and finished high school with
a 96 average in 1945. The money I earned helped me go to Lack-
awanna Junior College for one year. I ran an office for years in
Scranton, then later worked for twenty-eight years as an office
manager in Carbondale.
—Dolores (Gonus) Liuzzo, 23 June 1994

In 1994, Dolores (Gonus) Liuzzo remembered her mother, Helen
(Hulek) Gonus, going to work in the silk mill more than half a cen-
tury earlier. "It was the Depression," Liuzzo recalled, "and, you
know, in the Depression, the men didn't work." In 1943, young Do-
lores Gonus went to work in the Krapf mill in Peckville with her
mother. Dolores was fourteen but tall for her age. She said the mill
workers behaved "more like a family." The older women "treated
me like a little queen." Liuzzo began her working life in the silk
mill. Unlike her older co-workers, she worked weekends and con-
tinued her education. She had different occupational goals in mind.
 The Great Depression lingered past its appointed time in north
eastern Pennsylvania. Both the anthracite industry and the silk in
dustry declined in the 1940s and 1950s. Economic distress
characterized the anthracite region for decades after the Depression
The Lehigh Valley with its more diversified economy fared bette
in general, but there too the silk industry had faded into near obliv
ion by 1960.
 Most of the mines in the northern coalfields in the area surround
ing Scranton, Carbondale, and Wilkes-Barre had become unprofit
able and unsafe by the 1950s. The anthracite industry nearly
collapsed during the Great Depression, revived somewhat during
World War II, but died in the following decade. In the mid-twentieth
century, gas and oil replaced coal for home heating and industrial
fuel. By the 1980s the mines in the northern fields were defunct
The southern coalfields in Carbon, Luzerne, Schuylkill, and Nor

thumberland counties continued to produce a tiny fraction of the tonnage produced during World War I.

By the 1950s, more than a century of anthracite mining had left dangerous voids under the foundations of houses, schools, hospitals, neighborhoods, and towns in the hard-coal region. In haste to remove valuable fuel from underground shafts, mining companies had often neglected to allow enough coal to remain as pillars or construct supports for the roofs of the mines. Unsupported coal and rock in the mines sometimes shifted, causing cave-ins and deaths.[2] On 22 January 1959 the swollen, icy Susquehanna River broke through the roof of the Knox Mine near Pittston in the Wyoming Valley, killing twelve miners and dealing a death blow to the troubled hard-coal industry.[3]

While its decline was less precipitous, Pennsylvania's silk industry also dwindled between the 1930s and 1960s. The state's share of national production in this field declined from about forty percent in 1919 to about twenty-five percent in 1937, and the downward trend continued.[4] In 1929 silk and rayon goods represented more than twenty percent of all textiles produced in Pennsylvania. By 1946 the share had declined to about eight percent.[5] Silk yarns and thread (including rayon) accounted for nearly nine percent of the state's textile production in 1929, and approximately four percent in 1946.[6]

According to economist George Leffler, while textile production in the state increased between the 1920s and the 1940s, "heavy and discouraging" declines occurred in the production of silk and rayon yarns and thread, silk and rayon hosiery, and silk and rayon fabric. Each of these three industries had produced more than one hundred million dollars worth of products in 1929. The throwing industry (which produced silk thread) dropped below that figure by 1946, and according to Leffler "the other two showed great declines in value of production. In other words, three of the very important silk and rayon industries showed an immense slump in size during the 17-year period 1929–1946."[7] Unlike the state's other textile industries, silk (and rayon) production was concentrated in the hard-pressed anthracite region and the Lehigh Valley.

By the 1940s artificial fibers such as rayon replaced silk. Synthetic fabrics were cheaper and required less care. In the postwar years they captured a growing share of the consumer market. Pennsylvania mills began producing synthetic threads, yarns, and fabrics, but the state did not become a leader in rayon production. Industry leaders built newer, larger, more modern, and more effi-

cient plants for producing rayon in the southern states, especially North Carolina.

The 1947 *Census of Manufactures* clearly revealed the trends in production and employment in the silk and rayon industry. Pennsylvania continued to hold the lead in throwing mills, although North Carolina was making strong gains. Traditionally wages in throwing mills had been lower than those in weaving mills that produced narrow and broad fabric. In the weaving of silk and rayon fabric Pennsylvania had fallen behind. Of a total of more than five hundred rayon fabric manufacturing plants in the United States in 1947, 154 were located in New Jersey and 119 in Pennsylvania, but southern states had larger, more modern plants employing more workers. Although southern and western states accounted for only ninety-one plants, these employed 47,031 workers, nearly half of all those employed in the industry. By contrast, the small-scale New Jersey mills employed only 4,427 workers. Pennsylvania plants accounted for 16,412 employees.[8]

The steady decline continued after 1946. Between 1946 and 1950 the number of silk and rayon manufacturing plants in Pennsylvania declined from more than two hundred to approximately 160, according to Davison's directories of textile producers. In Scranton, Stewart Silk Corporation closed its doors, but most of the other mills remained open in 1950. The old Klots mill in Carbondale continued operating as General Textile Mills, specializing in parachute materials and molded plastics and later in medical/surgical materials. The other Carbondale mills, including the Empire mill, had closed before 1946.[9] In Allentown the number of mills dropped from a peak of more than fifty in 1928 to fewer than fifteen by 1950 and less than ten by 1960.[10] Allentown's last silk mill closed in 1989.[11] In the anthracite region the number of mills dwindled to less than a dozen, with each surviving mill filling some small specialized niche in the market.

As employment opportunities faded in both the anthracite mines and silk mills, working families joined in a mass exodus from the hard-coal region. The two most populous counties in the region, Lackawanna and Luzerne, grew steadily until the 1930 census and declined rapidly thereafter. Population figures for the Scranton reveal the sad decline of the region's urban center (see "Population/ Scranton" table).

Population

	1930	1940	1950	1960
Scranton	143,433	140,404	125,536	111,443[12]

Unlike Scranton, the city of Allentown in Lehigh County, with its more diversified economy, continued to grow despite the decline of the silk industry.

Census data for four silk-producing counties in the heart of the anthracite region also demonstrate the flight of workers and their families (see "Population/Counties" table).

Population[13]

	1910	1930	1940	1950
Carbon County	52,846	63,380	61,735	57,558
Lackawanna	259,570	310,397	301,243	257,396
Luzerne	343,186	445,109	441,518	392,241
Schuylkill	207,894	235,505	228,331	200,577

In contrast to these coal-producing counties, Lehigh County continued to grow steadily throughout this period, as follows:

Lehigh County	118,832	172,893	177,533	198,207[14]

The city of Carbondale experienced a disastrous decline in population between 1940 and 1960 while the underground fire raged. In 1930 the city's population reached a zenith of 20,061, Ten years

Hospital Street, Carbondale. Photo by Bonnie Stepenoff, 21 July 1991.

later the census revealed a moderate decline to 19,371.[15] Between
1940 and 1960 nearly a third of the town's residents fled in search
of better jobs and a safer environment. Carbondale's population in
1960 was 13,595.[16]

Carbondale suffered in a very dramatic way from the heedless
greed and final demise of the anthracite industry. In the late 1940s,
sections of Carbondale began to descend ominously into the mined-
out shafts. Like a biblical punishment for heedless greed, a mine
fire that began in 1946 continued to burn for more than fifteen
years. The fire started when the city began dumping trash into coal
pits west of town. The trash began to smolder, and flames moved
from the dump site into abandoned underground mine shafts.[17] Res-
idents noticed bad odors and some people felt ill. In 1952 a retired
miner and his wife died of carbon monoxide poisoning from the
fumes, and the neighborhood closest to the burning mines became
known as "Monoxide Gardens."[18] Chasms appeared as land col-
lapsed into an endlessly smoldering pit. Cracks split the founda-
tions of buildings, and the west side of town became a blighted,
nearly deserted area, a bleak memorial to the defunct anthracite-
coal industry.[19]

Life changed in Carbondale. Out-migration became more com-
mon than immigration, although more than one thousand of the
town's inhabitants in 1950, and nine hundred in 1960, were foreign-
born. Countries of origin of the foreign-born residents were chiefly
Italy, England, and Wales, with small numbers coming from Po-
land, Austria, Russia, Lithuania, Germany, Ireland, and Scotland.[20]
About one-fourth of the residents had foreign-born parents. Nearly
all the inhabitants were white (only twelve were non-white), and
most of them were children of native-born parents.[21]

Men fled the city in greater numbers than women. By 1960 the
coal mines were gone, but Carbondale and its surrounding towns
still had some silk and rayon, knitting, and dress mills. It seems
logical then that in 1960 Carbondale's population included 4,708
men and 5,599 women.[22] Young men in need of employment had to
go elsewhere—to the steel mills of Bethlehem, Pittsburgh, and
Ohio, or the automobile factories in Michigan.[23]

In 1960 about nine percent of males in Carbondale were unem-
ployed. Those who had jobs were nearly as likely to be involved in
professional, clerical, managerial, or sales work as in a craft or
manual labor. The occupational categories of Carbondale's 2,879
employed males are shown in the accompanying list.[24]

Professional	172
Teacher	12
Farmer	4
Manager	308
Clerical	233
Sales	232
Craftsman	598
Operative	751
Household	—
Service	271
Farm laborer	—
Laborer	157
Unknown	153

Women's participation in the Carbondale workforce followed nationwide trends. By 1960 the two-income family had become a common, though not the dominant, pattern in the United States. According to historian Alice Kessler-Harris, by 1960 just over thirty percent of wives worked for wages.[25] This national trend applied to Carbondale, where one-third of all working females in 1960 were married women whose husbands lived in their households. A substantial number (about ten percent of the female workforce) had children under six. Many of these mothers of young children had a husband present in the household and still elected or were forced to hold jobs.[26] A substantial number of women did not go to work outside the home. But the contrast with Carbondale in 1900 or 1910, when only a handful of mothers went out to work, is very striking.

Nearly all school-age children living in Carbondale in 1960 attended school. Most elementary students attended public school, but many high school students attended parochial schools. Carbondale had a total school enrollment of 2,964. Of these, 1,880 were in grade school and 848 were in high school. Ninety-four students attended college. School enrollment by age group is shown in the "School Enrollment" table.

School Enrollment

Age	Percentage
5–6	76.5%
7–13	97.5%
14–15	91.0%
16–17	77.6%
18–19	41.0%

The lower percentages in school attendance for those age sixteen to eighteen indicate that some adolescents were leaving high school in order to go to work, but here again the contrast with the early years of the century is apparent.

Higher levels of education meant that substantial numbers of Carbondale women could escape the factory floor and find new jobs in professional, clerical, and sales occupations. Of the working women in Carbondale in 1960, about one-third were factory hands. The second largest segment (about seventeen percent) held clerical positions. A sizable number worked in sales. More than ten percent of female workers held professional positions, mostly as teachers or nurses. Some worked in the service sector as waitresses or cooks. Only a very small number worked as maids, housekeepers, or domestic servants. The occupational breakdown for women in Carbondale in 1960 is shown in the "Occupational Categories" table.[27]

Occupational Categories

Operatives	638
Clerical	305
Professional	231
Medical	89
Teacher	75
Sales	173
Service	166
Craftsman	50[28]
Manager	38
Household	32
Unknown	199

Gender continued to limit their options. In the medical field, women became nurses rather than doctors. The teaching profession had been traditionally open to women as an extension of the maternal role. Although few women in 1960 worked as household or domestic servants, many entered service occupations working as waitresses, nurse's aides, beauticians, or cleaning ladies in offices. This too reflected nationwide patterns. As Kessler-Harris stated, eighty percent of women employed in 1960 worked in occupations stereotyped as female.[29]

For working women in northeastern Pennsylvania between 1940 and 1960, life was hard and choices were limited. But education offered hope of advancement, if not in one generation, then in the next. Measured against an ideal of equal opportunities for women, reality left much to be desired. Measured against the past, real prog-

ress had been made. Both male and female children attended school more frequently and for a longer period in 1960 than in 1900. Women's job choices had expanded to some extent. Women who possessed skills afforded by education had hope for a better future.

In the 1940s and 1950s, women in northeastern Pennsylvania struggled with poverty and uncertainty just as they had in 1900, but some things had changed. In 1900, most silk workers were young girls who left the workforce after marriage. In the later decades the number of young adolescents dwindled in the mills, and women were far more likely to remain in the workforce through adulthood, even after marriage and childbearing. It is true that some people continued to begin their working lives at fourteen or fifteen. But life histories reveal a tendency for young people to stay in school through adolescence, even if it meant working after school and on weekends.

Renee Roseto Bauer revealed in an interview in 1992 that she went to work in a silk mill in Allentown in the early 1930s. At that time she was fifteen or sixteen years old. Laws required that she be at least fourteen. Renee Bauer recalled that there were not many younger adolescents in the mill. She worked evenings and summers while she attended school. Her parents, who were Italian immigrants, and several other relatives worked in the silk mills. When she went to work, she said, "I just did it to add a little bit to the household expenses, you know."[30]

Renee Roseto Bauer finished high school. She attended a Catholic school where she took the business course. After graduation she looked for an office job, but failed to find one because of the Depression. She married at the age of twenty-two. At twenty-eight she went to work in an aircraft plant during World War II. Years later, between 1967 and 1980, she worked in real estate.[31]

Women's working lives, as reported in interviews, often continued, at least intermittently, throughout adulthood. Mary Schimenek, who responded to a Women's Bureau questionnaire in 1925, continued to work in Lehigh Valley silk mills through much of her married life. She participated in the strikes of the 1930s. When she did stop working it was because, she reported, "The mills closed up. The silk mill moved away. There is no more silk mill."[32]

Anna Zuercher worked in silk mills in the Allentown area from 1925 to 1970. Like Mary Schimenek, she participated in the strikes of the 1930s. She worked in several different mills, mostly as a weaver. When some mills shut down she went in search of new employment. When an interviewer asked her why the mills shut down, she replied:

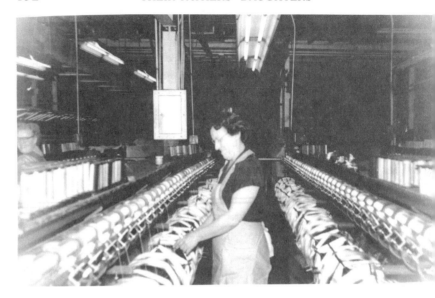

Silk reelers, 1950s. Photo courtesy of Dolores Gonus Liuzzo.

> Well, they got the silk, they took the silk mills and moved them down
> south. And when they got down south people don't work like in the
> north. Well, then well they went bankrupt. And later on, they came with
> this knitted stuff. Knitted stuff spoiled the silk mills.[33]

Her reply revealed an understanding of why the mills closed, a de-
gree of personal and local pride in her ability to work, and some
bitterness about the new polyester double-knit fabrics that replaced
silk and rayon.

Like Anna Zuercher, Catherine Haftel worked in several Lehigh
Valley mills before several of them went bankrupt. She began work
at the age of fourteen at the Diehl Silk Mill in Bath and continued
her career for twenty-five years, even after marriage and childbear-
ing. During World War II she worked at Royal Swan Mill in Cata-
sauqua. After the war she worked at Lehigh River mills until they
went out of business in the 1950s.[34]

Mothers worked. Helen Hulek Gonus "always worked in the silk
mill," according to her daughter Dolores. Dolores' father, Adam
Gonus, suffered from "miners' asthma" and was often unable to
work. The Gonus family struggled through the Depression. But
somehow Mrs. Gonus managed to save enough money to buy a
house.

In 1943, Helen Gonus brought her fourteen-year-old daughter
along to work in the mill. Dolores recalled that her mother's em-

Silk workers on lunch breaks, 1950s, Helen Hulek Gonus (second from right). Photo courtesy of Dolores Gonus Liuzzo.

ployer, Richard Krapf, who owned a silk mill in Peckville, said to her mother, "Why don't you bring Dolores in?" When the inspector came, she had to stop working for a while. But then she went back. She had to get up at 5 A.M. and walk two miles from her home in Jessup to the mill in Peckville. For her, working in the mill was a pleasant experience. Most of the workers were women. Men did the heavy work and young males served as bobbin boys. The older women treated Dolores well. "They treated me like their daughter." She worked in the mill two years. [35]

In 1945, Dolores graduated from high school at age sixteen. She had saved the money she earned in the mill in order to further her education. For one year she attended Lackawanna Junior College in Scranton. After that she obtained jobs as an office manager, first in Scranton and later in Carbondale.

In some respects Dolores Gonus' life history resembled that of Annie Denko. But there were striking differences between the story of Dolores Gonus in the 1940s and the story of Annie Denko in the early 1900s. Both lived in poverty; both were the daughters of coal miners who were not able to work steadily. Both went to work in silk mills as adolescents. But Annie Denko's mother did not go out of the home to work. Dolores Gonus' mother worked steadily in the silk mill for a period of thirty years. Annie Denko left school to work in the mill. Dolores worked weekends and continued to attend

school. Annie Denko brought her wages home to help support her parents and siblings. Dolores Gonus saved her earnings and used the money later to attend a junior college.

In the 1940s and 1950s, Martha Warosh Mroczka began working as an adolescent, bringing home wages to her parents and nine siblings, but later became a working mother. Over the course of three decades she held jobs in several silk mills in the Scranton-Carbondale area. When she began working in 1941 at the age of fifteen she had just completed the eighth grade. Her strict parents expected her to not only work in the mill but earn additional money by going out to do housework. She also helped with household chores and took care of a young brother.

Half a century later, she vividly remembered her work experience. Working days were about eight hours long, less than in Annie Denko's time. But the work was hard. Martha Mroczka recalled running up and down the narrow factory aisles, tying off the broken ends of the silk as it whirled onto cones. "If they caught you sitting," she recalled, "they'd holler. You couldn't stop to talk to anyone, you'd get heck for it. You'd get heck for everything. The more production you put out, the more they'd want."[36] The heat and humidity in the mills were oppressive. She wore short sleeves even in the winter. And the noise was deafening. "You couldn't talk to each other. You had to yell." She also remembered the smell of the dyes. It got in her clothes and lingered, especially in her winter coat. She found it embarrassing.[37]

Martha's father worked in the coal mines for fifty years. She remembered him as a union dignitary who posed proudly in front of the statue of John Mitchell in the courthouse square in Scranton. But Martha and her co-workers in the silk mills did not belong to a union.

After her marriage to Stanley Mroczka, Martha continued working off and on. When her daughter Linda was a baby she had to go back to work. Her husband was laid up in a full body cast for fourteen months. She cared for her husband and baby during the day and went to work at night. Martha's young brother helped with child care.

Martha alternated working with staying home as the situation demanded. She worked in several different mills, riding streetcars or buses from her home in Dickson City to jobs in Peckville, Scranton, and Dunmore. She described her working life by saying, "If I was laid off, I'd go to another one. Or if I had to leave and stay home for a while, I'd be embarrassed to go back to the same one. I was told I was a good worker."[38] The stress of the job plus family re-

sponsibilities made her life difficult. Her daughter Linda Newberry recalled, "She often came home tired, made supper, and was back to work. Her fingers were often cut and bandaged from getting cut on the threads. While good at her job, it was demanding."[39] Still, Martha said, she liked her job. "I was used to hard work."[40]

While working in the silk mills, Martha Mroczka brought up two daughters. Each finished high school and went on for further training. One daughter became a licensed practical nurse. The other, Linda Newberry, found a career as a business teacher in a high school in the anthracite region. [41]

These women's stories reveal courage, some resentment of hard work and poor conditions, an undercurrent of bitterness at the disappearance of the mills, and also a resilient hope of better things for themselves and their daughters. Dolores Liuzzo spoke proudly of working at the silk mill on weekends and still managing to graduate from high school with a ninety-six average.

Martha Mroczka complained about the hard work and oppressive conditions in the silk mill. But she also expressed pride in the way she pulled her family through hard times by working in a silk mill while caring for an ailing husband and tending a baby daughter. She also made a point of mentioning that the baby daughter, Linda, recently completed twenty-five years of teaching in the public schools.

Women like Dolores Liuzzo and Martha Mrozcka had the strength they needed to survive as industry declined in their communities. They began their working lives in silk mills, but they and their dreams outlived the mills. Neither one had joined a union and they did not remember the union as being a great factor in their working lives. As young women they went to work to help support struggling families, and their family loyalty remained strong. Dolores also felt a strong desire for personal betterment, leading her to do well in school, pursue higher education, and later obtain management positions. But family remained the focus of her life. Martha worked sporadically in response to family needs. Her major occupation was motherhood. But she encouraged her daughters to pursue career goals and was proud of their success.

These women followed in the footsteps of Annie Denko and Nellie Wilson, who went to the silk mills in the 1900s and 1910s in order to help their families. As the mills faded from the landscape, however, these women who came of age in the 1930s and 1940s found new ways of surviving, supporting their families, and achieving personal fulfillment for themselves and their children.

Conclusion:
Growing Up

During a silk strike in 1901, Mother Jones won sympathy for young female workers by portraying them as helpless tots victimized by greedy industrial giants. The silk workers needed compassion, and there was no moral justification for the exploitation of child labor in the mills. However most of the silk mill hands were not tots, but young women capable of standing up for themselves and fighting for their rights. When silk operatives struck their employers, parental figures like Mother Jones intervened on their behalf, bringing attention to their problems but depriving them of the dignity of self-determination.

The fathers of many silk workers joined the great anthracite strike of 1902. A UMWA poet created a sentimental picture of a young girl catching a glimpse of her father in a parade of striking miners. Through gestures and facial expressions, parent and child revealed a strong attachment to each another. By watching the parade the young girl learned to admire her father's courage. Although the poet did not ask this question, is it possible that the daughter also learned to emulate her father's behavior? Did she internalize his courage and make it her own?

During the Anthracite Coal Strike Commission hearings in 1902, a mill hand named Annie Denko described her life and work. Annie worked twelve-hour shifts in a local silk mill. Although she was only thirteen, she had been employed for a year and often worked nights. Her small wages helped support her parents and siblings. Annie's testimony aroused the anger of Judge George Gray, who demanded to hear from the father who sent this little girl out to the mill. The father testified that Annie wanted to work because she wanted clothes. Perhaps he said this to justify his own conduct. By saying this, however, he raised her from the status of a "tot" to that of a full human being with a will and desires of her own. The judge refused to listen, insisting that it was the father's duty to protect his daughter.

Five years later, thousands of silk workers in the Scranton area

followed their fathers' example and went on strike. Although most of the strikers were girls and young women, local reporters noted that they were outspoken and determined to air their grievances. As the strike progressed, male members of the UMWA intervened and pushed for a negotiated settlement. Coal miners' daughters proved that they could stand up for themselves, but their fathers asserted parental authority and determined the course of events.

In 1910 a crusading journalist went to northeastern Pennsylvania to expose conditions in the silk industry. She justly castigated the system of child labor. But she also revealed that at least one silk worker, a girl called Nellie, had managed to grow into a joyful, spirited, and brave young woman. Nellie dutifully brought her wages home, but she also enjoyed an active social life with male and female friends her own age. The journalist fretted about the state of Nellie's morals, but rejoiced that the young woman had completed the eighth grade. Her educational achievement along with her strong will, the journalist hoped, would give her a chance for a fulfilling life.

As a young girl growing up in the anthracite region in the 1920s and 1930s, Stacia Treski dreamed of completing her education and becoming a nurse. But the Great Depression put an end to her dreams. Stacia had to set aside her own desires and help support her parents. But for other girls in the region the dream became a reality as more and more young people finished junior high and high school and females found their way into clerical and even professional occupations.

Fourteen-year-old Dolores Gonus Liuzzo followed her mother to the silk mill during the 1940s. Her family was poor and her life hard. Her father had miners' asthma and could not work. She had a great deal in common with Annie Denko, but there was also one big difference. Annie Denko left school to go to the mill. Dolores Gonus worked weekends and continued her education. She finished high school and junior college, and as an adult worked as an office manager.

Another coal miner's daughter, Martha Warosh Mroczka, began working in a silk mill at fifteen. After marriage and motherhood, she continued working at mills in the Scranton-Carbondale area. Her two daughters finished high school and went on for further education. These daughters lived out Stacia Treski's dream. One became a teacher, the other a nurse.

In 1901, Mother Jones spoke out for the "tots" who reported to

Pennsylvania's silk mills. While she correctly perceived child labor as a great social evil, she failed to see that these "tots" were struggling to define a place for themselves in the working world. Generations of women in northeastern Pennsylvania fought to win higher wages in the mills. When that effort foundered, many found a different route to self-determination. For many women a high school education opened up opportunities for employment outside the factory, but also outside the home. These women accepted the fact that fathers and husbands could not always support their families. Often they entered the workforce as teenage girls, but they remained in it as adults. By the third quarter of the twentieth century, after a long series of strikes and protests, Mother Jones' "tots" had grown up.

Epilogue:
Not My Daughter!

Dolores Liuzzo had a daughter, Lisa, who was born with Down's syndrome. In 1994 Lisa Liuzzo was a charming young woman with an active social life. Deeply religious, she spent much of her time in church activities. She was friendly and outgoing, eager to share stories of parties and events. She lived with her parents in a neat, comfortable house in Carbondale until her death in 1996.

Dolores was justly proud of having worked in a silk mill as a young girl while finishing high school. Her good grades allowed her to go on to junior college. As a young mother she had worked part-time in offices. After her husband became ill, she accepted full-time employment. But her daughter was the focus of her life.

When Lisa was born, the doctor told her mother she would "be a vegetable and never get out of her crib." Dolores would not accept that. "Not my daughter!" she said. In spite of the doctor's prediction, Lisa was reading by the age of six. Dolores took defiant pride in that. She had not listened to the dire prediction of a male professional. She had made up her own mind. When it came to her daughter's future, she knew how to be tough. She had learned that while watching her mother go off to work at the mill during the Great Depression. She had learned it by going to the mill herself and doing what needed to be done.

Notes

INTRODUCTION

1. *Scranton Republican*, 27 April 1901.
2. Francis H. Nichols, "Children of the Coal Shadow," *McClure's Magazine* 20 (February 1903): 435–44.
3. Transcripts of the testimony in the Anthracite Coal Commission hearings are available in the Michael J. Kosik Collection at Pennsylvania State University.
4. John Bodnar, *Anthracite People: Families, Unions, and Work, 1900–1940* (Harrisburg, Pa.: Historical and Museum Commission, 1983); and his *Workers' World: Kinship, Community, and Protest in Industrial Society, 1900–1940* (Baltimore: Johns Hopkins University Press, 1982).
5. See "laborer" under "work" in *The New Roget's Thesaurus* (New York: G. P. Putnam's Sons, 1959), 546.
6. Ardis Cameron, *Radicals of the Worst Sort: Laboring Women in Lawrence, Massachusetts, 1860–1912* (Urbana: University of Illinois Press, 1993).
7. Richard Dobson Margrave, *The Emigration of Silk Workers from England to the United States in the Nineteenth Century* (New York: Garland Publishing, 1986).
8. Shichiro Matsui, *The History of the Silk Industry in the United States* (New York: Howes Publishing, 1930).
9. U.S. Congress, Senate, *Report on Condition of Woman and Child Wage-Earners* vol. 4: *The Silk Industry* (Washington, D.C.: Government Printing Office, 1911), 60.
10. Joseph M. Speakman, "Unwillingly to School: Child Labor and Its Reform in Pennsylvania in the Progressive Era" (Ph.D. diss., Temple University, Philadelphia, 1976), 150–61.
11. Clark Nardinelli, *Child Labor and the Industrial Revolution* (Bloomington: Indiana University Press, 1990).
12. Harold W. Aurand, "Diversifying the Economy of the Anthracite Region," in *Pennsylvania Magazine of History and Biography* 94 (January 1970):54–61.
13. *Scranton Daily Times,* 10 October 1873.
14. U.S. Industrial Commission, *The Silk Industry in America, as Represented to the United States Industrial Commission at a Hearing at the Fifth Avenue Hotel, New York, May 22, 1901* (Washington, D.C.: Government Printing Office, 1901).
15. Walter I. Trattner, *Crusade for the Children* (Chicago: Quadrangle, 1970).
16. Samuel Walker, "Terence V. Powderly, Machinist: 1866–1877," *Labor History* 19 (spring 1978): 165–84. See also Richard Oestreicher, "Terence V. Powderly, the Knights of Labor, and Artisanal Republicanism," in *Labor Leaders in America*, ed. Melvyn Dubofsky and Warren Van Tine (Urbana: University of Illinois Press, 1987), 36–37.
17. UMWA President John Mitchell, a powerful leader in the anthracite region,

came out squarely against child labor. For biographical information see Elsie Gluck, *John Mitchell, Miner* (New York: John Day, 1929) and Craig Phelan, *Divided Loyalties: The Public and Private Life of Labor Leader John Mitchell* (Albany: State University of New York Press, 1994).

18. Trattner, *Crusade for the Children.*

19. Warren P. Seem, "Scientific Management Applied to Silk Throwing," *Textile World* (17 July 1926): 27–29.

20. *Allentown Morning Call* and *Allentown Chronicle-News,* July and August, 1931.

21. James C. Cobb, *The Selling of the South: The Southern Crusade for Industrial Development, 1936–1990* (Urbana: University of Illinois Press, 1993), 214. Cobb concluded that labor costs were the most important factor in the movement of the textile industry to the South.

Chapter 1. To Keep Them from Becoming Harlots

Clarence Darrow, *Attorney for the Damned*, ed. Arthur Weinberg (New York: Touchstone, 1957), 348.

1. Perry K. Blatz, *Democratic Miners: Work and Labor Relations in the Anthracite Coal Industry, 1875–1925* (Albany: State University of New York Press, 1994), 9–36.

2. Ibid., 55.

3. Aurand, "Diversifying the Economy," 56.

4. William J. Walsh, *The United Mine Workers of America as an Economic and Social Force in the Anthracite Territory* Washington, D.C.: Catholic University of America, 1931), 11.

5. McAlister Coleman, *Men and Coal* (New York: Farrar and Rinehart, 1943), 31; U.S. Anthracite Coal Strike Commission, *Report to the President on the Anthracite Coal Strike of May–October 1902* (Washington, D.C.: Government Printing Office, 1903), 42.

6. Priscilla Long, *Where the Sun Never Shines: A History of America's Bloody Coal Industry* (New York: Paragon House, 1989), 21.

7. Ibid., 20.

8. Matthew S. Magda, "The Welsh in Pennsylvania," *The People of Pennsylvania Pamphlet No. 1* (Harrisburg: Pennsylvania Historical and Museum Commission, 1986): [2].

9. Long, *Where the Sun Never Shines*, 91.

10. Grace Palladino treats this subject in great depth in *Another Civil War: Labor, Capital, and the State in the Anthracite Regions of Pennsylvania, 1840–1868* (Champaign: University of Illinois Press, 1990).

11. Blatz, *Democratic Miners*, 10.

12. Ellis W. Roberts, *The Breaker Whistle Blows: Mining Disasters and Labor Leaders in the Anthracite Region* (Scranton, Pa.: Anthracite Museum Press, 1987), 17. It's likely, however that Powderly never made the pilgrimage he described. See Oestreicher, "Terence Powderly," 41.

13. Blatz, *Democratic Miners*, 39.

14. Oestreicher, "Terence Powderly," 32.

15. Samuel Walker, "Terence V. Powderly, Machinist: 1866–1877," *Labor History* 19 (spring 1978): 176–78.

16. Oestreicher, "Terence Powderly," 41.

17. Vincent J. Falzone, "Terence V. Powderly: Politician and Progressive Mayor of Scranton," *Pennsylvania History* 41 (July 1974): 291–92.

18. Ibid., 294.

19. Ibid., 297.

20. Oestreicher, "Terence Powderly," 46–47.

21. Ibid., 50–59.

22. *Scranton Republican*, 10 October 1873.

23. Ibid.

24. U.S. Bureau of the Census, *Thirteenth Census of the United States, vol. 3: Population 1910* (Washington, D.C.: Government Printing Office, 1913), 531.

25. Rowland Berthoff, "Social Order of the Anthracite Region, 1825–1902," *Pennsylvania Magazine of History and Biography* 89 (1965): 261–91.

26. Aurand, "Diversifying," 59.

27. Ibid., 60.

28. Ibid., 59–60.

29. Duplan Corporation, *These Fifty Years, 1898–1948* (New York: Duplan Corp.), unpaginated.

30. *Scranton Republican*, 28 August 1897.

31. Ibid., 26 and 29 October 1897.

32. U.S. Industrial Commission, *Report of the Industrial Commission on the Relations and Conditions of Capital and Labor Employed in Manufactures and General Business,* vol. 14 (Washington, D.C.: Government Printing Office, 1901), 702.

33. Matsui, *History of the Silk Industry,* 1.

34. Philip Scranton, *Proprietary Capitalism: The Textile Manufacture at Philadelphia, 1800–1885* (New York: Cambridge University Press, 1983), 325.

35. Steve Golin, *The Fragile Bridge: Paterson Silk Strike, 1913* (Philadelphia: Temple University Press, 1988), 16.

36. Margrave, *Emigration of Silk Workers,* 316.

37. Ibid., 317.

38. Ibid.

39. Golin, *Fragile Bridge,* 17–19.

40. L. P. Brockett, *Silk Industry in America* (New York: Silk Association of America, 1876), appendices.

41. Senate, *Report on Condition,* vol. 4, 19.

42. U.S. Industrial Commission, *Report,* vol. 14 (1901), 696.

43. Ibid.

44. Ibid.

45. Ibid., 672–80.

46. Ibid.

47. Ibid.

48. Senate, *Report on Condition,* vol. 4, 46.

49. Ibid., 163.

50. Ibid., 63.

51. Ibid., 64.

52. Ibid., 47–50.

53. Ibid., 48

54. Ibid., 59.

55. Ibid., 51.

56. Ibid., 46.

57. Speakman, "Unwillingly to School," 150.

58. Senate, *Report on Condition,* vol. 4, 46.

59. Speakman, "Unwillingly to School," 160–61.
60. Pa. Bureau of Industrial Statistics, *Annual Report*, vol. 14 (Harrisburg, Pa.: 1887), 38–52.
61. Ibid., 38.
62. Pa. State Factory Inspector, *Annual Report*, 1905 (Harrisburg: State Printer, 1905), 6.
63. U.S. Department of Labor Children's Bureau, *Child Labor: Outline for Study* (Bureau Publication no. 93, August 1926): 16.
64. Pa. State Factory Inspector, *Annual Report* (1905) 6.
65. As early as 1901, silk manufacturers began building mills in Delaware, North Carolina, and other southern states. U.S. Industrial Commission, *Report*, vol. 14 (1901), 702.
66. Cameron, *Radicals of the Worst Sort.*
67. Ibid., 9–10.

CHAPTER 2. MOTHER JONES AND THE SILK STRIKE OF 1900–1901

Mother Jones, *The Speeches and Writings of Mother Jones*, ed. Edward M. Steele (Pittsburgh, Pa.: University of Pittsburgh Press, 1988), 5.

1. Dale Fetherling, *Mother Jones the Miners' Angel* (Carbondale, Ill.: SIU Press, 1974), 10, 195–96.
2. Ibid., 1–9.
3. Ibid., 4.
4. Ibid., 5.
5. *Scranton Republican*, 10 October 1873.
6. *National Cyclopedia of American Biography*, vol. 33 [1943], 345.
7. Ibid.
8. *Carbondale City Directory*, 1899.
9. U.S. Bureau of the Census, *Federal Population Census, 1910* (Washington, D.C.: National Archives), microfilm, reel no. 1356.
10. *National Cyclopedia of American Biography*, vol. 30, p. 94.
11. Klots Throwing Company, payroll records, January 1903, time book, Hagley Museum and Library.
12. Information on Carbondale's silk workers in this chapter has been drawn from two sources: payroll records in the Klots Throwing Company papers, Hagley Museum and Library, and the microfilmed 1900 Federal Population Census for Carbondale (Lackawanna County), Pa., reel no. 1418, available from the National Archives.
13. Time book, January 1903, Klots Throwing Company papers.
14. Information has been derived from the time books in the Klots Throwing Company papers.
15. Senate, *Report on Condition*, vol. 4, 162–63.
16. Ibid.
17. 1900 federal census for Carbondale.
18. Klots payroll records and 1900 census.
19. These facts and figures have been derived from a study of the 1900 census for Carbondale. Of the total of 246 silk workers identified in the census, twenty-five percent were the children of coal miners; twenty-one percent were children of other types of male laborers; seventeen percent lived in female-headed households; and fifty percent had siblings working in silk mills. Distribution of workers by age

was as follows: two were 11; eight were 12; sixteen were 13; 44 were 14; 42 were 15; 39 were 16; 43 were 17; twenty were 18; thirteen were 19; six were 20; two were 21, and eleven were over 21. Of the fourteen mothers who listed any occupation at all, seven were housekeepers; three were washwomen; two were dressmakers; one was listed as a boardinghouse keeper, and one was listed as a janitor. Except for the janitor, all these jobs could have been performed in the woman's own home.

20. Information from Carbondale census.

21. Carbondale census, 1900, fourth ward.

22. Ibid.

23. Ibid., sixth ward.

24. The author took a one-in-thirteen random sample of 216 families from a total of 2,924 families listed in the 1900 U.S. census for Carbondale. This sample yielded twenty-six families with working children. The author compared the child-laboring families with the complete general sample.

25. Ethnic origins of the silk workers identified in the 1900 Carbondale census in descending order of occurrence included: Irish (about fifty-six percent); English (about twenty percent); German and Welsh (each about six percent), Austrian, Scottish, and others (the remaining twelve percent).

26. For silk workers identified in the 1900 Carbondale census, the modal number of children living in the household was five; the median was also five.

27. Carbondale census, 1900, fifth ward.

28. Carbondale census, 1900, second ward.

29. Carbondale census, 1900, fourth ward.

30. Carbondale census, 1900, second ward.

31. Ibid., fourth ward.

32. Ibid., first ward.

33. Ibid., sixth ward.

34. Ibid., fifth ward.

35. Ibid., Carbondale Township.

36. Ibid., fourth ward.

37. Ibid., sixth ward.

38. U.S. Industrial Commission, *Report,* vol. 14 (1901), 680.

39. U.S. Department of Labor women's Bureau, *Report no. 45* (Washington, D.C.: Government Printing Office, 1925), 1.

40. *Scranton Republican,* 5 December 1900.

41. Ibid., 8 December 1900.

42. Ibid.

43. Ibid., 8 December 1900.

44. In this they resembled the retail sales clerks described by Susan Porter Benson in *Counter Cultures.* They also resembled female workers in the shoe factories of Lynn, Massachusetts, described by Mary Blewett in *Men, Women, and Work* (Urbana: University of Illinois Press, 1988). Male shoe workers acted in ways that upheld the traditional family economy.

45. *Scranton Republican,* 19 December 1900.

46. Ibid., 19 and 21 December 1900.

47. *Scranton Republican,* 19 December 1900.

48. Ibid., 2 February 1901.

49. *Scranton Republican,* 2 February 1901.

50. Ibid., 6 February 1901.

51. Fetherling, *Mother Jones,* 37–41.

52. Priscilla Long, *Mother Jones, Woman Organizer and her Relations with Miners' Wives, Working Women, and the Suffrage Movement* (Boston: South End Press, 1976), 14.
53. *Scranton Republican,* 19 February 1901.
54. *Scranton Republican,* 25 February 1901.
55. *Scranton Republican,* 25 February 1901.
56. Ibid., 6 February 1901.
57. Ibid., 9 February 1901.
58. U.S. Industrial Commission, *Report,* vol. 14 (1901), 680.
59. *Scranton Republican,* 27 April 1901.
60. Ibid., 29 April 1901.
61. Ibid., 8 March 1901.
62. Ibid., 30 April 1901.
63. Jones, *Speeches and Writings,* 268.

CHAPTER 3. SILK WORKERS AND THE ANTHRACITE STRIKE OF 1902

Darrow, *Attorney for the Damned,* 349.
1. Robert H. Wiebe, "The Anthracite Strike of 1902: A Record of Confusion," *Mississippi Valley Historical Review* 48 (September 1961): 235–36.
2. Craig Phelan, *Divided Loyalties,* preface. Phelan characterizes Mitchell as a conservative man who was a hero to the workers, but also a friend to politicians and big business.
3. Ibid., 162–63.
4. Philip S. Foner, *History of the Labor Movement in the United States,* vol. 3: *The Policies and Practices of the American Federation of Labor 1900–1909* (New York: International Publishers, 1964), 95–99.
5. *United Mine Workers' Journal,* 30 October 1902.
6. Ibid.
7. John M. Hull, "Papa on Parade," *United Mine Workers' Journal,* 30 October 1902.
8. Ibid.
9. For accounts of the Anthracite Coal Strike Commission's hearings, see the *Scranton Republican,* 16 December 1902, and the transcripts of the hearings in the Michael J. Kosik Collection, Historical Collections and Labor Archives, Pattee Library, Pennsylvania State University Libraries, University Park, Pa., hereinafter cited as the Kosik Collection.
10. Darrow, *Attorney for the Damned,* 317.
11. Testimony of Annie Denko, Superior Courtroom, Scranton, 15 December 1902, Kosik Collection, box 2, vol. 20.
12. Ibid.
13. Ibid.
14. Ibid.
15. Ibid.
16. Anthracite Coal Strike Commission, *Report,* (1903), 39–40, contains the following information:

The statistics produced at the hearings show that the percentage of employees living in company houses is not large. So far as could be ascertained the facts show that in the northern and southern coal fields less than 10 percent of the employees rent their houses

from the employing companies, while in the middle coal fields less than 35 per cent. of employees so rent their houses.

Statistics included with the report indicated that in the anthracite counties about thirty-six percent of the population lived in owner-occupied homes, a higher percentage than in non-anthracite counties. In Lackawanna County the proportion of owner-occupied housing was forty percent.

17. Ibid.
18. Testimony of John Denko, Superior Courtroom, Scranton, 17 December 1902, Kosik Collection, box 2, vol. 22.
19. Ibid.
20. Ibid.
21. Ibid.
22. Ibid.
23. Ibid.
24. Ibid.
25. Cameron, *Radicals of the Worst Sort*, 105.
26. Anthracite Coal Strike Commission, *Report*, (1903), 44.
27. Nichols, "Children of the Coal Shadow," *McClure's Magazine* 435–44.
28. Ibid., 436.
29. Ibid., 442.
30. Ibid., 444.
31. Peter Roberts, *Anthracite Coal Communities* (New York: Macmillan, 1904), 14.
32. Ibid., 14–15.
33. Ibid., 17–21.
34. John A. Turcheneske, Jr., "A Guide to the Microfilm Edition of the John Mitchell Papers 1885–1919" (Glen Rock, N.J.: Microfilming Corporation of America, 1974), 7.
35. Walsh, *United Mine Workers*, 138–42.
36. Fetherling, *Mother Jones*, 46.
37. David Montgomery, *The Fall of the House of Labor: The Workplace, the State, and American Labor Activism, 1865–1925* (New York: Cambridge University Press, 1987), 279.
38. Marc Karson, *American Labor Unions and Politics 1900–1918* (Carbondale: Southern Illinois University Press, 1958), 244–45.
39. Turcheneske, "Guide," 8.
40. Ibid., 192–93.
41. Foner, *History of the Labor Movement*, vol. 3, 94–97. For a book-length treatment of the life of John Mitchell, see Gluck, *John Mitchell*.
42. Joseph E. Finley, *The Corrupt Kingdom: The Rise and Fall of the United Mine Workers* (New York: Simon and Schuster, 1972), 26.

CHAPTER 4. FAMILY LOYALTY AND THE LABOR PROTEST

1. John Brophy, "Miner John Brophy Learns His Trade, 1907," oral testimony, in *Major Problems in the History of American Workers*, ed. Eileen Boris and Nelson Lichtenstein (Lexington, Mass.: D. C. Heath, 1991), 277.
2. Ibid., 278.
3. John Bodnar, "The Family Economy and Labor Protest in Industrial

America," in *Hard Coal, Hard Times*, ed. David L. Salay (Scranton, Pa.: Historical and Museum Commission, 1984), 78–99. See also Bodnar, *Anthracite People*, and Bodnar, *Workers' World*.

4. Cameron, *Radicals of the Worst Sort.*

5. *Scranton Republican*, 7, 13, and 16 May 1903.

6. *Scranton Republican*, 25 July 1907.

7. Klots Throwing Company time book, January 1903.

8. Senate, *Report on Condition*, vol. 4, 163.

9. *United Mine Workers' Journal*, 15 August 1907.

10. Ibid.

11. *Scranton Republican*, 25, 26, 27, 31 July and August 1907.

12. Ibid., 2 August 1907.

13. *United Mine Workers' Journal*, 15 August 1907.

14. Ibid.

15. Ibid.

16. Philip S. Foner, *Women and the American Labor Movement* (New York: Free Press, 1979).

17. *Scranton Republican*, 16 August 1907.

18. *Scranton Republican*, 29 September 1907.

19. Ibid.

20. Foner, *Women and the American Labor Movement*, 393–99.

21. Cameron, *Radicals of the Worst Sort*, 125–26.

22. Foner, *Women and the American Labor Movement*, 437.

23. Ibid.

24. For detailed accounts of the great Paterson silk strike of 1913, see Golin, *Fragile Bridge*, and Anne Huber Tripp, *The I.W.W. and the Paterson Silk Strike of 1913* (Urbana: University of Illinois Press, 1987).

25. Patrick M. Lynch, "Pennsylvania Anthracite: A Forgotten I.W.W. Venture, 1906–1916" (master's thesis, Bloomsburg State College, Bloomsburg, Pa., 1974).

26. Joyce L. Kornbluh, ed., *Rebel Voices: An I.W.W. Anthology* (Ann Arbor: University of Michigan Press, 1964), 216.

27. *Scranton Truth*, 17 May 1913.

28. *Scranton Times*, 7 June 1913; *Scranton Truth*, 7 June 1913.

29. Lynch, *Pennsylvania Anthracite*, 112.

30. Melvyn Dubofsky, *We Shall Be All: A History of the Industrial Workers of the World* (Chicago: Quadrangle Books, 1969), 266–67.

31. Cameron, *Radicals of the Worst Sort.*

32. Blatz, *Democratic Miners*, 208. See also Joseph M. Gowaskie, "John Mitchell and the Anthracite Mine Workers: Leadership Conservatism and Rank-and-File Militancy," *Labor History* 27 (winter 1985–86): 54–83; and Craig Phelan, "John Mitchell and the Politics of the Trade Agreement, 1898–1917," in *The United Mine Workers of America*, ed. John H. M. Laslett (University Park: Pennsylvania State University Press, 1996), 97.

33. *Scranton Republican*, 8 October 1908.

34. Turcheneske, *Microfilm Edition*, reel 55, photos 72–77.

35. Walsh, *United Mine Workers*, 193.

36. *Scranton Republican*, 8 October 1908.

37. Melvyn Dubofsky and Warren Van Tine, *John L. Lewis: A Biography* (New York: Quadrangle Books, 1977), 61.

38. Ibid., 112.

39. Lynch, *Pennsylvania Anthracite*, 111–12. Lynch's work is a very important

source of information on the Hazleton strike. Unfortunately no copies of the *Hazleton Standard* seem to be available for January–June of 1913. The Hazleton Public Library does not have copies; neither does the newspaper office in Hazleton. The Pennsylvania State Library lists the paper among its microfilm holdings, but the issues from 1 Jan.–30 June 1913 have been reported missing.

40. Blatz, *Democratic Miners*, 55–56.
41. Ibid., 113–18.
42. Ibid., 121.
43. Ibid., 122–25.
44. Ibid., 127.
45. *Scranton Truth*, 2 April 1913.
46. Ibid.
47. *Scranton Truth*, 3 April 1913.
48. Ibid., 129–34.
49. Senate, *Report on Condition*, vol. 4, 297.
50. *New Textile Worker*, February 1920–May 1923.
51. Boris and Lichtenstein, *Major Problems*, 278–79.

CHAPTER 5. THE PROGRESSIVE ERA CAMPAIGN AGAINST CHILD LABOR IN THE PENNSYLVANIA SILK MILLS

Clipping in scrapbook, National Child Labor Committee Papers, box 59, Library of Congress Manuscript Collection.

1. Ibid.
2. Vincent A. McQuade, *The American Catholic Attitude on Child Labor Since 1891* (Washington, D.C.: Catholic University of America, 1938), 36; and John A. Ryan, *A Living Wage: Its Ethical and Economic Aspects* (New York: Grosset and Dunlap, 1906), 110.
3. Ibid., 120.
4. Ibid., 123–36.
5. *Annals of America, vol. 13, The Progressive Era* (Chicago: Encyclopedia Britannica, Inc., 1968), 85–89.
6. Philip S. Foner, ed., *Mother Jones Speaks: Collected Writings and Speeches* (New York: Monad Press, 1983), 102.
7. Nichols, "Children of the Coal Shadow," 442.
8. Ibid., 435–44.
9. William S. Waudby, "The Industrial Crime: Child Labor," *American Federationist* 10 (May 1903): 357–58.
10. Ibid., 358.
11. C. K. McFarland, "Crusade for Child Laborers: Mother Jones and the March of the Mill Children, " *Pennsylvania History* 38 (July 1971): 292.
12. Ibid., 296.
13. Thomas F. McMahon, *United Textile Workers of America* (New York: Workers Education Bureau Press, 1926), 26.
14. Ibid.
15. National Child Labor Committee, *Proceedings of the Sixth Annual Meeting* (Philadelphia: American Academy of Political and Social Science, 1910): 184–85.
16. National Child Labor Committee, Report of the General Secretary, Trustee Meeting, 12 May 1909, National Child Labor Committee papers, box 5, Library of Congress Manuscripts Collection.

17. *Scranton Republican*, 9 February 1901; 9 September 1907.

18. U.S. Industrial Commission, *Report*, vol. 14 (1901), 680.

19. John Spargo, *The Bitter Cry of the Children* (New York: Macmillan, 1909), 177–78.

20. Ibid., 174.

21. Florence Lucas Sanville, "Home Life of the Silk-Mill Workers," *Harper's Monthly Magazine* (June 1910): 24.

22. Florence Lucas Sanville, "A Woman in the Pennsylvania Silk-Mills," *Harper's Monthly Magazine* 120 (April 1910): 654.

23. Ibid., 651–61.

24. Ibid.

25. Sanville, "Home Life," 27.

26. Sanville, "A Woman," 653–56.

27. Sanville, "Home Life," 22.

28. Ibid., 31.

29. Kathy Peiss, *Cheap Amusements: Working Women and Leisure in Turn-of-the-Century New York* (Philadelphia: Temple University Press, 1986).

30. Kathy Peiss, "Gender Relations and Working-Class Leisure: New York City, 1880–1920," in *To Toil the Livelong Day: America's Women at Work, 1780–1980* (Ithaca: Cornell University Press, 1987), 109.

31. Sanville, "Home Life," 23–34.

32. Ibid., 23.

33. Ibid., 28.

34. Ibid., 28.

35. Ibid., 28.

36. Senate, *Report on Condition*, vol. 4, 51–52.

37. Ibid., 51–57.

38. Ibid., 162–63.

39. Pa. Secretary of Internal Affairs, *Annual Report 1904* (Harrisburg: State Printer, 1905), 431–32.

40. Molly Ladd-Taylor, "Hull House Goes to Washington: Women and the Children's Bureau," in *Gender, Class, Race, and Reform in the Progressive Era*, ed. Noralee Frankel and Nancy S. Dye (Lexington: University Press of Kentucky, 1991), 118.

41. For a discussion of the fight to end child labor, see LeRoy Ashby, *Saving the Waifs: Reformers and Dependent Children, 1890–1917* (Philadelphia: Temple University Press, 1984), in addition to Trattner's *Crusade for the Children*.

42. There are several good books on the Paterson silk strike of 1913, including Golin, *Fragile Bridge*, and Tripp, *The I.W.W. and the Paterson Silk Strike*. For perspectives on Pennsylvania's workers during this strike, see Bonnie Stepenoff, "Papa on Parade: Pennsylvania Coal Miners' Daughters and the Great Silk Strike of 1913," *Labor's Heritage* 7 (winter 1996): 4–21.

43. *Scranton Times*, 13 February 1913.

44. Ibid.

45. U.S. Bureau of Labor Statistics, *Monthly Review* (March 1916): 247–249.

46. Ibid.

47. Edwin Markham, *Children in Bondage* (New York: Hearst's International Library, 1914), 156.

48. Ibid., 157.

49. Ibid., 56–57.

50. Ibid., 164.

51. NCLC papers, scrapbook, box 59.

CHAPTER 6. HOPE FOR THIS GIRL

Sanville, "Home Life," 28.

1. Margaret F. Byington, *Homestead: The Households of a Mill Town* (New York: Russell Sage Foundation, 1910), 125.

2. Alice Kessler-Harris, *Out to Work: A History of Wage-Earning Women in the United States* (New York: Oxford University Press, 1982), 108.

3. Between 1860 and 1910, live births dipped by nearly one-third; among foreign-born women birth rates remained higher than average, but even among these women births fell by about twenty-six percent between 1891 and 1925 according to Kessler-Harris, 110.

4. U.S. Census Bureau, *Thirteenth Census,* vol. 3, 543.

5. Senate, *Report on Condition,* vol. 4, 60.

6. Data derived from close study of silk workers listed in the 1910 census for Carbondale.

7. Ibid.

8. U.S. Census Bureau, *Thirteenth Census,* vol. 3, 590.

9. Of the Carbondale silk workers identified in the 1910 census, ninety-five percent were single. All but one of the married workers was male. All the silk workers who were heads of households were male. But twenty-two percent of the workers were children of single mothers who were heads of households.

10. All this information has been derived from the 1910 census for Carbondale.

11. U.S. Census Bureau, *Federal Population Census, 1910*, Carbondale (Lackawanna County), Pa., ward 2, microfilm reel no. 1356.

12. Ibid.

13. Ibid., sixth ward.

14. Ibid., third ward.

15. Ibid., fourth ward.

16. Ibid., third ward.

17. Ibid., sixth ward.

18. Ibid., third ward.

19. Ibid., sixth ward.

20. Ibid., fourth ward.

21. Carbondale census data, 1900 and 1910.

22. Ibid.

23. Ibid.

24. This information has been abstracted from *Historical Statistics of the United States Colonial Times to 1970*, part 1 (Washington, D.C.: U.S. Bureau of the Census, 1975), 134.

25. Klots Throwing Company payroll records, 1910, and Carbondale census 1910.

26. Carbondale census, 1900 and 1910.

27. Pa. General Assembly, *Laws of the General Assembly of the Commonwealth of Pennsylvania Passed in the Session of 1901* (Harrisburg: State Printer), 659.

28. *Scranton Republican*, 13 May 1903.

29. Pa. State Factory Inspector, *Annual Report* (1905) 5–7.

30. *United Mine Workers' Journal*, 5 September 1907.

31. Pa. General Assembly, *Laws of the General Assembly of the Commonwealth of Pennsylvania Passed in the Session of 1905* (Harrisburg: State Printer, 1905) 352.

32. Pa. General Assembly, *Laws of the General Assembly of the Commonwealth*

f Pennsylvania Passed in the Session of 1909 (Harrisburg: State Printer, 1909), ?83–87.

33. See table for 1900.
34. Roberts, *Breaker Whistle*, 3.
35. Klots Throwing Company payroll records.
36. Ibid.
37. Senate, *Report on Condition*, vol. 4, 21.
38. Pa. Secretary of Internal Affairs, *Annual Report: 41st Report of the Bureau of Industrial Statistics* (Harrisburg: 1915), 22.
39. Anthracite Coal Strike Commission, *Report,* (1903), 41.
40. Right Reverend Monsignor Oechtering, Fort Wayne, Ind., "The Home and the School," *Catholic School Journal* 9 (October 1909): 5.
41. Ibid.
42. Reverend James A. Burns, "Facts and Figures on Catholic School Attendance," *Catholic School Journal* 1 (October 1901): 1–2.
43. *Catholic School Journal* 10 (March 1911): 410.
44. J. A. Burns and Bernard J. Kohlbrenner, *A History of Catholic Education in the United States* (New York: Benziger Brothers, 1937), 122–23.
45. See Spargo's *Bitter Cry of the Children.* Sanville deplored the use of child labor in her articles for *Harper's Monthly Magazine.*
46. See Denko's testimony quoted in chapter two.
47. *American Federationist* (May 1903): 342
48. *United Mine Workers' Journal,* 5 September 1907.
49. Sanville, "Home Life," 23.
50. Census for Carbondale, 1910.
51. Sanville, "Home Life," 28.
52. Ibid., 29–30.
53. Sanville, "Woman in the Pa. Silk Mills," 658.
54. Sanville, "Home-Life," 28–30.
55. Ibid., 28.
56. Ibid.
57. U.S. Bureau of Labor Statistics, *Monthly Review* (March 1916): 37–39.

CHAPTER 7. MOTHERS, DAUGHTERS, AND CHOICES

1. Gerald Zahavi, *Workers, Managers, and Welfare Capitalism: The Shoeworkers and Tanners of Endicott-Johnson, 1890–1950* (Urbana: University of Illinois Press, 1988), 72.
2. Ibid., 73.
3. Ibid., 71.
4. Alba M. Edwards, *A Social-Economic Grouping of the Gainful Workers of the United States* (Washington, D.C.: Government Printing Office, 1938), 6–7.
5. White House Conference on Child Health and Protection, *Report of the Subcommittee on Child Labor* (New York: Century, 1932), 13–15.
6. Manning, "Immigrant Woman," 7.
7. The 1920 federal census for Carbondale lists four thirteen-year-olds and twenty-one fourteen-year-olds working in silk mills, a slight increase from the 1910 figures. Nevertheless, the average age of workers rose.
8. Ibid.
9. This data was derived from a close examination of information on 246 silk

workers listed in the 1910 census and 262 silk workers listed in the 1920 census for Carbondale.

10. These ethnic identifications refer to heads of households from a random sample of 216 households listed in the 1900 census and 243 households listed i the 1920 census for Carbondale.

11. The 1900 sample included twenty-six adult women in gainful employment The 1920 sample included fifty such women (double the 1900 figure) in a some what larger sample group (243 families in 1920 as opposed to 216 in 1900).

12. Based on a study of a random sample of 216 families listed in Carbondale" 1900 census and 243 families listed in Carbondale's 1920 census.

13. Carbondale census, 1920, ward 3.

14. Carbondale census, 1920, wards 5 and 3.

15. Carbondale census, 1920, first ward.

16. Ibid.

17. Cy Grosvenor, "Carbondale Was a Saturday Night Town When Coal Wa King," *Carbondale News*, 29 April 1987.

18. Ibid.

19. G. d'A. Belin, Scranton, Pa., to Pierre Du Pont, Wilmington, Del., 6 Ma 1920; and "Klots Throwing Company Plan for Consolidation and Readjustmer of Capitalization, 1926," Longwood Manuscripts, Hagley Museum and Library Wilmington, Del.

20. Ibid.

21. Ibid.

22. Grace Hutchins, *Labor and Silk* (New York: International Publishers, 1929 12.

23. "Klots Throwing Company and its Subsidiaries Plan for Consolidation an Adjustment of Capitalization," 7 August 1926, Longwood Manuscripts; Hutch ins," *Labor and Silk*, 46.

24. Hutchins, *Labor and Silk*, 46.

25. Ibid.

26. Ibid.

27. Daniel Nelson, *Managers and Workers: Origins of the New Factory Syster in the United States, 1880–1920* (Madison: University of Wisconsin Press, 1975 55–58.

28. Warren P. Seem, "Scientific Management Applied to Throwing," part 2 *Textile World* 18 December 1926: 33.

29. Hutchins, *Labor and Silk*, 84.

30. Louise Lamphere, *From Working Daughters to Working Mothers: Immi grant Women in a New England Industrial Community* (Ithaca: Cornell Universit Press, 1987), 177.

31. Hutchins, *Labor and Silk*, 83.

32. U.S. Bureau of Labor Statistics, *Bulletin of the U.S. Bureau of Labor Statis tics* (October 1929), 404; and "Silk Textile Industry," NRA typescript on file i record group 9, box 22, folder no. 2, National Archives and Records Administra tion, Washington, D.C.

33. Seem, "Scientific Management," part 2, 27.

34. Seem, "Scientific Management," part 1, 329.

35. Seem, "Scientific Management," part 2, 33.

36. Ibid., 47.

37. Carl William Hasek, et. al., *Industrial Trends in Pennsylvania Since 191 (State College, Pa.: The Pennsylvania State College Studies, no. 11, 1941), 52–5

38. Zahavi, *Workers, Managers*, 69.
39. Alfred Charles Krause, "The Silk Industry of Pennsylvania" (master's the-
s, Pennsylvania State College, 1933), 43–46.
40. Ibid.
41. Ibid.
42. Ibid.
43. Manning, "Immigrant Woman," 7.
44. Ibid.
45. Manning, "Immigrant Woman," 31.
46. Manning, "Immigrant Woman," 22.
47. Ibid., 23.
48. Ibid.
49. Ibid., 49.
50. Ibid., 48.
51. Ibid., 48–49.
52. Ibid.
53. Original questionnaire on file with the records pertaining to Women's Bu-
au bulletin no. 74, record group 86, National Archives.
54. Ibid., 56–57.
55. Ibid.
56. Ibid., 49.
57. Ibid., 54.
58. Ibid.
59. Ibid., 55.
60. Ibid., 50.
61. Ibid.
62. Original questionnaires, record group 86, previously cited.
63. Ibid., 49.
64. Ibid., 59.
65. "Immigrant Woman," 59.
66. Ibid., 35.
67. Ibid., 37.
68. Ibid., 38.
69. Ibid., 39.
70. Manning, "Immigrant Woman," 52.
71. Ibid.
72. Ibid., 44.
73. Ibid., 41.
74. Ibid., 44–45.
75. This argument is supported by the Women's Bureau study previously cited,
d a close reading of census data for Carbondale in 1920; i.e., the 1920 census
owed a larger number of young single women living independently.
76. Manning, "Immigrant Woman," 52–53.
77. Ibid., 59.
78. John Bodnar, "The Family Economy and Labor Protest in Industrial
nerica," *Hard Coal, Hard Times: Ethnicity and Labor in the Anthracite Region*,
David L. Salay (Scranton, Pa.: Anthracite Museum Press, 1984), 89.
79. Ibid.
80. "George and Stacia Treski," interview in Bodnar, *Anthracite People*, 37.
81. Ibid.
82. Ibid., 36.

83. Ibid., 37.
84. Ibid., 37.

CHAPTER 8. DIVIDED LABOR

Walsh, *United Mine Workers*, 193.
1. *New Textile Worker* (14 February 1920).
2. Ibid.
3. See Alice Kessler-Harris, "Where are the Organized Women Workers?"
Feminist Studies 3 (fall 1975): 92–110.
4. James P. Johnson, "Reorganizing the United Mine Workers of America
Pennsylvania During the New Deal," *Pennsylvania History* 37 (April 1970): 11S
5. Alan J. Singer, "Something of a Man: John L. Lewis, the UMWA, and th
CIO, 1919–1943," in *The United Mine Workers of America*, ed. John H. M. Lasle
(University Park: Pennsylvania State University Press, 1996), 110.
6. Dubofsky and Van Tine, *John L. Lewis*, 139–140.
7. Roberts, *Breaker Whistle*, 118.
8. Bodnar, "The Family Economy," 79.
9. Singer, "Something of a Man," 115.
10. Johnson, "Reorganizing the United Mine Workers," 120.
11. Walsh, *United Mine Workers*.
12. Bodnar, "The Family Economy," 80.
13. Joe Pascoe, "The Thirties in Carbondale," text of a speech for the bicente
nial celebration, on file at the Carbondale Historical Society.
14. Ibid.
15. Dolores Gonus Liuzzo interview, Carbondale, Pa., 23 June 1994.
16. Bodnar, "The Family Economy," 78–88.
17. Ibid., 89–91.
18. U.S. Bureau of Labor Statistics, *Monthly Labor Review* 37 (Decemb
1933): 1355–58.
19. Records of the National Labor Board of the National Recovery Administr
tion, Record Group 9, box 22, file 2, on file at the National Archives and Recor
Administration (NARA), Washington, D.C.
20. "Silk Textile Industry, Conditions in the Industry Prior to and After t
Code," files of the National Recovery Administration, Record Group 9, box 2
Reports, Studies, and Surveys, folder no. 2, NARA, Washington, D.C.
21. Fred Keightly to H. L. Kerwin, director, Bureau of Conciliation, Departme
of Labor, 20 May 1931, Records of the Federal Mediation and Conciliation Se
vice, Record Group 280, box 213, file no. 170–6239, National Archives and R
cords Administration, Suitland, Md.
22. U.S. Bureau of the Census, *Census of Manufactures: 1929, vol. 3: Repo
by States* (Washington, D.C.: Government Printing Office, 1933), 462.
23. U.S. Bureau of the Census, *Sixteenth Census of Population, vol. 2, par*
(Washington, D.C.: Government Printing Office, 1940), 236.
24. *Sixteenth Census*, vol. 2, part 6, 184.
25. Christopher M. Sterba, "Family, Work, and Nation: Hazleton, Pennsylvan
and the 1934 General Strike in Textiles," *Pennsylvania Magazine of History a
Biography* 120 (1996):18.
26. Fred Keightly and Thomas Davis, Commissioners of Conciliation, to H.
Kerwin, director, Bureau of Conciliation, Department of Labor, 4 May 19.

Record Group 280, box 213, file no. 170–6230 (Allentown, Pa., 1931–34), Na-
tional Archives and Records Administration, Suitland, Md.
 27. A great wealth of information on this strike is contained in Record Group
280, box 213, file no. 170–6230 previously cited.
 28. Keightly and Davis to Kerwin, 6 May 1931, Record Group 280.
 29. Ibid.
 30. The newspaper does not specify, but this may have been an African-Ameri-
can team.
 31. *Allentown Morning Call*, 12 June 1931.
 32. Ibid., 28 June 1931.
 33. *Allentown Chronicle-News*, 9 August 1931.
 34. Lamphere, *From Working Daughters*, 190–193.
 35. *Allentown Chronicle-News*, 7 August 1931.
 36. *Allentown Morning Call*, 7 August 1931.
 37. Ibid., 8 July 1931.
 38. Ibid., 31 August 1931.
 39. Ibid., 28 July 1931.
 40. Ibid., 1 August 1931.
 41. Ibid., 8 August 1931.
 42. Keightly to Kerwin, 15 July 1931.
 43. Keightly to Kerwin, 1 and 4 August 1931.
 44. *Allentown Morning Call*, 16 July 1931; Keightly to Kerwin, 15 July 1931.
 45. *Allentown Morning Call*, 7 August 1931.
 46. Ibid.
 47. Ibid., 8 August 1931.
 48. Ibid.
 49. A copy of the broadside is on file in record group 280, Box 213, file no.
170–6230, NARA, Suitland, Md.
 50. Ibid.
 51. *Allentown Morning Call*, 18 July 1931.
 52. Ibid., 11 August 1931.
 53. *Allentown Morning Call*, 10 August 1931.
 54. *Allentown Morning Call*, 10 and 18 August 1931.
 55. Ibid., 16 August 1931.
 56. Ibid., 15 August 1931.
 57. Keightly to Kerwin, 4 August 1931.
 58. Keightly to Kerwin, 4 and 11 August 1931. On 30 June, Governor Pinchot
asked the Association of Silk Manufacturers of Allentown to appoint a committee
of five people to meet with silk workers' representatives at the executive mansion
(*New York Times*, 1 July 1931). Despite the governor's efforts however, the silk
manufacturers made no concessions to the strikers except to grant them the right
to return to their jobs without recriminations and the right to belong to a union.
 59. Keightly to Kerwin, 18 August 1931.
 60. Keightly to Kerwin, 22 August 1931.
 61. Dubofsky and Van Tine, *John L. Lewis*, 177–78.
 62. Singer, "Something of a Man," 116.
 63. Johnson, "Reorganizing the United Mine Workers of America," 121.
 64. Alan Dawley, *Struggles for Justice: Social Responsibility and the Liberal
State* (Cambridge: Harvard University Press, 1991), 385.
 65. Ibid., 81–84.
 66. Bodnar, "Family Economy," 81–84.

67. Ibid., 80.
68. Ibid., 81.
69. Ibid., 83.
70. Ibid., 84.
71. Roberts, *Breaker Whistle*, 101–3.
72. Dubofsky and Van Tine, *John L. Lewis*, 222. Two years later this would become the Congress of Industrial Organizations.
73. Ibid., 231.
74. Dubofsky and Van Tine, *John L. Lewis*, 291.
75. Roberts, *Breaker Whistle*, 119. The twenty-ninth of October was the anniversary of the settlement of the 1900 strike, not the 1902 strike.
76. Ibid., 120.
77. Records of the National Labor Board, National Recovery Administration, Record Group 9, box 65, vol. 3, testimony, 1935, on file at the National Archives and Records Administration, Washington, D.C.
78. Ibid.
79. Lamphere, *From Working Daughters*, 353.
80. Ibid.
81. Records of the National Labor Board of the National Recovery Administration, Record Group 9, box 22, file no. 2 on file at the National Archives and Records Administration, Washington, D.C.
82. Ibid., file 3.
83. Sterba, "Family Work," 22–24.
84. *Allentown Chronicle and News*, 22 March 1934.
85. Ibid.
86. Ibid.
87. "Subject: Majestic Silk Company, Allentown, Pennsylvania vs. Irene Clark," 17 March 1934, document on file in Record Group 25, National Labor Board, Philadelphia regional file, docket 112 (Majestic Silk), National Archives and Records Administration, Suitland, Md.
88. "Summary—Majestic Silk Co, Allentown, Pa," in Record Group 25, docket 112.
89. *Allentown Chronicle and News*, 9 April 1934.
90. Ibid., 10 April 1934.
91. Minutes of a meeting held at the Majestic Silk Mills, Inc., 16 May 1934 at 11:25 A.M., on file in National Labor Board, Philadelphia regional file, docket 112, Majestic Silk, NARA, Suitland, Md.
92. Ibid.
93. Ibid.
94. Ibid.
95. *Sixteenth Census*, vol. 2, part 6, 184.
96. Ibid.
97. Roberts, *Breaker Whistle*, 119.
98. David J. Goldberg, *A Tale of Three Cities: Labor Organization and Protest in Paterson, Passaic, and Lawrence, 1916–1921* (New Brunswick: Rutgers University Press, 1989), 22.
99. See Christopher M. Sterba, "Family, Work, and Nation: Hazleton, Pennsylvania, and the 1934 General Strike in Textiles," Pennsylvania Magazine of History and Biography 120 (1996): 3–35.

CHAPTER 9. FINDING A NEW WAY

1. Dolores Gonus Liuzzo, interview with the author, Carbondale, Pa., 23 June 1994.

2. Roberts, *Breaker Whistle*, 132–33.

3. Ibid., 143–53.

4. Hasek, "Industrial Trends," 34.

5. George L. Leffler, "The Pennsylvania Textile Industry: Economic Changes Since 1926," *Bulletin of The Pennsylvania State College Bureau of Research*, no. 35 (State College, Pa., 1948), 10.

6. Ibid.

7. Leffler, "Pennsylvania Textile Industry," 9.

8. U.S. Bureau of the Census, *Census of Manufactures: 1947*, vol. 2 (Washington, D.C.: Government Printing Office, 1949), 156.

9. This information was gleaned from listings in *Davison's Textile Directory for Executives and Salesmen* (Ridgewood, N.J.: Davison Publishing, July 1946), 265–321; and *Davison's Textile Directory for Executives and Salesmen* (1950), 299–365.

10. *Allentown Center City News*, November 1982, n.p.

11. Kim Fortney, Sara Kelly, Andree Mey, and Sarah Nelson, *The Silk Industry in the Lehigh Valley* (Allentown, Pa.: Lehigh County Historical Society, 1993), 5.

12. U.S. Bureau of the Census, *Sixteenth Census of the United States: Population*, vol. 1 (Washington, D.C.: Government Printing Office, 1942), 926; and *Eighteenth Census of the United States: Population*, vol. 1 (Washington, D.C.: Government Printing Office, 1961), 93.

13. Data for this tabulation was derived from U.S. Bureau of the Census, *Fourteenth Census of the United States: Population*, vol. 1 (Washington, D.C.: Government Printing Office, 1921), 125–26; and *Seventeenth Census of the United States: Population*, vol. 1 (Washington, D.C.: Government Printing Office, 1952).

14. Ibid.

15. *Sixteenth Census*, vol. 1, 924.

16. *Eighteenth Census*, part 40 (Pennsylvania) vol. 1, pp. 40–325.

17. Charles Remsberg, "The Fire That's Saving a Small Town," *Kiwanis Magazine* (June 1965): 27–29.

18. Ibid.

19. Martin Mann, "Fighting the Fire that Won't go Out," *Popular Science* (May 1960): 59–60; Joseph Rosenberg, "Mine-Fire," *Newark Sunday News*, 16 April 1967; *Congressional Record—Senate*, 20 February 1956, 2479–80.

20. A. E. Warne and Helen M. Pierce, *Carbondale, Pennsylvania* (Pennsylvania State University, Bureau of Business Research, 1957), 4.

21. *Eighteenth Census*, 40–325.

22. Ibid., 40–345.

23. Roberts, *Breaker Whistle*, 119.

24. *Eighteenth Census*, 40–365.

25. Kessler-Harris, *Out to Work*, 302.

26. Ibid.

27. Ibid.

28. This category would include foreladies in mills.

29. Kessler-Harris, *Out to Work*, 303.

30. Renee Roseto Bauer, interview with Thomas Dublin, 6 August 1992, transcript on file at the Lehigh County Historical Society, Allentown, Pa.

31. Ibid.

32. Mary Schimenek, interview with Thomas Dublin, 6 August 1992, transcript (p. 15), on file at the Lehigh County Historical Society.

33. Anna Zuercher, interview with Kim Fortney, 19 August 1992, transcript (p. 31), on file at the Lehigh County Historical Society.

34. Catherine Haftel, interview with Kim Fortney, 25 August 1992, transcript on file at the Lehigh County Historical Society.

35. Ibid.

36. Martha Warosh Mroczka, interview with the author, Carbondale, Pa., 24 June 1994.

37. Ibid.

38. Ibid.

39. Linda Mroczka Newberry, interview with the author, Carbondale, Pa., 24 June 1994.

40. Martha Mroczka interview.

41. Ibid.

Selected Bibliography

Primary Sources

Contemporary Books/Journals/Articles

Amalgamated Textile Workers of America. *New Textile Worker.* (12 April 1919—August 1924).

Balch, Emily Greene. "Our Slavic Fellow-Citizens: Women and the Household." *Charities and the Commons* 19 (5 October 1907): 781.

Burns, James A. "Facts and Figures on Catholic School Attendance." *Catholic School Journal* 1 (October 1901): 1–2.

Carbondale City Directory, 1900–1901.

Carbondale City Directory 1899. Scranton, Pa.: Taylor's Directory, 1899.

Carbondale, Pa. map. Drawn by T. M. Fowler, Morrisville, Pa. Boston: A. E. Downs, lith., 1890.

Catholic School Journal. Milwaukee, Wis., 1901–11.

Davison's Silk Trade, 1921.

Davison's Silk and Rayon Trades, 1929.

Davison's Textile Blue Book, 1926–27.

Davison's Textile Directory, 1946.

Durland, Kellogg. "Child Labor." *American Federationist* 10 (May 1903): 342–43.

——— "Child Labor in Pennsylvania." *Outlook* 74 (9 May 1903): 124, 126.

Hunt, Edward E., ed. *What the Coal Commission Found.* Baltimore: Williams and Wilkins, 1925.

Hutchins, Grace. *Labor and Silk.* New York: International Publishers, 1929.

Industries of Pennsylvania, Wilkes-Barre, Scranton, Pittston, Plymouth, Carbondale, Kingston. Philadelphia: Richard Edwards, 1881.

Jones, Mother. *Autobiography of Mother Jones.* Edited by Mary Field Parton. Chicago: Charles H. Kerr and Co., 1925.

Kimball, Alice. "In the Silk." *The World Tomorrow* 6 (January 1923): 50–51.

Kimball, Louisa. "As a Winder Sees It." *The World Tomorrow* 5 (December 1922): 360–61.

MacLean, Annie Marion. *Wage-Earning Women.* New York: The Macmillan Co., 1910.

Markham, Edwin. *Children in Bondage.* New York: Hearst's International Library, 1914.

179

McMahon, Thomas F. *United Textile Workers of America: Their History and Policies*. New York: Workers Education Bureau Press, 1926.

Mitchell, John. *Organized Labor*. Philadelphia: American Book and Bible House, 1903.

National Child Labor Committee. *Child Employing Industries: Proceedings of the Sixth Annual Meeting of the NCLC*. Philadelphia: American Academy of Political and Social Science, 1910.

——— *Child Labor*. New York: 1905.

——— *Child Labor Facts*. New York: Herald-Nation Press, 1939.

National Industrial Conference Board. *Cost of Living in the United States, 1914–1926*. New York: 1926.

——— *Hours of Work as Related to Output and Health of Workers: Silk Manufacturing*. Boston: 1919.

Nearing, Scott. *The Solution of the Child Labor Problem*. New York: Moffat, Yard and Co., 1911.

——— *Financing the Wage-Earner's Family*. New York: B. W. Huebsch, 1913.

Nichols, F. H. "Children of the Coal Shadow." *McClure's* 20 (February 1903): 440.

Pennsylvania Child Labor Association. "Some of Pennsylvania's Child Workers." Pittsburgh, Pa (1913).

Perkins, G. W. "Child Labor." *American Federationist* 10 (May 1903): 341–42.

Roberts, Peter. *Anthracite Coal Communities*. New York, 1904.

Ryan, John A. *A Living Wage: Its Ethical and Economic Aspects*. New York: Grosset and Dunlap, 1906.

Sanville, Florence. "Home Life of the Silk-Mill Workers." *Harper's Monthly Magazine* (June 1910): 22–31.

——— "Silk Workers in Pennsylvania and New Jersey." *The Survey* 37 (18 May 1912): 307–12.

——— "A Woman in the Pennsylvania Silk-Mills." *Harper's Monthly Magazine* (April 1910): 651–62.

Seem, Warren P. "Scientific Management Applied to Silk Throwing." *Textile World* (17 July 1926).

Silk Association of America. *Annual Reports*, 1873–1919. New York: Silk Association of America.

Spargo, John. *The Bitter Cry of the Children*. New York: Macmillan, 1909.

United Mine Workers' Journal. Indianapolis, Ind. 1891–1902.

Waudby, William S. "The Industrial Crime: Child Labor." *American Federationist* 10 (May 1903): 357–58.

Wheeler, Robert J. "The Allentown Silk Dyers' Strike." *International Socialist Review* 13 (May 1913): 820–21.

Newspapers

Allentown Chronicle, 1931.

Allentown Morning Call, 1907, 1931.

Carbondale Evening Leader.

Carbondale News.
New York Times 1907, 1913, 1931, 1937.
Scranton Republican 1897–1913.
Scranton Truth 1913.

Government Publications

Pennsylvania. Bureau of Industrial Statistics. *Report.* Official Document no. 14. Harrisburg: 1889.
—— *Annual Report.* vol. 14. Harrisburg: 1887.
—— *Report.* Official Document no. 9. Harrisburg: 1895.
—— *Industrial Directory of the Commonwealth of Pennsylvania.* Harrisburg: 1956.
Pennsylvania. General Assembly. *Laws of the General Assembly of the Commonwealth of Pennsylvania Passed at the Session of 1901.* Harrisburg: State Printer, 1901.
—— *Laws of the General Assembly of the Commonwealth of Pennsylvania Passed at the Session of 1905.* Harrisburg: State Printer, 1905.
—— *Laws of the General Assembly of the Commonwealth of Pennsylvania Passed at the Session of 1909.* Harrisburg: State Printer, 1909.
Pennsylvania. State Factory Inspector. *Annual Report.* Official Document no. 15. Harrisburg: 1905.
Pennsylvania. State Secretary of of Internal Affairs. *Annual Report 26.* Part 3: *Industrial Statistics.* Harrisburg: 1899.
—— *Annual Report 32.* Part 3: *Industrial Statistics.* Harrisburg: 1905.
—— *Annual Report 41: Report of the Bureau of Industrial Statistics.* Part 3. Harrisburg: 1915.
U.S. Anthracite Coal Strike Commission. *Report to the President on the Anthracite Coal Strike of May–October 1902.* Washington, D.C.: Government Printing Office (GPO), 1903.
U.S. Bureau of the Census. *Census of Manufactures.* Washington, D.C.: GPO, 1914.
—— *Census of Manufactures 1939.* Washington, D.C.: GPO, 1942.
—— *Census of Manufactures 1947.* Washington, D.C.: GPO, 1949.
—— *Census of Manufactures 1963.* Vol. 2, part 1. Washington, D.C.: GPO, 1966.
—— *Federal Population Census, 1900.* Washington, D.C.: National Archives Microfilm, reel no. 1418.
—— *Federal Population Census, 1910.* Washington, D.C.: National Archives Microfilm, reel no. 1356.
—— *Federal Population Census, 1920.* Washington, D.C.: National Archives Microfilm, reel no. 1557.
—— *Eighteenth Census of Population 1960.* Vol. 1, parts 1 and 40 (Pennsylvania). Washington, D.C.: GPO, 1961.
—— *Fifteenth Census of the United States Taken in the Year 1930.* Vol. 1: Population. Washington, D.C.: GPO, 1931.
—— *Fourteenth Census of the United States Taken in the Year 1920.* Vol. 1: Population. Washington, D.C.: GPO, 1921
—— *Ninth Census of the United States: Statistics of Population.* Washington, D.C.: GPO, 1872.

——— *Seventeenth Census of the United States Taken in the Year 1950*. Vol. 1: Population. Washington, D.C.: GPO, 1952.

——— *Sixteenth Census of the United States Taken in the Year 1940*. Vol. 1: Population. Washington, D.C.: GPO, 1942.

——— *Thirteenth Census of the United States Taken in the Year 1910*. Vol. 3. Washington, D.C.: GPO, 1913.

U.S. Congress. Senate. *Report on Condition of Woman and Child Wage-Earners in the United States*. Washington, D.C.: GPO, 1911.

U.S. Department of Labor. Bureau of Labor Statistics. *Bulletin no. 568: Wages and Hours of Labor in the Manufacture of Silk and Rayon Goods, 1931*. Washington, D.C.: GPO, 1932.

——— *Bulletin no. 128, 150, 190*. Washington, D.C.: GPO, 1913–16.

——— *Bulletin no. 265. Survey in Selected Industries in the United States, 1919*. Washington, D.C.: GPO, 1920.

——— *Bulletin no. 603. History of Wages in the United States from Colonial Times to 1928*. Washington, D.C.: GPO, 1920.

——— Women's Bureau. *Bulletin of the Women's Bureau, no. 45*. Washington, D.C.: GPO, 1925.

——— *Bulletin of the Women's Bureau, no. 74*. Washington, D.C.: GPO, 1930.

U.S. National Recovery Administration. *Codes of Fair Competition. Code no. 48: Code of Fair Competition for the Silk Textile Industry*. Washington, D.C.: GPO, 1933.

Manuscript Collections and Archives

Anthracite Museum, Scranton, Pennsylvania

Black Diamond Silk Company Collection.

Carl A. Luft Collection.

Ray Zabofski Collection.

Catholic University of America, Washington, D.C.

Mitchell, John. John Mitchell Papers. Microfilm Edition. Glen Rock, N.J.: Microfilming Corporation of America, 1974.

University Archives, University of Missouri-St. Louis. Powderly, Terence V. Terence V. Powderly Papers and John William Hayes Papers, 1880–1921, Knights of Labor. Copies obtained from George P. Rawick, Collection, folders 219–227.

Hagley Museum and Library, Wilmington, Delaware

Klots Throwing Company Collection.

Longwood Manuscripts (Pierre S. Du Pont Papers). Group 10, series A, file 441. Klots Throwing Company, New York, 1902–26, 229 items.

Library of Congress

National Child Labor Committee Papers.

National Archives and Records Administration

Record Group 9. National Industrial Recovery Administration files. Washington, D.C.

Record Group 25. National Labor Board, 1933–34, and National Labor Relations Board, 1934–35. Philadelphia region. Suitland, Md.

Record Group 86. United States Department of Labor. Women's Bureau Files. Washington, D.C.

Record Group 174. General Records of the Department of Labor. Washington, D.C.

Record Group 280. Records of the Federal Mediation and Conciliation Service, 1913–48. Suitland, Md.

White House Conference on Child Health and Protection, Report of the Subcommittee on Child Labor. New York: Century, 1932.

Pennsylvania State University
Michael J. Kosik Collection. Anthracite Coal Commission, testimony.

Personal Interviews

Liuzzo, Dolores Gonus. Interview with the author, Carbondale, Pa., 23 June 1994.

Mroczka, Martha Warosh. Interview with the author, Carbondale, Pa., 24 June 1994.

Zabofski, Ray. Interviews with the author on several occasions between 1992 and 1994.

SECONDARY SOURCES

General Works

Abell, Aaron I. *American Catholicism and Social Action.* Garden City, N.Y.: Doubleday, 1960.

Berthoff, Rowland. *British Immigrants in Industrial America.* Cambridge: Harvard University Press, 1953.

Boris, Eileen and Nelson Lichtenstein, eds. *Major Problems in the History of American Workers.* Lexington, Mass.: D. C. Heath, 1991.

Brandes, Stuart D. *American Welfare Capitalism, 1880–1940* Chicago: University of Chicago Press, 1970.

Braverman, Harry. *Labor and Monopoly Capital: The Degradation of Work in the Twentieth Century.* New York: Monthly Review Press, 1974.

Brody, David. *Labor in Crisis: The Steel Strike of 1919.* Westport, Conn.: Greenwood Press, 1965.

Burns, J. A. and Bernard J. Kohlbrenner. *A History of Catholic Education in the United States.* New York: Benziger Brothers, 1937.

Cobb, James C. *The Selling of the South: The Southern Crusade for Industrial Development, 1936–1990.* Urbana: University of Illinois Press, 1993.

Cohen, Lizabeth. *Making a New Deal: Industrial Workers in Chicago, 1919–1939.* New York: Cambridge University Press, 1990.

Coleman, McAlister. *Men and Coal.* New York: Farrar and Rinehart, 1943.

Darrow, Clarence. *Attorney for the Damned.* Edited and with notes by Arthur Weinberg. New York: Touchstone, 1957.

Dawley, Alan. *Class and Community: The Industrial Revolution in Lynn*. Cambridge: Harvard University Press, 1976.

———— *Struggles for Justice*. Cambridge: Harvard University Press, 1991.

Dubofsky, Melvyn. *We Shall Be All: A History of the Industrial Workers of the World*. Chicago: Quadrangle Books, 1969.

Dubofsky, Melvyn and Warren Van Tine. *John L. Lewis: A Biography*. New York: Quadrangle Books, 1977.

Edsforth, Ronald. *Class Conflict and Cultural Consensus: The Making of a Mass Consumer Society in Flint, Michigan*. New Brunswick, N.J.: Rutgers University Press, 1987.

Falzone, Vincent J. *Terence V. Powderly: Middle Class Reformer*. Washington, D.C.: University Press of America, 1978.

———— "Terence V. Powderly: Politician and Progressive Mayor of Scranton, 1878–1884." *Pennsylvania History* 41 (July 1974): 290–309.

Fetherling, Dale. *Mother Jones the Miners' Angel*. Carbondale: Southern Illinois University Press, 1974.

Finley, Joseph E. *The Corrupt Kingdom: The Rise and Fall of the United Mine Workers*. New York: Simon and Schuster, 1972.

Foner, Philip S. *History of the Labor Movement in the United States*. New York: International Publishers, 1947.

———— *History of the Labor Movement in the United States*. Vol. 4: *The Industrial Workers of the World, 1905–1917*. New York: International Publishers, 1965.

———— ed. *Mother Jones Speaks: Collected Writings and Speeches*. New York: Monad Press, 1983.

Fox, Maier B. *United We Stand: The United Mine Workers of America, 1890–1990*. International Union, United Mine Workers of America, 1990.

Gabert, Glen. *In Hoc Signo? A Brief History of Catholic Parochial Education in America*. Port Washington, N.Y.: Kennikat Press, 1973.

Gluck, Elsie. *John Mitchell, Miner: Labor's Bargain with the Gilded Age*. New York: John Day, 1929.

Greene, Thomas R. "The Catholic Committee for the Ratification of the Child Labor Amendment, 1935–1937: Origins and Limits." *Catholic Historical Review* 74 (April 1988): 248–69.

Hall, Jacquelyn Dowd, et al. *Like a Family: The Making of a Southern Cotton Mill World*. Chapel Hill: University of North Carolina Press, 1987.

Hareven, Tamara K. *Family Time and Industrial Time: The Relationship between the Family and Work in a New England Industrial Community*. New York: Cambridge University Press, 1982.

Kane, Nancy Frances. *Textiles in Transition: Technology, Wages, and Industry Relocation in the U.S. Textile Industry, 1880–1930*. New York: Greenwood Press, 1988.

Kornbluh, Joyce L., ed. *Rebel Voices; an I.W.W. Anthology*. Ann Arbor: University of Michigan Press, 1964.

Ladd-Taylor, Molly. "Hull House Goes to Washington: Women and the Children's Bureau." In *Gender, Class, Race, and Reform in the Progressive Era*. Edited by Noralee Frankel and Nancy S. Dye. Lexington: University Press of Kentucky, 1991, 110–26.

Laslett, John H. M., ed. *The United Mine Workers of America: A Model of Industrial Solidarity?* University Park: Pennsylvania State University, 1996.

Long, Priscilla. *Mother Jones, Woman Organizer*. Boston: South End Press, 1976.

——— *Where the Sun Never Shines: A History of America's Bloody Coal Industry*. New York: Paragon House, 1989.

Miller, Kerby A. *Emigrants and Exiles: Ireland and the Irish Exodus to North America*. New York: Oxford University Press, 1985.

Montgomery, David. *The Fall of the House of Labor*. New York: Cambridge University Press, 1987.

Nelson, Daniel. *Managers and Workers: Origins of the New Factory System in the United States, 1880–1920*. Madison: University of Wisconsin Press, 1975.

Nevins, Allan, ed. *The Diary of Philip Hone*. New York: Dodd, Mead, 1936.

Noble, David F. *Forces of Production: A Social History of Industrial Automation*. New York: Alfred A. Knopf, 1984.

Oestreicher, Richard. "Terence V. Powderly, the Knights of Labor, and Artisanal Republicanism." in *Labor Leaders in America*. Edited by Warren R. Van Tine and Melvyn Dubofsky. Urbana: University of Illinois Press, 1987.

Painter, Nell Irvin. *Standing at Armageddon: The United States 1877–1919*. New York: W. W. Norton, 1987.

Phelan, Craig. *Divided Loyalties: The Public and Private Life of Labor Leader John Mitchell*. Albany: State University of New York Press, 1994.

Powderly, Terence. *The Path I Trod*. New York: Columbia University Press, 1940.

Roy, Andrew. *History of the Coal Miners of the United States*. Westport, Conn., 1970.

Schatz, Ronald W. *The Electrical Workers: A History of Labor at General Electric and Westinghouse, 1923–1960*. Urbana: University of Illinois Press, 1983.

Singer, Alan J. "Something of a Man: John L. Lewis, the UMWA, and the CIO, 1919–1943." In *The United Mine Workers of America*. Edited by John H. M. Laslett. University Park: Pennsylvania State University Press, 1996, 104–50.

Walker, Samuel. "Terence V. Powderly, Machinist; 1877–1886," *Labor History* 19 (Spring 1978): 165–84.

Weir, Robert W. *Beyond Labor's Veil: The Culture of the Knights of Labor*. University Park: Pennsylvania State University Press, 1996.

Wilson, Laurel E. and Lavina M. Franck. "She had a Web of Cloth to Weave": Women's Role in 19th-Century Textile Production." *Clothing and Textiles Research Journal* 8 (spring 1990): 58–64.

Zahavi, Gerald. *Workers, Managers, and Welfare Capitalism: The Shoeworkers and Tanners of Endicott Johnson, 1890–1950*. Urbana: University of Illinois Press, 1988.

Silk Industry

Adams, Carol, et. al. *Under Control: Life in a Nineteenth-Century Silk Factory*. London: Cambridge University Press, 1983.

Brockett, L. P. *The Silk Industry in America*. New York: Silk Association of America, 1876.

Duplan Corporation. *These Fifty Years, 1898–1948*. New York: Duplan, 1948.

Feltwell, John. *The Story of Silk*. New York: St. Martin's Press, 1990.

Fogelson, Nancy. "They Paved the Streets with Silk: Paterson, New Jersey Silk Workers, 1913–1924." *New Jersey History* 97 (1979): 133–48.

Goldberg, David J. *A Tale of Three Cities; Labor Organization and Protest in Paterson, Passaic, Lawrence, 1916–1921*. New Brunswick, N.J.: Rutgers University Press, 1989.

Golin, Steve. *The Fragile Bridge: Paterson Silk Strike, 1913*. Philadelphia: Temple University Press, 1988.

Havira, Barbara S. "Managing Industrial and Social Tensions in a Rural Setting: Women Silk Workers in Belding, Michigan, 1885–1932." *Michigan Academician* 13 (1981): 257–73.

Heusser, Albert H. *History of the Silk Dyeing Industry in the United States*. Paterson, N.J.: Silk Dyers' Association, 1927.

Jowitt, J. A. and A. J. McIvor, eds. *Employers and Labour in the English Textile Industries, 1850–1939*. London: Routledge, 1988.

Krause, Alfred Charles. "The Silk Industry of Pennsylvania." Masters' thesis, Pennsylvania State College, June 1933.

Linton, George. *Modern Textile Dictionary*. New York: Duell, Sloan and Pearce, 1963.

Malmgreen, Gail. *Silk Town: Industry and Culture in Macclesfield, 1750–1935*. Hull University Press, 1985.

Manchester, H. H. *The Story of Silk and Cheney Silks*. New York: 1916.

Margrave, Richard Dobson. *The Emigration of Silk Workers from England to the United States in the Nineteenth Century*. New York: Garland Publishing, 1986

Matsui, Shichiro. *The History of the Silk Industry in the United States*. New York: Howes Publishing, 1930.

Porter, G. R. *Treatise on the Origin, Progressive Improvement and Present State of the Silk Manufacture*. London: Longman, Brown, 1831.

Rothstein, Natalie. "Introduction of the Jacquard Loom to Great Britain." In *Studies in Textile History*. Edited by Veronika Gervers. Toronto: Royal Ontario Museum, 1977.

Scranton, Philip. *Proprietary Capitalism: The Textile Manufacture at Philadelphia, 1800–1885*. NY: Cambridge University Press, 1983.

——— ed. *Silk City: Studies on the Paterson Silk Industry, 1860–1940*. Newark, N.J.: New Jersey Historical Society, 1985.

Silk. Bethlehem, Pa.: Laros Silk Company, 1926.

Silk: Its Origin, Culture, and Manufacture. Florence, Mass.: Corticelli Silk Mills, 1911.

Stepenoff, Bonnie. "Child Labor in Pennsylvania's Silk Mills: Protest and Change, 1900–1910." *Pennsylvania History* 59 (April 1992): 101–21.

——— "Keeping it in the Family: Mother Jones and the Pennsylvania Silk Strike of 1900–1901," *Labor History* 38 (fall 1997): 432–49.

——— "Papa on Parade: Pennsylvania Coal Miner's Daughters and the Great Silk Strike of 1913." *Labor's Heritage* 7 (winter 1996): 4–21.

Sterba, Christopher M., "Family, Work, and Nation: Hazleton, Pennsylvania, and the 1934 General Strike in Textiles," *Pennsylvania Magazine of History and Biography* 120 (1996): 18.

Tripp, Anne Huber. *The I.W.W. and the Paterson Silk Strike of 1913*. Urbana: University of Illinois Press, 1987.

Volyn, Robert Paul. "The Broad Silk Industry in Paterson, New Jersey: A Troubled Industry in Microcosm, 1920–1935." Ph.D. dissertation, New York University, 1980.

Wright, Gavin. "Cheap Labor and Southern Textiles, 1880–1930," *Quarterly Journal of Economics* 96 (November 1981): 605–29.

Wyckoff, William Cornelius. *American Silk Manufacture*. New York: Silk Association of America, 1887.

Women and Children at Work

Abbott, Edith. *Women in Industry*. New York: D. Appleton and Co., 1913.

Abbott, Grace. *The Child and the State*. Vol. 1: *Legal Status in the Family, Apprenticeship and Child Labor*. Chicago: University of Chicago Press, 1938.

Baron, Ava. *Work Engendered*. Ithaca: Cornell University Press, 1992.

Benson, Susan Porter. *Counter Cultures: Saleswomen, Managers, and Customers in American Department Stores, 1890–1940*. Urbana: University of Illinois Press, 1986.

Blewett, Mary H. *Men, Women, and Work: Class, Gender, and Protest in the New England Shoe Industry, 1780–1910*. Urbana: University of Illinois Press, 1988.

Cameron, Ardis. *Radicals of the Worst Sort: Laboring Women in Lawrence, Massachusetts, 1860–1912*. Urbana: University of Illinois Press, 1993.

Cobble, Dorothy Sue. *Dishing It Out: Waitresses and Their Unions in the Twentieth Century*. Urbana: University of Illinois Press, 1991.

Cooper, Patricia A. *Once a Cigar Maker: Men, Women, and Work Culture in American Cigar Factories, 1900–1919*. Urbana: University of Illinois Press, 1987.

Dublin, Thomas. *Transforming Women's Work: New England Lives in the Industrial Revolution*. Ithaca: Cornell University Press, 1994.

———— *Women at Work: The Transformation of Work and Community in Lowell, Massachusetts, 1826–1860*. New York: Columbia University Press, 1979.

Eisenstein, Sarah. *Give Us Bread but Give Us Roses: Working Women's Consciousness in the United States, 1890 to the First World War*. London: Routledge and K. Paul, 1983.

Ets, Marie Hall. *Rosa, the Life of an Italian Immigrant*. Minneapolis: University of Minnesota Press, 1970.

Foner, Philip S. *Women and the American Labor Movement*. New York: Free Press, 1979.

Fraundorf, Martha N. "The Labor Force Participation of Turn-of-the-Century Married Women." *Journal of Economic History* 39 (June 1979): 401–17.

Hartmann, Heidi. "Capitalism, Patriarchy, and Job Segregation by Sex." *Signs: Journal of Women in Culture and Society* 1 (spring 1976): 137–70.

Holland, Ruth. *Mill Child*. London: Crowell-Collier, 1970.

Kelley, Florence. *Modern Industry in Relation to the Family, Health, Education, Morality*. Westport, Conn.: Hyperion Press, 1975.

Kennedy, Susan E. *If All We Did Was to Weep at Home: A History of White Working-Class Women in America.* Bloomington: Indiana University Press, 1979.

Kessler-Harris, Alice. "Gender Ideology in Historical Reconstruction: A Case Study from the 1930s." *Gender and History* 1 (spring 1989): 31–49.

——— *Out to Work: A History of Wage-Earning Women in the United States.* New York: Oxford University Press, 1982.

——— "Where are the Organized Women Workers?" *Feminist Studies* 3 (fall 1975): 93–110.

Lamphere, Louise. *From Working Daughters to Working Mothers: Immigrant Women in a New England Industrial Community.* Ithaca: Cornell University Press, 1987.

Lown, Judy. *Women and Industrialization.* Minneapolis: University of Minnesota Press, 1990.

MacLean, Nancy. "The Leo Frank Case Reconsidered: Gender and Sexual Politics in the Making of Reactionary Politics." *Journal of American History* 78 (December 1991): 917–48.

Matthies, Susan A. "Families at Work: An Analysis by Sex of Child Workers in the Cotton Textile Industry." *Journal of Economic History* 42 (1982): 173–80.

McFarland, C. K., "Crusade for Child Laborers: Mother Jones and the March of the Mill Children." *Pennsylvania History* 38 (July 1971): 283–290.

Osterud, Nancy Grey. "Gender Division and the Organization of Work in the Leicester Hosiery Industry." In *Unequal Opportunities: Women's Employment in England, 1800–1918.* Edited by Angela V. John. Oxford: Basil Blackwood, 1986.

Parsons, Donald O. and Claudia Goldin, "Parental Altruism and Self-Interest: Child Labor Among Late Nineteenth Century American Families." *Economic Inquiry* 27 (1989): 637–59.

Peiss, Kathy. *Cheap Amusements: Working Women and Leisure in Turn-of-the-Century New York.* Philadelphia: Temple University Press, 1986.

Pinchbeck, Ivy. *Women Workers and the Industrial Revolution, 1750–1850.* London, George Routledge, 1930.

Schofield, Ann. "Rebel Girls and Union Maids: The Woman Question in the Journals of the AFL and IWW, 1905–1920." *Feminist Studies* 9 (summer 1983): 335–58.

Sen, Gita. "The Sexual Division of Labor and the Working Class Family: Toward a Conceptual Synthesis of Class Relations and the Subordination of Women." *Review of Radical Political Economics* 12 (summer 1980): 76–86.

Smith, Judith E. *Family Connections: A History of Italian and Jewish Immigrant Lives in Providence, Rhode Island, 1900–1940.* Albany: State University of New York Press, 1985.

Tentler, Leslie Woodcock. *Wage-Earning Women: Industrial Work and Family Life in the United States.* New York: Oxford University Press, 1986.

Tilly, Louise A. and Joan W. Scott. *Women, Work, and Family.* New York: Holt, Rinehart, and Winston, 1978.

Trattner, Walter I. *Crusade for the Children.* Chicago: Quadrangle Books, 1970.

Weiner, Lynn Y. *From Working Girl to Working Mother; The Female Labor Force in the United States, 1820–1980.* Chapel Hill: University of North Carolina Press, 1985.

Regional/Local History

Andrews, J. Cutler. "The Gilded Age in Pennsylvania." *Pennsylvania History* 34 (January 1967): 16.

Aurand, Harold W. "Diversifying the Economy of the Anthracite Region." *Pennsylvania Magazine of History and Biography* 94 (January 1970): 54–61.

——— "Education of the Anthracite Miner." *Proceedings of the Canal History and Technology Symposium* 4 (14–15 June 1985): 93–103.

——— *From the Molly Maguires to the United Mine Workers.* Philadelphia: Temple University Press, 1971.

Berthoff, Rowland. "Social Order of the Anthracite Region, 1825–1902." *Pennsylvania Magazine of History and Biography* 89 (1965): 261–91.

Blatz, Perry K. "The All-too-youthful Proletarians." *Pennsylvania Heritage* 7 (1981): 13–14, 16–17.

——— *Democratic Miners: Work and Labor Relations in the Anthracite Coal Industry, 1875–1925.* Albany: State University of New York Press, 1994.

Bodnar, John. *Anthracite People: Families, Unions, and Work, 1900–1940.* Harrisburg, Pa.: Historical and Museum Commission, 1983.

——— "The Family Economy and Labor Protest in Industrial America." In *Hard Coal, Hard Times.* Edited by David L. Salay. Scranton, Pa.: Anthracite Museum Press, 1984, 78–99.

——— *Workers' World: Kinship, Community, and Protest in Industrial Society, 1900–1940.* Baltimore: Johns Hopkins University Press, 1982.

Broehl, Wayne G. *The Molly Maguires.* Cambridge: Harvard University Press, 1965.

Byington, Margaret F. *Homestead: The Households of a Mill Town.* New York: Russell Sage Foundation, 1910.

Carbondale 125th Anniversary Commemorative Book 1851–1976.

Chandler, Alfred D., Jr. "Anthracite Coal and the Beginnings of the Industrial Revolution in the United States." *Business History Review* 46 (1972): 141–81.

Coode, Thomas H. and John F. Bauman. *People, Poverty and Politics: Pennsylvanians during the Great Depression.* Lewisburg, Pa.: Bucknell University Press, 1981.

Cornell, Robert J. *The Anthracite Coal Strike of 1902.* Washington, D.C.: The Catholic University of America Press, 1957.

Davies, Edward J. *The Anthracite Aristocracy: Leadership and Social Change in the Hard Coal Regions of Northeastern Pennsylvania, 1800–1930.* Dekalb, Ill.: Northern Illinois University Press, 1985.

——— "Class and Power in the Anthracite Region: The Control of Political Leadership in Wilkes-Barre, Pennsylvania, 1845–1885." *Journal of Urban History* 9 (1983): 291–334.

Dublin, Thomas. *When the Mines Closed: Stories of Struggle in Hard Times.* Ithaca, NY: Cornell University Press, 1998.

Folsom, Burton W. *Urban Capitalists: Entrepreneurs and City Growth in Pennsylvania's Lackawanna and Lehigh Regions, 1800–1920.* Baltimore, Md.: Johns Hopkins University Press, 1981.

Gibbons, William. *Those Black Diamond Men: A Tale of the Anthrax Valley.* New York: Fleming, Revell Co., 1902.

Gowaskie, Joseph. "Charisma in the Coal Fields: John Mitchell and the Anthracite Mine Workers, 1899–1902." *Proceedings of the Canal History and Technology Symposium* 4 (14–15 June 1985): 131–146.

——— "John Mitchell and the Anthracite Mine Workers: Leadership Conservatism and Rank-and-File Militancy." *Labor History* 27 (winter 1985–86): 54–83.

Greene, Victor R. *The Slavic Community on Strike; Immigrant Labor in Pennsylvania Anthracite.* Notre Dame, Ind.: University of Notre Dame Press, 1968.

Grosvenor, Cy. "Carbondale Was a Saturday Night Town When Coal Was King," *Carbondale News,* 29 April 1987.

Hasek, Carl William, et al. *Industrial Trends in Pennsylvania Since 1914.* State College, Pa., [1941].

Henwood, James. *Laurel Line: An Anthracite Region Railway.* Glendale, Calif.: Interurban Press, 1986.

Historical Souvenir of Carbondale, Pennsylvania. 1901.

History of Luzerne, Lackawanna, and Wyoming Counties, Pennsylvania. New York: W. W. Munsell and Co., 1880.

History of Scranton, Pennsylvania. Dayton, Ohio: United Brethren Publishing House, 1891.

Johnson, James P. "Reorganizing the United Mine Workers of America in Pennsylvania During theNew Deal," *Pennsylvania History* 37 (April 1970),117.

Jones, Eliot. *The Anthracite Coal Combinations in the United States with Some Accounts of Early Development of the Anthracite Industry.* Cambridge: Harvard University Press, 1914.

Leffler, George L. "The Pennsylvania Textile Industry: Economic Changes Since 1926." *Bulletin of the Pennsylvania State College Bureau of Business Research* no. 35. State College, Pa., 1948.

Lynch, Patrick M. "Pennsylvania Anthracite: A Forgotten I.W.W. Venture, 1906–1916." Masters' Thesis, Bloomsburg State College, Bloomsburg, Pa., 1974.

Miller, Donald L. and Richard E. Sharpless. *The Kingdom of Coal.* Philadelphia University of Pennsylvania Press, 1985.

Miller, Fredric M. and Morris J. Vogel. *Still Philadelphia: A Photographic History 1890–1940.* Philadelphia: Temple University Press, 1983.

Morawska, Ewa. *For Bread with Butter: The Life-Worlds of East Central Europeans in Johnstown, Pa.* New York, Cambridge University Press, 1985. *Northeastern Pennsylvania* 1 (20 February 1980), School Issue.

Palladino, Grace. *Another Civil War: Labor, Capital, and the State in the Anthracite Regions of Pennsylvania, 1840–1868.* Champaign: University of Illinois Press, 1990.

Pascoe, Joe. "The Thirties in Carbondale." Speech for bicentennial program on on file at Carbondale Historical Society.

Remsberg, Charles. "The Fire That's Saving a Small Town." *Kiwanis Magazin* (June 1965): 27–31 +.

Roberts, Ellis W. *The Breaker Whistle Blows: Mining Disasters and Labor Leaders in the Anthracite Region.* Scranton, Pa.: Anthracite Museum Press, 1984.

Rodechko, James. "Irish-American Society in the Pennsylvania Anthracite Region

1870–1880." In John E. Bodnar, ed., *The Ethnic Experience in Pennsylvania.* Lewisburg, Pa.: Bucknell University Press, 1973.

Salay, David L. *Hard Coal, Hard Times: Ethnicity and Labor in the Anthracite Region.* Scranton, Pa.: Anthracite Museum Press, 1984.

Speakman, Joseph M. "Unwillingly to School: Child Labor and Its Reform in Pennsylvania in the Progressive Era." Ph.D. diss., TempleUniversity, 1976.

Sterba, Christopher M. "Family, Work, and Nation: Hazleton, Pennsylvania, and the 1934 General Strike in Textiles," Pennsylvania Magazine of History and Biography 120 (1996): 3–35.

Stevens, Sylvester Kirby. *Pennsylvania: A Student's Guide to Localized History.* New York: Columbia University Press, 1965.

Suydam, Fred. *Take Me Out to the Ballgame: A History of Honesdale Baseball, Teams, Players, and Opponents, 1897–1947.* N.p., [1948].

Wallace, Anthony F. C. *St. Clair: A Nineteenth-Century Coal Town's Experience with a Disaster-Prone Industry.* New York: Knopf, 1987.

Walsh, William J. *The United Mine Workers of America as an Economic and Social Force in the Anthracite Territory.* Washington, D.C.: Catholic University of America, 1931.

Warne, A. E. and Helen M. Pierce. *Carbondale, Pennsylvania.* Penn State University, Bureau of Business Research, 1957.

Wiebe, Robert H. "The Anthracite Strike of 1902: A Record of Confusion." *Mississippi Valley Historical Review* 48 (1961): 229–51.

WPA Writers Program. *Pennsylvania: A Guide to the Keystone State.* New York: Oxford UniversityPress, 1940.

Yearley, Clifton K. *Enterprise and Anthracite: Economics and Democracy in Schuylkill County, 1820–1875.* Baltimore, Md.: Johns Hopkins University Press, 1961.

Index

Numbers in italics refer to illustration pages.

193